An Essay on
the Objects of
Ann Hamilton
by Joan Simon

Sound, voice, touch, motion, extension and moral recognition . . .
The figure made by practices of making themselves.

Susan Stewart, *Poetry and the Fate of the Senses*

Made of many things tangible and intangible, including language spoken and written, Ann Hamilton's objects and installations share many qualities with poetry—the makings of "the figure," as Susan Stewart illuminates that process and that form. Hamilton has also often described herself as a maker, invoking the how as much as the what of the installations that have brought her international critical acclaim and the objects, which, since the outset in the mid-1980s, have had an important if less critically explored relation to the installations. For both types of work, Hamilton draws on her training in textiles and design as an undergraduate and in sculpture as a graduate student, as well as her self-taught investigations of film, photography, video, and audio. She is an artist whose works employ many types of matter and whose individual projects and objects are characterized by a particular gesture of the hand.

Hamilton's installation work follows a form of making where a site is claimed temporarily for performative events or situations and for the gathering there of found or made elements. They follow on 1960s happenings, assemblages, and environments, and in particular they share qualities with such hand-makings as the commodities within Claes Oldenburg's Store and the obsessive repetitions for the sculptural environments (as well as the furniture and costumes) of Yayoi Kusama. They also continue the 1970s "whole house" reclamations and domestic narratives of Los Angeles's Womanhouse, where daily labor as well as contemporary myth and taboo were offered up in transgressive acts, interventions, and performance. And, with those of her contemporaries who also first came to public attention in the 1980s, Hamilton's installations share an understanding of socioeconomic subtexts that are embedded in consciousness as well as in place but are often lost or effaced from written histories.

Hamilton's environments share an even longer strand of exploration: the autobiographical interventions of Kurt Schwitters's "Merz" art, created at different sites over some fourteen years from the 1920s to the mid-1930s, and Dada and Surrealist interventions that redefined rooms or galleries so as to engage viewers actively with the space as much as (if not more than) with individual objects, such as Duchamp's addressing the ceiling (with an estimated 1,200 suspended coal sacks for the 1938 *Exposition Internationale du Surréalisme*) or the spaces "in

between" (created in the central void that he crisscrossed with miles of string for the 1942 *First Papers of Surrealism* exhibition in the gilded Whitelaw Reid Mansion). Hamilton's installations echo the quantities and obsessive repetition of materials used in these Duchamp installations and the experiential exploration required of viewers who step within the bounds of such environments.

Hamilton's installations (and the objects that relate to them) are distinguished from related artistic practice in three significant ways. First is her emphasis on time, not only as a process but also as a material itself and for its relation to the experience of the body. Her hand-makings tactily count out time as they fill space. Related is the slow pace of sensory investigation required of the visitor. The duration of a Hamilton installation is as important as any of the objects materialized (or unmade) during the course of an installation's display, and the cycles of growth as well as decay played out during its course. This quality relates as well to the objects which embody a gesture of ongoing time, and the incipient possibility of such a gesture's reenactment, for Hamilton's objects are keyed to a moment between the temporal and the fixed.

Second, Hamilton brings to installation sites something more ineffable than surreal coordinates and does more than place unusual things in juxtaposition within rather usual sites. Her materials, and her methods of making, serve as an invocation of place, of lost collective voices, of communities past and communities of labor present. In different ways this collective voicing, which Hamilton herself has referred to as a variably sized "choir," is embodied materially as well as spoken audibly.

Third is the paradoxical nature of combining a conceptualist's roaming of language and ideas with an almost contradictory quest to materialize these referents and further to craft them individually and/or hand-place each found bit into a large incremental, formally specific placement. This sense of crafting—of making, figuring, and ending by touch—the component parts (as well as the whole) distinguishes Hamilton's work from many of her generation who use resonant elements of an abject sort, collected or dispersed informally. Even more so does the political and moral sense of how her works are made set Hamilton apart: the visceral understanding that each placement of an element is an act of attention, a unit of a larger collective act of labor. Perhaps the most crucial aspect of Hamilton's figuring of objects to installation and re-figuring of installations to objects is the sense of isolating the necessary gesture, the relation of act and thing, and the almost moral imperative that the making of each object (as an independent work or as a component of an installation) condense both voice and matter.

It is perhaps helpful to note that Hamilton has, as a critical part of her practice, recognized herself as a reader. She reads spaces for her site-responsive installations; she reads for the specifics of her installation's component parts and as background and inspiration, digging into volumes of history, socioeconomic theory, anthropology, and urban and agricultural studies. She has included readers (herself and others) within her installations, who absorb texts by speaking

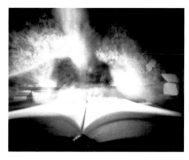

Study for a new Ann Hamilton series of pinhole works in which the exposure is determined by the time of speaking or reading: *reading · "The Tender Carnivore" by Paul Shepard, June 2006.*

them silently to themselves while moving a hand over a line of text so as to rub or burn it out, or actually to lift it from its two-dimensional plane. Hamilton has used books in her installations as sensuous, tactile presences remade by the mark of the body. Books have also issued as objects from her installations. Moreover, each book serves practically and conceptually as an overall "corpus"—a body of information, a given container or figure—that is used in its entirety just as she also addresses the body and its sheltering clothing and architecture.

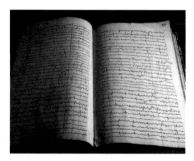

An accounting book Hamilton filled with her tracings of found EEG charts. She used this book as a model for the floor in her 1987–88 installation *the earth never gets flat.*

Hamilton is a reader of dictionaries, often searching in them for titles that serve to abstract or otherwise interweave her component subjects. She is a reader of literary criticism and poetry, and she has often used particular texts as inspiration and as material by, among others, Walt Whitman, Charles Reznikoff, Susan Howe, A. R. Ammons, Ann Lauterbach, and Susan Stewart, the last many times over. No thinker, in fact, has been more important for Hamilton than Stewart, whose books of poetry and innovative critical analysis of literature and art have been mainstays for the artist for many years, most recently Stewart's *Poetry and the Fate of the Senses.* With Stewart, Hamilton shares a converse of ideas that began in the early 1990s, when Stewart wrote the keynote essay for Hamilton's first exhibition catalogue, which accompanied her 1990 installation *between taxonomy and*

communion at the Museum of Contemporary Art San Diego, La Jolla, California. How Hamilton concretizes her ideas, how her works function, and, in particular, how she renders the dynamic relation between her objects and her installations may also be imagined reading through a passage from Stewart's *Poetry and the Fate of the Senses* (Chicago, 2002: 327–28):

> Made of language, poetry participates both in the generalizations of inherited systems of meaning and in the particularities of expression—at this moment, in this place, with this voice, and so serves as what eighteenth century aestheticians thought of as a "concrete universal," a form bearing witness to individuation and universality at once.

A parallel illumination of sorts may be gleaned as well from this passage—with the substitution of the word "art" for "poetry" and the addition of "and other things" to Stewart's phrase "made of language": the way Hamilton moves from the particular to the general and back to the particular, remaking the "figure" of an object into an installation, or, conversely, unmaking an installation and remaking its component parts as different "figures," fixing at different points in time and in different ways the concepts and relationships, indeed the voices and defining silent spaces, between her elements.

The subject of this book is Hamilton's objects, and it is conceived by Hamilton as an inventory. Her choice of this word rather than others for a volume of collected works—for example, catalogue or an even more detailed record of the relation of objects and their history of ownership and publication, catalogue raisonné—is telling of Hamilton's engagement with language, process, and makings. From Hamilton's search in the *Oxford English Dictionary* are the following entries for inventory:

> 1. inventory, *n.* A detailed list of articles, such as goods and chattels, or parcels of land, found to have been in the possession of a person at his decease or conviction, sometimes with a statement of the nature and value of each; hence any such detailed statement of the property of a person, of the goods or furniture in a house or messuage, or the like.
> 2. verb-1. *trans.* To make an inventory or descriptive list of; to enter in an inventory, to catalogue: a. goods, etc.
> 3. noun-a. *gen.* or *fig.* from 1. A list, catalogue; a detailed account.

Other dictionary entries include a "list of things, especially of property." Inventory may also refer to a "business's current assets, including property owned as well as merchandise on hand and the value of work in progress and work completed but not sold." Another definition includes "the merchandise or stock that a store or company has on hand" or "the works in an exhibition or collection," referring in the definition also to such words as "catalogue" or "catalogue raisonné." Lastly, inventory may also mean "the act or process of making an inventory, or the period of time when this is done"—a "stocktaking."

In a sense, this book—*An Inventory of Objects*—partakes of the listing functions of all of the definitions above, but, most critically for the artist, the process of stocktaking. In this process Hamilton has looked back at what she has made (when, why, and where) and recognized along the way new objects now incorporated into her body of work. She has seen possibilities for revisiting earlier pieces and, moreover, has found ideas for works to come. As Hamilton herself has recognized, "this inventory means not closing the book in summary form but opening the book to go forward beyond the here and now."

This inventory of objects documents the many forms Hamilton's objects take and relates them to one another and to her practice in installation. The objects include photographs, sculptures (sometimes comprised of multiple parts in several mediums), found objects remade, and video and audio works, the last obviously less object-like in their presentation if not their containers. These objects may take the form of unique works or multiples. Her multiples comprise editioned sculpture, photographs, and video and audio pieces, as well as prints.

This book may also, by definition, serve as a catalogue for any of a number of upcoming shows and it also serves many, but not all, of the functions of a catalogue raisonné. While the entries are detailed, reasoned (by the artist and others), and related one to another (and to other aspects of Hamilton's practice), the entries do not trace provenance of ownership or cite bibliographic references to previously published illustrations or texts about individual works.

In many ways this inventory is the result of Hamilton's consideration of which objects might step outside the time and context of one of her installations. The recognition that objects and installations are or may be sold also plays a part and engages the questions of production and distribution. An important sub-theme is the artist's collaboration with technical advisors and her makings in concert with the guidance of workshops. And while the gallery system is the most apparent means of distribution, it is important to note the nature of different commissions, including objects created specifically to benefit institutions as fundraisers.

The first objects created independently of an installation were books remade by replacing typographic marks with tiny stones. Each object used a different ready-made book, so the total set of books is an edition consisting of variations rather than multiple replications (*Untitled*, created in 1992, for the New Museum of Contemporary Art, New York [see pp. 102–103]). The New Museum's invitation, resulting in "a gift" on the artist's part, was an inspiration for objects that otherwise might not have been made. Critically, this work and others similarly commissioned have also led Hamilton to new forms of making.

Many of Ann Hamilton's objects were made as components of site-responsive, architecturally bounded, temporal, theatrical sculptural projects. Others were made prior to or during the course of the public life of an installation, often by the performing presence, variously recognized by Hamilton as "an attendant, a figure, a tender." Of these types of objects made prior to or during the exhibi-

tion calendar of an installation, a number were recognized as objects within Hamilton's oeuvre after an installation had been dismantled—some of them many years later. In an economy of method and thinking, an example of another kind of tending, Hamilton keeps many elements of an installation after it has been disassembled and often draws upon them for new uses—revising, remaking, or recombining elements for subsequent pieces.

The newly recognized object serves as a trace of the temporal event, a relic, a condensation of the installation's tangible embodied history and memory. Whether presented anew as a single unit or as part of an assemblage of elements, these objects, as Hamilton notes, "have their own resonance" and "consolidate the relationships that were part of the larger work." See, for example, *(privation and excesses)*, 1989 (pp. 80–81), where metal chair, cloth, felt hat, and honey are re-used, but for which the hat is refilled with honey each time the object is shown to evoke the potential of the gesture that was key to the installation. For the installation, an attendant sat on the chair, cloth on lap, hat on cloth, and wrung his or her hands in the honey.

Ann Hamilton: sample study page for the altered book pages used in the edition *Untitled* 1992 (left) and the installation *indigo blue*, 1991 (right).

Still another type of Hamilton object is made independently of an installation, though some of these objects may be related conceptually to contemporaneous installation ideas in process. For example, the stone-marked book of *Untitled*, 1992—that first object made independently of an installation—is related to components of two installations that Hamilton had been thinking about at the same time. In its effacing of some of the page's typographic marks, it is related to the pages of an eighteenth-century index of Swedish botanist

Carolus Linnaeus's sexual system of plant classification that Hamilton had punctured with pin-sized holes not only to trace the shape of the letter forms but also to obliterate the legibility of it as language. These pages, contained in a folio case and set upon a comptroller's table, were part of the installation *Ann Hamilton/David Ireland* (originally an untitled installation) at the Walker Art Center in Minneapolis in 1992. The collective object in its entirety lived on after the fact as *(Ann Hamilton/David Ireland)*, 1992, including not only the refigured pages and the table on which they were set but also the work's audio component, a female voice reading the genus and species list of Linnaeus's system (see pp. 100–101).

Ann Hamilton: details of *aleph*, 1992, List Visual Arts Center, Massachusetts Institute of Technology, Cambridge, Massachusetts.

Untitled, 1992, may also be seen as related to Hamilton's installation *aleph*, 1992, at the List Visual Arts Center, Massachusetts Institute of Technology, Cambridge, Massachusetts. In this installation Hamilton conjoined the body and the book in a monumental vertical stacking of thousands of disused books, interlayered with sawdust-stuffed and sewn wrestler's dummies to line a 92-foot-long wall. The texts of these closed books—whose weight and position were not unlike the way stone walls are hand-placed, or the stacking of bones to create patterned walls of catacombs—pressing down onto the strata of bodies evoked both the disused life of the mind and the disused life of a created figure. They offered together a new kind of architectural corpus, an overall figure with both body and book silenced. That these elements together created a kind of absorptive, acoustic wall was in contrast to the video in the same installation, seen on the small screen of a round-backed monitor set into a wall bounding the far end of the room.

That video, *(aleph · video)*, 1992/1993 (see pp. 106–107), shows the image of a mouth in which stone marbles are rolling around inside, slipping to the edge but never fully spilling irretrievably out of bounds. Heard are the sounds of the

marbles scraping against each other, creating a kind of audible language, similar to the way Hamilton had used the materiality of tiny stones as a tangible sculptural, if silent, voice on the surface of a printed book's pages for *Untitled*, 1992.

Yet other objects have developed out of possibilities or techniques offered in collaborative situations, such as at The Institute for Electronic Arts at Alfred University in Alfred, New York, where Hamilton has made digital prints (pp. 138–139, 188–191, 200–201, 210–213, 250–253, 262–263); or at Gemini G.E.L. in Los Angeles, where she has made both prints based on photo negatives and also sculpture editions (pp. 208–209, 234–237, 260–261); The Wexner Center for the Arts in Columbus, Ohio, which served as the laboratory where the artist developed multiple video and sound works as part of her Resident Fellowship; The Fabric Workshop and Museum, Philadelphia, which fabricated components for many of Hamilton's installations as well as several independent works (see pp. 116–117, 120–121); and ideas developed in conversation with Marty Chafkin of Perfection Electricks, New York, who has designed and fabricated the electro-mechanical components in Hamilton's projects for the past seven years (see, for example, the spinning speakers, pp. 240–241, 254–255, 256–257). In addition, Hamilton's dialogue with graphic designer Hans Cogne facilitated the creation of the object that is this book, which evokes the tactility and the sensuality of material as well as the precise formal concerns evidenced in all of her work. Previous to this publication, Hamilton and Cogne worked together closely both on the book included in the installation *aloud* (p. 31) that subsequently became the artist's book *Ann Hamilton: aloud* (p. 243) and also on *Ann Hamilton: lignum* (Bibliography, p. 278).

This inventory of objects also serves as a complement to the cataloguing of the artist's installations in *Ann Hamilton* (Harry N. Abrams, 2002), research that informs this inventory as well. As the installation book included a chronology of objects to cross-reference the interrelation between her works, this objects book includes a chronology of installations (see p. 265) serving the same purpose. Both the installation book and this inventory begin their cataloguing with works made during the 1983–1984 school year, when Hamilton was a graduate student in sculpture at the Yale School of Art and Architecture, where she received her MFA in 1985. In making her decision whether to go to graduate school in sculpture or in textiles, which she had studied as an undergraduate, and informed also by her introduction to conceptual art and her exploration of many media during her postgraduate stay at the Banff Centre in Canada, and later when living in Montreal, Hamilton recalls: "I decided either to study sculpture or weaving. I can remember saying to myself, 'I'm interested in the relationships between things in space. And more important than the things themselves is the way they come into relation.' I assumed then this was more sculpture and less textiles; now I might say it is more textiles and less sculpture." (*Ann Hamilton*, 2002: 31)

Two projects from the 1983–1984 school year, which were shown as part of the sculpture department's open houses, set the direction of all her other projects.

One of them, the studio installation *room in search of a position*, 1983, was considered by the artist a failure, yet out of this work she found the materials and ideas that would become her *body object series*, the photographs that were a defining mark in her practice, and a series that remains ongoing. The other project, *suitably positioned*, 1984, was considered by the artist successful from the outset. For this "studio tableau," Hamilton used a conjunction of the body and an object (herself and a re-made men's suit). This project opened three directions that her art would ultimately take: installation, performance, and objects.

Hamilton used objects in her first room-sized installation at Yale, *room in search of a position*. The three-sided room was built within a studio and was painted white along with all of the objects within the studio, including a chair, window blind, table, and shoe. Many of these objects appeared to be penetrating and partially passing through walls. Barely three-quarters of a door, for example, protrudes at a downward angle into the room while the remaining portion of the door is presumed by the viewer to be "behind" the wall. Hamilton considered the pictorial nature of this installation a failure, which led her to use a figure (herself) in relation to the objects. As she explained to this writer in 2006, Hamilton's asking herself the question "how can I make something that demonstrates the thinking or demonstrates a relation instead of making a picture of a relation" marked a shift in process and subject matter. This shift, according to Hamilton, prompted the first of what later were titled the *body object series* of photographs. The first photographs in this series were shot in 1993 as she worked with her then-husband, photographer Bob McMurtry. In these *body object* photographs, Hamilton wore components of her *room in pursuit of a position* installation as well as objects selected for but not used in the installation. These photographs were printed in 1984 and first editioned in 1991 (see pp. 38–42).

Other photographs were shot later and editioned in 1993 (see pp. 42–45); and, in a circular process of stocktaking, Hamilton editioned a third group in 2006, returning to one image first photographed in 1984 and two others in 1987 (see pp. 48–49, 50–51). All of the body object photographs are obviously also pictures, but rather than being dominantly pictorial for Hamilton, they convey a physical predicament that embodies some of her ideas and process.

Hamilton's next installation employed a figure. It was the first installation (which she at the time would more readily describe as a "studio tableau") in which a performer participated as a material within a defined, existing architectural space. Hamilton used herself and wore an "object" that she had created: a ready-made men's suit that had been found in a thrift shop and was elaborated with other found items, namely thousands of wood toothpicks, some as long as skewers. These elements were each spray-painted blue-black and were individually glued to the fabric. This process related to the incremental repetitive procedures and the duration of time and hand-work involved in making a textile. At the same time, the suit offered several possibilities for use in her developing sculptural, indeed performative, installation practice, and her condensation of

ideas of the body and the object—ideas of skin, housing, container, camouflage, and the crossing of genders (male suit/female body) and species (an item of haberdashery or hide).

Hamilton had made the suit independently of the installation, but it was first employed for her project titled *suitably positioned*, referring both to the body in relation to its hide and also to the hide-covered figure's relation to the room. The suit itself had "developed," as Hamilton now recalls, "within the conversations I was taking part in during that year." Among them were discussions held in a course she was taking at Yale on the cultural construction of the body. Hamilton remembers being uncertain about what to do with the toothpick suit. As she remembers, she "wasn't clear about how to present this work." She also says that, "somewhat ironically, [she] was thinking of welding an armature—but didn't know how to weld." The work may be seen as a summary of both her past experience and studies and also her contemporaneous investigations: the construction techniques, materials, and conceptual approaches in the expanding field of textiles as well as her explorations of the cultural import of the constructed identity of a body and the many ways to read it.

If the objects in *room in search of a position* were in some sense in a state of arrested animation, Hamilton was beginning to explore how to introduce a live, ongoing presence into her work as well as an animated relation between object and figure. When her fellow student Melinda Hunt saw the toothpick suit and suggested that Hamilton wear it, she recognized the possibilities that would allow her a way to incorporate both object and figure, especially her desire to express the relation between things.

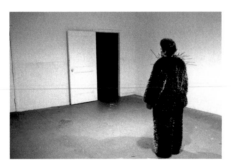

Ann Hamilton: *suitably positioned*, 1984, Yale School of Art and Architecture studio.

Hamilton wore the suit in what she referred to at the time as installation tableaux or studio tableaux, the latter particularly related to the site of these works, which were the open studios that were her first exhibition possibilities at Yale. For *suitably positioned*, 1984, she stood at the center of the otherwise empty studio for the two-and-a-half hour duration of one of the open house showings. From a distance the suit appears soft and furry, while from up close it signals the incipient danger of a porcupine ready to release its quills.

Standing at attention in the middle of the room, Hamilton herself was a sculptural presence, to be explored in the round by visitors. In presenting herself as a living and breathing entity, she also could be said to have contributed to the ongoing definition of performance art, which Rose Lee Goldberg summarized as "live art by artists." When she held her position wearing the suit for an hour during a performance series at Franklin Furnace in New York, which was a variant of the *suitably positioned* studio installation, this public presentation was categorized as performance. The suit, emerging as an object from its use in these two situations, thus gained the title *(suitably positioned)* (see pp. 52–53). Hamilton's parenthetical titling both recognizes the generative event and sets the object apart from it.

The paradox of performance art—and temporal installations as well—is that while the event has a finite (and ephemeral) life, the staging also may live on after the fact in written documentation and in visual documentary records. Though Hamilton would not begin to work with video until 1988, and then only to create elements for an installation but not to document one, she had already begun to work with photographs, and the many ways she has selected photographs of herself in the toothpick suit—and of the toothpick suit alone—tells much about her vision and her understanding of the relation between her chosen elements. These photographs also offer ways to see the differences between the way a photograph is used as documentation and an artist's creation of a set-up or documentary-like photograph as an artwork.

How Hamilton is seen photographed wearing the toothpick suit reveals much about her vision of the constructed body, how it may be understood in space and time, and how it may be read differently at different moments in time. The toothpick suit may be seen as the key piece not only in Hamilton's developing practice, but also in her ongoing understanding of her body of work. It served the three interrelated directions her art would take—the making of objects, performances, and installations—and it continues to reveal her eye and process, as well as the work's import, by virtue of the way she comported herself in it and selected photographs of those moments. Though Hamilton did not shoot any of these photographs herself, she directed the photographic sessions, working with Bob McMurtry, to whom she was married at the time, and selected from the many recorded.

A comparison may be helpful here. One of the images is a color slide of the installation version. The photographer takes a point of view from behind Hamilton and is positioned along a diagonal axis in the room. The sidelong glance that Hamilton herself has often assumed while participating in one of her installations is that of the "camera eye." We see Hamilton from the back, but also from the side, and so gain a glimpse of the left side of her face as she looks toward an open door, where a visitor is presumed to enter (see left). Hamilton is a solitary figure, at attention. We may read an expectant look into the small bit of ruddy face we see. Overall, a human presence and its expectant stance over-

ride the constructed animal presence of the suit. The photograph privileges our scrutiny of this figure, the particular person in this strange suit, as the viewer to the installation would have. As a document, it serves the moment well.

By comparison, two other photographs have a more animated though different resonance and reveal the difference between the documentary function of a photograph in recording a performance or installation, and what many artists began to pursue during the 1980s and 1990s (with important precedents from the 1960s and 1970s): the staged photograph made expressly for the camera as an artwork in its own right. In one of these photographs, Hamilton is seen in the suit bearing on her back a similarly prickly toothpick-encrusted chair. She leans forward as if to balance it or to press against its weight so that it does not overwhelm her (see *body object series #13 · toothpick suit/chair* 1984/1993, p. 45).

Another image is a more generalized view. Seen full-figure but from the back, the human figure is abstracted. The wearer is dwarfed within the suit's mass. The black-and-white photo emphasizes the texture and the likening of human hair and animal fur. The particulars of the human body are absented: no face or hands are in view. Shot with the figure centered against an overall white background that more typically is the taxonomic set-up for types seen in Irving Penn or Richard Avedon photos, the white background also sets off clearly the long skewer-like spines projecting from the hide at its topmost part—"shoulders" seems the incorrect word for this fully merged animal/human hybrid.

The image bears a containment that is also palpably animate. It has a presence as a sculptural object and as an overall conceptual figure. That Hamilton more than twenty years later saw in this image an economy of all that she had been working with, a visually compelling pictorial image and a conceptual referent to her process, separate from either installation or performance, led her to include it in her *body object series* (see *body object series #17 · toothpick suit*, 1984/ 2006; p. 48), where it joins *body object series #13 · toothpick suit/chair* 1984/1993 (p. 45) and *(suitably positoned)* (pp. 52 –53), the suit itself.

While the particulars of Hamilton's objects are detailed in the narrative entries in the inventory that follows, a conceptual frame for addressing her objects is in order here. Necessary as well is an introduction of some of the key subjects and themes, including a discussion of when they entered her body of work. Also important is Hamilton's continuing investigation of language spoken and written, and the newest forms, especially audio, that language is now taking in her oeuvre.

The book, perhaps the most recurrent image in Hamilton's body of work, first entered Hamilton's practice in two ways during her installation *the earth never gets flat*, 1987. It appeared most obviously in the open book set within a wall-mounted glass vitrine (see pp. 58 –59) and, less obviously, in the image underfoot. On a Marly floor (a kind of theatrical flooring), Hamilton painted,

13

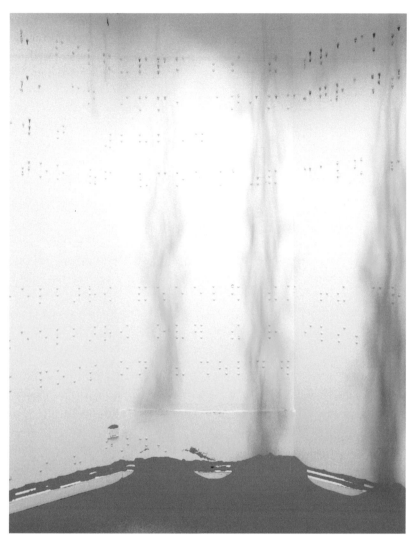

Ann Hamilton: *myein*, 1999, U.S. Pavilion, 48th Venice Biennale. Detail of vinyl powder falling over Braille-encrusted walls and visitors writing in the accumulated powder.

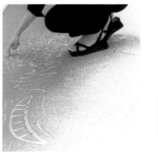
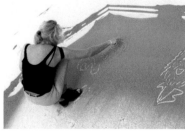

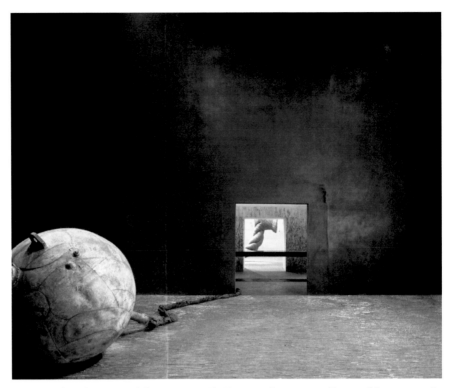

Ann Hamilton: *the capacity of absorption*, 1988, The Temporary Contemporary, Museum of Contemporary Art, Los Angeles. View from the third room through to the second and first rooms of this three-part installation. Below, detail of linotype floor.

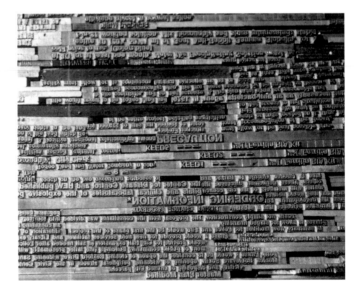

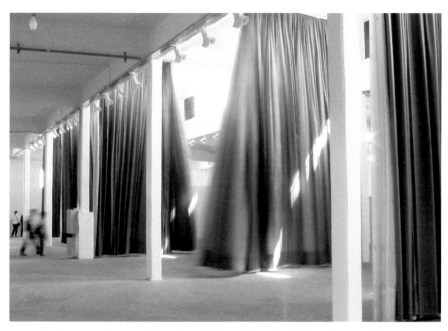

Ann Hamilton: *appeals*, 2003, Istanbul Bienniale, five curtains mechanically opening and closing, 32 speakers with recorded voice.

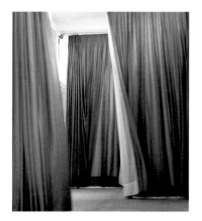

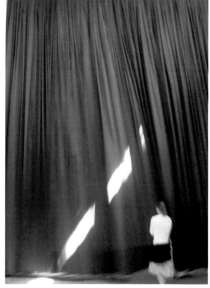

as she notes, "a giant book page." This page was constituted not of lines of written language but rather the brain wave readout lines of hospital medical records. Such EEG (electroencephalograph) images are recordings of electrical impulses from the brain which are picked up by electrodes attached to a patient's scalp. These electrical signals are sent to galvanometers connected to pens, which, in order to measure the impulses, record the multiple signals on a strip of continuously moving graph paper (see p. 3).

The graphic continuity of these mechanically generated lines anticipates Hamilton's later videos of continuous writing (see pp. 202–205, 248–249) as well as more immediately her many uses of body measure, such as calipers (see pp. 70–71) or phrenology charts, and her material ways of recording thinking itself (including "reading"). In later works Hamilton continued to put text underfoot: in a floor made up of lead typesetter letters (*capacity of absorption*, 1988) (p. 14), on wax blocks (*palimpsest*, 1989), and for a floor created of large wood block letters for her Seattle Central Library Commission (2001–2003) (see right).

For her San Francisco Public Library Commission, 1990–1995 (see right), Hamilton papered a three-story wall with thousands of library catalogue cards amended by volunteer readers. In a ledger, she wrote out in her own hand a Cotton Mather sermon for (*whitecloth · book*, 1999) (pp. 172–173). She offered Charles Rezinkoffs "Testimony" conveyed in large-scale Braille dots on the walls of her Venice Biennale installation *myein*, 1999 (p. 13). She has also embroidered text onto a blanket (*awaken*, 2000; see pp. 198–199), filigreed text into thimbles (*scripted*, 1997 [pp. 162–163]; *slaughter*, 1997 [pp. 164–165]; and *cinder*, 1999 [pp. 170–171]), and written text on the backs of mirrors (*bearings*, 1997) and on paper for prints (see pp. 188–189, 1999; and pp. 208–209, 2000). She has used texts read and recorded (Whitman in *malediction*, 1991; T.S. Eliot in *tropos*, 1993; and A. R. Ammons in *lignum*, 2002). She has also included texts that she herself has written. The first of these was a phrase she wrote and then cut into a curtain for her *lumen* installation, 1995: "A voice from the exterior opens and closes to reveal and conceal the hand" (see pp. 133–134). For *phora*, 2005, Hamilton not only wrote a text, but used the phrases within it to trigger an improvisatory multi-voiced reading. Each of three readers read in each of three languages (English, French, and Classical Arabic) an unscripted selection of some of the words and, importantly, the order in which to say them. Their recorded ensemble reading was played as part of the installation (see pp. 258–259).

The relation of Hamilton's objects to installations and installations to objects also should be noted here. While she is a maker, Hamilton, like many conceptual or process artists before her, has engaged methods and materials that from their first use were thought of as mutable. Her installation *malediction*, 1991, at the Louver Gallery, New York, is a turning point in her address of the relation between the "ongoing" and the "fixed."

When Hamilton sat daily on a high stool at a table, taking from a bowl of bread dough a segment that she pressed into the mold of the cavity of her mouth,

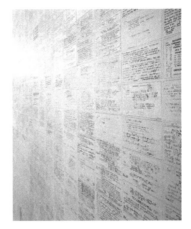

Ann Hamilton and Ann Chamberlain: San Francisco Public Library Commission, 1990–95. Detail of 50,000 library shelf-list cards hand-annotated by individual readers.

Ann Hamilton: Seattle Central Library Commission, 2001–2003. Detail of wood floor with relief reverse letter forms of "first lines" of selected books from the Literacy, English as a Second Language and World Languages Collection, Seattle Central Library.

Ann Hamilton: *corpus*, 2003–2004, MASS MoCA. One of the installation's three rooms: accumulated paper from ceiling-mou

then setting each into the large basket on the table, she was alone yet surrounded by other elements of the installation such as sheets lining the wall she faced—which were the same material as the sheets strewn underfoot as visitors entered the first of the gallery's two rooms. The air was filled with both the smell of the yeasty dough and the wine-stained sheets twisted and mouldering on the other side of the entrance wall and also the sounds of Walt Whitman's "I Sing the Body Electric" and "Song of Myself." At the end of the day, the Louver Gallery's then director, Sean Kelly (who for nearly fifteen years now has been the proprietor and director of the eponymous Sean Kelly Gallery, representing Hamilton) would collect some of the day's makings, then bake and store them.

As Hamilton notes, Kelly was in a sense "harvesting" them, for "otherwise they would not have survived." Arresting the process quite literally, the baked molds contrasted with the dough molds left in the basket, which would continue to rise. Over time, the fermenting yeast would swell the dough to the point that the individual mark of the mouth in each piece would be re-absorbed by and abstracted back into the dough's mass.

Hamilton continues to remember her ambivalence about the idea of fixing something changeable, however important the fixed component was to the longer life of the piece. In selecting components of this installation to become an independent composite object that would resonate with the relations that had once been present, Hamilton chose the table, basket, bowl, and bread

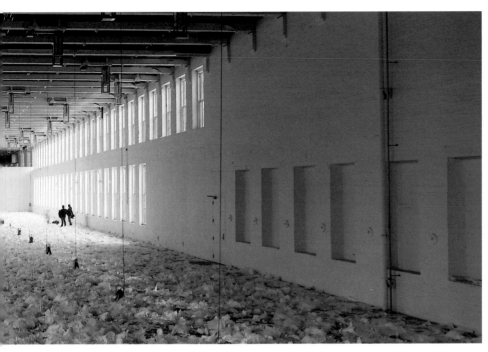

erated paper droppers, 24 speakers in a descended position, silk cloth filtering window light.

molds, as well as the recording of Whitman read aloud by Mary Kelly that had played from within the gallery walls. Hamilton, as she has done throughout her career, employed matter from the same site of "making": both the voice and the molds issued from the mouth. More critically, the voice served as a "live" presence in relation to this large scale "still-life." This selection of elements to stand long-term for a temporal installation would set a precedent for how Hamilton would reanimate the inanimate, and how she would literally re-figure an installation. In short, this installation and its related object became the paradigm for Hamilton's intuitive poesis: the making of a figure, the unmaking of it, and the making of another figure anew.

In later works, such as *whitecloth*, 1999, or *aloud*, 2004, the idea of a figure animating a Hamilton work in relation to the larger overall "figure" of an installation privileged not the artist's makings (or the tender's makings within an installation), but tilted the relation toward the figure of the visitor as an animating presence. In these works, in fact, the overall "figure" cannot be constructed without the movement of the figure—the audience—within the space. In many ways, this was anticipated in *tropos*, where a performing presence sat working at a desk as one focal point; but, in fact, the movement of a visitor toward the light, toward the presence of sound that was always out of reach—out of bounds, outside the windows yet shifting among speakers there—constituted the ever-shifting, animating experience of the overall "figure."

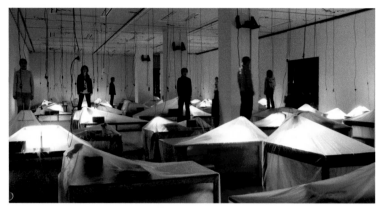

Ann Hamilton: *voce*, 2006, two-room installation, Contemporary Art Museum, Kumamoto, Japan.
View of first room: plastic-wrapped tables set with tube radios, kimonos, and desk lamps serve as platforms for performers and volunteers to stand on and vocalize the sounds of a bird calling.
View of second room: details of each of two videos spinning 360 degrees clockwise and counterclockwise, the circling beam of light, illuminating the eight cable-extended speakers spinning overhead emitting the recorded sound of cicadas.

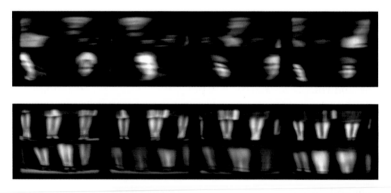

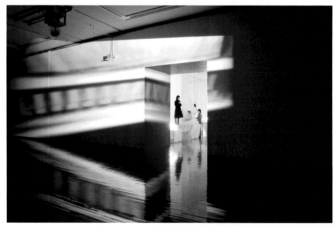

In Hamilton's installation *whitecloth*, 1999, at The Aldrich Contemporary Art Museum, Ridgefield, Connecticut, the visitor moved through the two-story space, following a fleeting white cloth that moved along a motorized cable. Only in passage could the visitor perceive the work in its entirety. This was true also for *myein*, in Venice in 1999, whose changing climate and shifting pigment and voicings triggered movement in response to the artist's offerings. Movement was also necessary for the "figure" in *corpus*, 2003 (pp. 18–19), where visitors turned toward the light from the rose-colored windows and toward the falling paper and either to or away from the sound emanating from moving speakers. What had been rather clearly defined bounds of being in or out of an installation—crossing a liminal divide—became in Hamilton's work what she calls an "internal shift-ing" for the visitor. The overall figure of a work "cannot be made or imaged" except in relation to the moving witness. The fulcrum of the experience, as Hamilton says, is the "turning toward or being turned by or surrounded."

In Hamilton's most recent installation, *voce*, 2006, in Kumamoto, Japan (see left), the visitor could address component figures individually—tables topped with kimonos, desk lamps, and radios, each totally beneath a plastic sheath—or survey the multiple figures as an overall "landscape," or, in fact, be part of the larger surround. Visitors could join with the dozen performers atop a dozen of the tables and add their own figurative presences and voices by standing atop other tables in the installation. Donning earphones, they could then hear and mimic aloud the birdsongs that the others were uttering. If Hamilton had always set the stage for a mobile visitor, this staging is now a collective place where multiple figures and voices are no longer *in* but *of* these makings. In a much more subtle example, Hamilton's instructions for hanging high up on a wall the flat-screen monitor for her 2003 video *up* causes the visitor not only to look up but also to viscerally take up the same upturned chin gesture as the figure (unseen in the video) blowing into a pipe-like device to hold a ball aloft at its end (see pp. 232–233).

The container and the contained are continuing themes in Hamilton's work, whether envisioned as the body and its skin, the surrounds of clothing, or the surrounds of architecture. More problematic for Hamilton than including multiple figures within the overall body of an installation (within the givens of its right-angled rooms) has been deciding how to contain an object or whether to bound it at all. The table itself is one of Hamilton's most recurrently used sub-jects and objects—second only in her oeuvre to the book. She has often sited her tenders at tables, which take on the form of work stations, and has used tables to serve functionally as pedestal-like forms for the display of a variety of objects. It became evident to Hamilton that for certain installations she could transpose the table and its objects into independent works.

More problematic still for Hamilton is the question of how to present an object as an isolated object—one made independently of an installation or one made during the course of an installation. This was the case for the toothpick

suit that she had made prior to *suitably positioned*, but which she wore for its two variant public presentations in 1984. Hamilton solved the suit's independent display problem when it was shown in 1996 as part of her solo traveling exhibition *the body and the object*, organized by and presented at the Wexner Center for the Arts, Columbus, Ohio in 1996. For this exhibition, the first to focus exclusively on Hamilton's objects, she used an armature that she had devised for the suit's display. To independently exhibit the books she had reworked during her installation, *indigo blue*, 1991, Hamilton chose two options, which together reflect her ambivalence at that point about whether to explicitly contain, frame, or otherwise "house" them. One variant is a set of surviving books shown in a vitrine whose materials and dimension were specified by the artist (see pp. 88–89), while another set of books is exhibited as an "object" with no further framing (see pp. 90–91).

For the most part Hamilton would find that, as the room was necessary to the figure of an installation, so too was a box-like container necessary for such works as the poetry-filigree thimble, a work that has several variants (see pp. 162–163). One of these variants is set within a vitrine, while another is set within a book-binder's case, a clam shell box (see pp. 170–171). In both of these instances, Hamilton chose housings to set the objects apart.

Another ongoing aspect of Hamilton's project is her practice of finding tools and testing gestures to work them in a manner that animates inanimate forms. Two changes in her use of photography and video are important here, for in recent years Hamilton has used these media to "return time" to still images. Since 1999, Ann Hamilton has used a small pinhole camera made of a plastic film canister held in her mouth to take a picture. The long exposure of the pinhole which records the time of two people standing face to face extends into time the moment of "exposure." Her use of a tiny surveillance camera, by comparison, when moved by the hand over a photograph or object renders these subjects animate and dimensional in time. In both cases, one sensory organ is exchanged for another: the mouth or the hand serves as an "eye."

Just as Hamilton had used her mouth as a site for making the molds in *malediction*, she used her mouth for making photographs. When she inserted into her mouth the odd pinhole camera that she had carefully fitted with a tiny piece of hand-cut film and a precisely tested pinhole, she used her open lips to allow light to enter the doubled chamber to expose the film, and her closed lips to serve as a shutter. Initially, she held a mirror to capture her own reflected image, whereas later she turned her sight outward to other people and landscapes (see pp. 194–197, 214–219). Of the latter series, titled *Face to Face*, Hamilton says, "it is a trace presence of the time of standing or sitting 'face to face' with a person or before a landscape. The figure or landscape becomes the pupil in the eye shape created by my mouth, much the same way as one sees a tiny image of oneself in the reflection of another person's pupil. The word pupil comes from the Latin *pupilla*, which means little doll or puppet."

The images resulting from these pinhole exposures captured multiple housings. One saw the image taken set within an ovoid internal frame that appeared to be not unlike the shape of an eye, but which could also be read (with some concentration) as the outline of her mouth. At the same time, the scale shifts of

The artist exposing a pinhole image from a camera placed in her mouth (left). From an ongoing series: *Face to Face*, summer 2006 (right).

these tiny photographs, which were later printed at different, though still relatively small, sizes (see p. 214, pp. 234–237), also appeared to give the viewer not only the point of view of looking into a chamber but also an initially confounding point of view—either looking in or looking out. Because the room surrounding the photographed figure became part of the image, creating almost a fisheye effect, the outer was perceived as the inner, within the mouth itself. At the same time, one experiences looking into a chamber, cave-like, with illuminations and shadows, yet also quite literally one reads the opening as another portal, entering and defining the void of the mouth. That Hamilton titled one of the photographic series *portals* (see pp. 194–197) calls on the multiple meanings of the word, but focuses on the crossing of a boundary, even if the directions of in and out are confounded.

For elements of her installation *the picture is still*, 2001, and then for her installation *aloud*, 2004, Hamilton attached a tiny video surveillance camera to her hand, turning the appendage of touch into an extension of sight. For *the picture is still*, Hamilton moved her hand at close distance over a still photo, focusing on the subject's open mouth. In doing this, Hamilton created a distorted, abstracted, and ambiguous image that could be read as alive or dead, and, if alive, a figure that paradoxically could be either laughing or crying. Coming into the image at such close range, Hamilton also immediately turned the particular into the abstracted realm of the universal (see pp. 220–221).

Hamilton used this same technique for *aloud*, 2004. To create this video, she stood on a ladder, head lamp illuminating her subjects, and moved her hand over the faces of small painted medieval altarpiece sculptures at Stockholm's Museum of National Antiquities. The figures were not only animated by the movement of her hand moving in and out of proximity, but also, as Hamilton says, by her attempt, however futile, to coax them into speech. A precedent for this work was Hamilton's use of ventriloquists' dummies, also known as

"vents," whose wooden jaws snapped open and shut in her *lumen* videos (see pp. 140–141). These vents, as well as her earliest spinning bamboo puppets (see p. 58), derive from Hamilton's collection of dolls, puppets, and other articulated figures that she has found at flea markets. Hamilton presented the images of the sculptures' faces captured in *aloud* in two different ways: she first collected and published them as an artist's book in 2004 and then she printed them in a larger size as elements scaled to the architectural frame for *phora*, 2005, an installation at the Maison Rouge in Paris (see p. 33, pp. 250–253).

Hamilton's *linea*, 2005 (see right), a permanent commission at the Cabo Rojo Lighthouse in Cabo Rojo, Puerto Rico, reveals the artist's continuous circling of her materials, her conversations, her ways of reading and stocktaking, and the immediate relation of hand to material, material to matter, and matter to method. Hamilton in *linea* returned again not only to a Susan Stewart text, but also, importantly, to her own markings and highlights in her copy of Stewart's *Poetry and the Fate of the Senses*. She has turned this conversation between reader and writer, between beholder and beheld, into another kind of inventory and, in the process, into new matter for her work. Hamilton read this book several times and each time underlined or marked passages. For the Cabo Rojo project, she re-read the book with a focus on the passages she had previously noted. As she read the book in its entirety in this way, she lifted fragments of these underlined sections, "sometimes three words here, two words there." She then sequenced these selections in their original order to create a cumulative text. Hamilton's gloss absented large sections of Stewart's book.

What Hamilton did in *linea* was not unlike what she had evoked previously with the sequence of words she had written for *phora*, 2005, which could be re-ordered as they were spoken aloud by the artist and two others in three different languages. But with this unmaking and remaking of Hamilton's and Stewart's acts of reading and writing, Hamilton set a new course both in her formal method and in her ongoing conversation with Stewart. This text work represents what Hamilton has called her condensed version of Stewart's book, and she personally read it aloud (in English) for a recording that was part of *linea*. In *linea*, she incorporated this spoken work with excerpted readings in Spanish and English in multiple voices from *The Odyssey* and from *Mr. Dampier's Voyages, Vol. II, Part III: A Discourse of Winds, Breezes, Storms, Tides, and Currents*. Writer Lilliana Ramos served as Hamilton's collaborator on all of the texts for *linea*; Ramos's voice is also one of those recorded. Interestingly, Hamilton's use of several texts cut into each other began with her 1997 *bounden* installation in Lyon where the hand-stitched continuous cursive line of text for extended "curtains" derived from different sources (and where she used poetry by Susan Stewart as well as by John Donne and Jorie Graham in addition to selections from *Grey's Anatomy*).

As Hamilton describes the *linea* installation, "These recorded voices are sequenced to shift between four speakers—one on each end of a steel pole—and slowly circle from centrally placed ceiling-mounted mechanisms in four adjacent

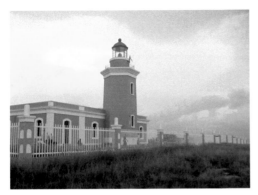

Ann Hamilton: *linea*, Cabo Rojo Lighthouse, The Public Art Project of Puerto Rico, San Juan, completed in 2004. A commissioned project which Hamilton approached as a site of reading and writing.

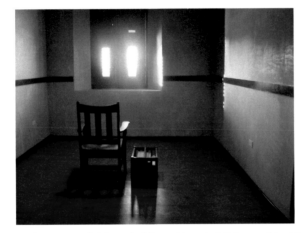

The nine-room lighthouse building and tower installation consists of four rotating speakers and video projections, 38 wall hung folding chairs, 38 copies of *The Odyssey*, four tables, and three large reading chairs. The walls have artisan plaster surfaced over printed pages which contain the marginalia of anonymous readers.

Detail of Ann Hamilton's copy of *Poetry and the Fate of the Senses* by Susan Stewart (below right).

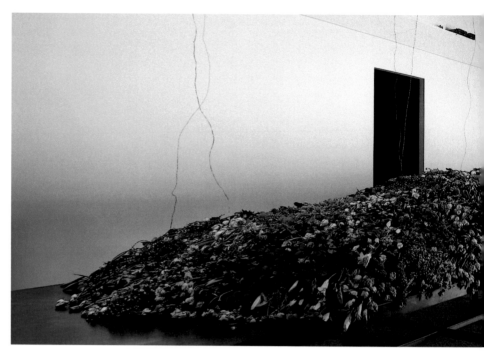

Ann Hamilton: *mantle*, 1998, Miami Art Museum. A figure, hand-sewing wool coats, sits in front of a long steel table w▮

and symmetrically related rooms. This turning unit also projected video onto
the surrounding walls and across the furniture: a table and wall-hung folding
chairs, the bottom of each seat containing a copy of different editions of *The
Odyssey*. Together, the circling voices and images move within walls covered in
pages scanned and printed from books whose pages are heavily marked by the
hand of the reader—books from Lilliana Ramos's collection as well as from Susan
Stewart's." These pages were seen together with anonymously marked pages
of books found by Hamilton on the library shelves of the university where she
teaches. "All of these pages," Hamilton further notes, "were covered in a tinted
plaster that mostly obscured the text's legibility." Hamilton had previously used
this method of adding a film of plaster over individual paper elements to create
a continuous wall surface for her Mess Hall Commission, 1989–1990, at the
Headlands Center for the Arts, Sausalito, California, where she had used copies
of plant specimen etchings. She also used this method in her collaboration with
Ann Chamberlain on the San Francisco Public Library Commission, where
annotated library catalogue cards cover a three-story wall.

The wall surface and audio component of *linea* echo poet Susan Howe's analysis
of marginalia—the notes, writings, emendations, and commentary written in
books that were the focus of Howe's critical study, *The Birthmark: Unsettling the
Wilderness in American Literary History*. Hamilton used this study as inspiration
in part for the installations and objects in her *whitecloth* installation, a project

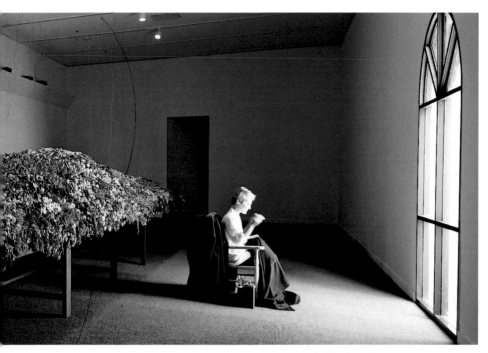

...ltiple speakers connected to seven short wave scanning radios are buried in a bed of fresh-cut flowers.

which was developed in conversation with poet Ann Lauterbach. This installation marked an important shift in Hamilton's oeuvre, for its making was based on a multitude of objects (see pp. 172–187) that she selected or created to serve as correlative commentaries on the history of the house's former use. Howe's book evoked the written and vocalized word in early New England cultures, particularly women's voices at the margins of society, and quite literally the words written by many writers in the margins of a book's pages. At that time, Hamilton also responded to these writings as they related to her own formal placement of language at a room's (or body's) margins or beyond its borders.

Hamilton has yet to determine the next ways to materialize her underlinings in Stewart's *Poetry and the Fate of the Senses*—her re-figuring of Stewart's own "figures." In thinking about how to further use these words in audio works, Hamilton is continuing to investigate the ongoing problem of how to contain and present her objects. As Hamilton herself puts it, "how do you house an experience in a way that doesn't fully close it off?" One thought is to continue to work with the spinning speakers she had used in the Cabo Rojo Lighthouse project and in other installations. In a number of her recent installations, Hamilton has worked many variations on spinning speakers, "projecting song, sound, breath, word."

Hamilton has also recently returned to the shortwave radios she used in *mantle* in 1998 (see above). For that installation, the radios set high on a shelf on the wall had their wires descending to speakers buried within a mound of flowers

on a table and were set to pick up speaking voices. For *voce*, 2006, as previously noted, tube radios and clothing were set beneath translucent plastic sheeting, and while participants could stand atop the table and be part of a collective act of speech, the radios, as Hamilton notes, "were not tuned to a station but emitted the sound of their internal workings—the tubes. The sound of the tubes rose and fell in response to fluctuations in the electricity and the proximity of people walking through the space." Hamilton had included a group of "shape note singers" mingling among guests at a collaborative dinner by the artist and Alice Waters held in 2004 at the Whitney Museum of American Art, New York, to benefit the Minetta Brook Foundation's support of art and agriculture in the Hudson Valley.

Hamilton had also conjoined voices in her installation *aloud* for the Gothic Hall of the Museum of National Antiquities, Stockholm, Sweden, in 2004. "Projecting sound, song, breath, and air," Hamilton employed two related modes to generate these aspirations. Fourteen hand-cranked wind-machines were made for the installation. These devices, open-ribbed barrels turning under a silk cloth, were wound at varying velocities to achieve different volumes by fourteen performers wearing felt costumes that Hamilton had designed with Marie-Louise Sjöblom at HV Studio Stockholm (see p. 31, pp. 246–247). In addition, for the opening Hamilton included four additional figures, also similarly dressed—Hamilton herself, Hans Cogne, Marie-Louise Sjöblom, and Anne Magnusson—who, while turning the pages of her artist's book *aloud*, enacted the images there, the reproductions of the photos she had elicited by running her hand with a small video surveillance camera over the faces of the museum's medieval statuary, concentrating on their mouths and thereby animating their frozen form. All four performers had tiny microphones near their mouths. As they looked at the shape of the image of the mouth on a page, Hamilton says, "they breathed that shape." Hamilton, linking their acts of page-turning to their acts of cranking the wind-machines, notes the use of the artist's book *aloud* in this context "as if it were a songbook for breath."

These new works mark a change in Hamilton's locus of voices from the perimeter of a room (in *malediction*, *tropos*, or *myein*) to a central position within the room (in *lignum*, *corpus*, *aloud*, and *voce*). The voice was the core of *lignum*, 2002, at the Wanås Foundation, Knislinge, Sweden (pp. 30–31). There, Hamilton used Leslie speakers, which, as she explains, "are unique mechanical rotary tremolo speaker systems that separate treble and bass—the treble is thrown from two spinning cones, which is what you see in *lignum*, removed from their original housing and re-figured." In *lignum* these speakers become, as Hamilton remarks, "the central spine of the work linking five material horizons" as they ascend and descend through the multi-storied building.

Hamilton's most recent works have changed both the nature of the chorus and also the spaces in which their voices might echo, or float away. Meredith Monk, with whom Hamilton collaborated on *mercy*, 2001, may sing in the

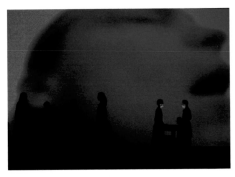
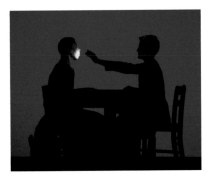

Ann Hamilton: *mercy*, 2001. Opening passage of collaborative performance with Meredith Monk. Hamilton raises a small hand-held light to Monk's face to illuminate the video camera held within her mouth's cavity as she sings. The view from Monk's mouth facing out toward Hamilton, who sits opposite her at the table, is projected as a live feed onto the background screen.

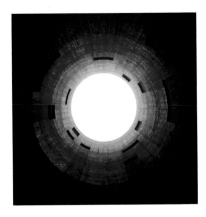

Ann Hamilton: *Tower*, 1994–2006. Oliver Ranch, Alexander Valley, California. Sound projects will be commissioned to respond to the landscape and site, the acoustic conditions of this concrete tower, and the relationship between the performer and the audience as both move up and down the interior double helical staircase. First performance scheduled for 2007.

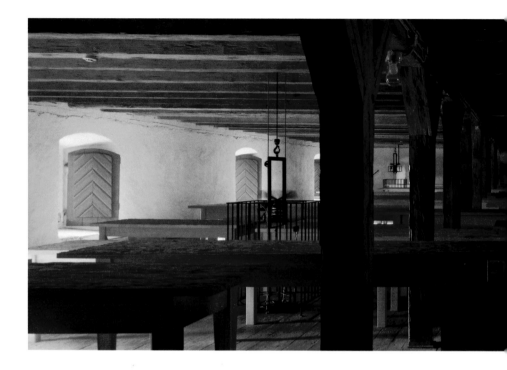

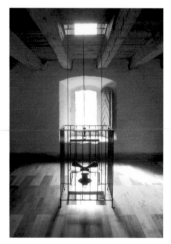 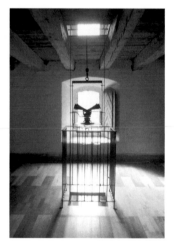

Ann Hamilton: *lignum*, completed 2002, The Wanås Foundation, Wanås, Sweden. View of the middle floor of a five-level stone barn and two details of one of four Leslie speakers turning and throwing sound as they moved vertically through the barn's structure.

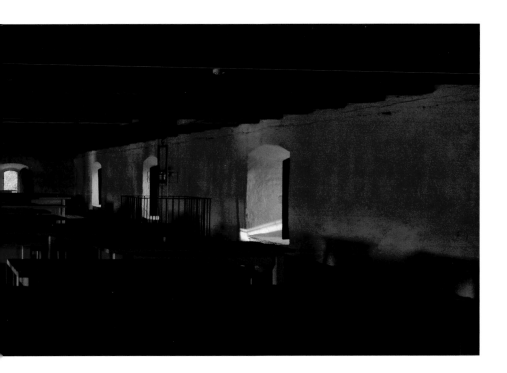

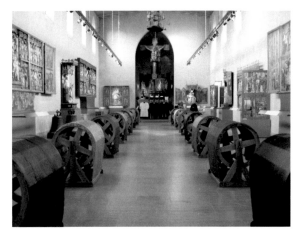

Ann Hamilton: *aloud*, 2004, Statens Historiska Museum/The Museum of National Antiquities, Stockholm, Sweden. 14 wind machines set into The Museum's Gothic Hall were hand-cranked by volunteers wearing wool coat and hat costumes. The sound of the machines filled the space of the museum with friction-generated wind.

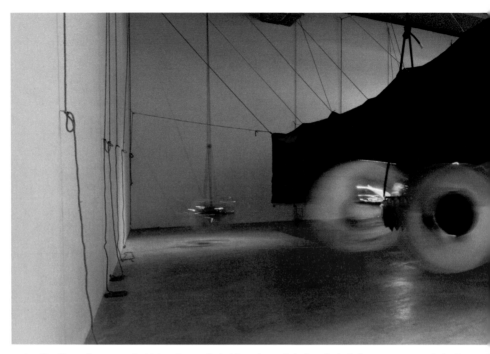

Ann Hamilton: *phora*, 2005, La Maison Rouge, Paris. View of one of the installation's five rooms: suspended refugee te

permeable though fixed chamber of Hamilton's *Tower* (see p. 29), a commission at the Oliver Ranch in Northern California, when it is dedicated in 2007. *Tower*, which has been in development for twelve years, began construction in 2004 and was completed in 2006. It is designed to be open to light and air. The tower has no roof and is punctuated by window-like openings (including a "window" that serves as an entry instead of a "doorway"). Voices will emanate from the boats of her Laos project, *The Quiet in the Land*, where "one large boat—a floating meditation chamber, a vessel of silence inhabited by a single figure—will be moored to a smaller boat with many passengers whose unison voices will fall in and out of silence to shadow or trail the larger boat." The second of her projects for voices afloat on water is for the Galapagos Islands, where "a boat of unison speaking" is proposed to circle the islands. Hamilton says, "For now, the project has no name but is administratively called the R.A.R.E. project, referring to the collaborating agency that does advocacy work with UNESCO world heritage and environmental sites. R.A.R.E. is collaborating with the Museum of Contemporary Art San Diego and three other U.S. museums."

In thinking once again about her *phora* installation, she speculated about the future: "As the voice has come from the perimeter of the room to the center, might the architecture and the material surround now drop away altogether to find a form for the solo or ensemble voice as the central question of the work?" Both the Laos and Galapagos Islands projects have voices as their core elements.

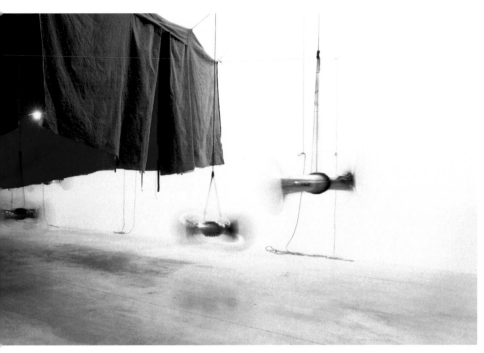

ning sousaphones and sound.

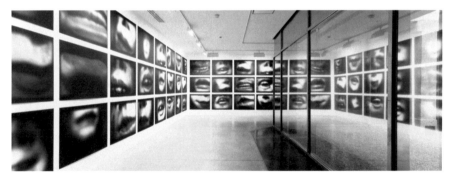

Ann Hamilton: *phora*, 2005, detail of print stills installed in a mirrored hallway surrounding the site's eponymous red house and its garden.

While the specific texts that will be spoken in the Laos work are not yet determined, for the Galapagos Islands project, Hamilton offers that her "proposal says it will be an inventory—of loss—of species named and recognized as being lost—more than likely it will be living and lost." For another work in progress, Hamilton is collaborating for a second time with Minetta Brook and Alice Waters. This project is for New York City's Highline, a new public park to be developed on a disused elevated rail line, sited there after many years of preservationists' efforts to get approval for the park. This project "will be structured

around a collective speaking and passing of food." As Hamilton says, "It may be interesting to note that whereas in the beginning the materially encrusted walls and/or floors of an installation were the surround for the live gesture of a figure, so here the landscapes—the Mekong river, the Pacific ocean, and the city in the Highline project—become that surround and what is materially immersive is the volume of the voice's sound."

Hamilton's investigations and makings play in the space between the possible and the as yet unimagined, the conversation begun, arrested, and ongoing. This inventory is not the closed book on Hamilton's objects to date, for, if past experience predicts future use, other objects will yet issue from her installations as well as from the objects now selected from her larger field of investigation and fixed at this time. Hamilton works between the tangible and the intangible, between the realities of the here and now. She functions "at this moment, in this place, with this voice," in works that are of "sound, voice, touch, motion, extension, and moral recognition"—to borrow two of Stewart's passages.

Hamilton often works with elements and ideas that may be impossible at this time to realize concretely, but for which she might find or invent the means at a later date. Both formally and conceptually, she is drawn to possibilities as yet out of reach. Her tools are the mouth, the hand, and the eye (often transposed in function in Hamilton's work), and her subjects, interrelated as figures, are the body and the object. Her works are the makings of line, language (visual and verbal), and matter, and their housings are various but might generally be called, as she titled an earlier installation, *corpus*, drawing on the multiple meanings of the body, its knowledge, and the literal meaning of a book. Hamilton herself discussed such voicings in a commencement address she gave at The School of the Art Institute of Chicago in 2005 (as cited here, Hamilton represents the "breath" of her speaking with punctuation that appears to be ellipses; no words are deleted, however):

> I began to think about how our first accountability is in the way we exercise the actions of our voices How might we find a way to speak together? to be a chorus of speakers summoning together a need to say? and I tried to imagine what that space might be and what would be said? This question What is speaking? what is this orphic machine of the mouth opening and closing to sound? . . . to the vowels and consonants of letters filling into words and on down the road to sentences and meanings and looming even larger in a haunting sort of way What is being said? What are the forms and possibilities of saying? . . . and so as I started to think about joining you to think about the space of someone speaking and someone listening / a situation of response . . . I began to think about words . . . what can words do? How can words be acts of making? . . . and . . . I began to ask myself what words need to be said now . . . what can words say now through what process might I find words that are up to the task of all the things that need saying . . . I began to wonder how words might become the material of my making.

In her commencement address, Hamilton also spoke about the trilingual voicing in her *phora* installation, not only about the shaping of words in the mouth's hollow cavity, but also about how she:

> began thinking about how learning another language . . . before it is learning grammar and vocabulary and syntax before it is gaining an entirely new set of metaphor-making possibilities . . . it is, first, a newly acquired muscle memory of the mouth. to learn another language is to re-form the shape habits of one's speaking to take on those of another to take on another's language is to take another culture and all the accumulations of its history into the body. One is touched and in being touched one is changed. Empathy and understanding have a chance.

She concluded her exchange with the class of graduating students by talking of a daily odyssey, the route by which she and they had arrived at that day, at those words, at that time. It is a passage that may also serve to summarize the open-ended, exploratory "reach" of her makings, her sense of time both as duration and as matter, the relations "between" that constitute her formal focus, and the ongoingness and exploratory, multi-directional openness of her practice:

> one doesn't arrive in words, or in art, by necessarily knowing where one is going in every work of art something appears that does not previously exist and so by default you work from what you know to what you don't know. You may set out for New York but you may find yourself as I did in Ohio. You may set out to make a sculpture and find that time is your material. You may pick up a paint brush and find that your making is not on canvas or wood but in relations between people. You may set out to walk across the room but getting to what is on the other side might take ten years. You have to be open to all possibilities and to all routes circuitous or otherwise.

Ann Hamilton: Study for *speaking, June 2006*.

An Inventory
of Objects
1984–2006

E ach entry gives the work's title, date, medium, dimensions in inches and centimeters (height × width × depth), and collection credit, followed by a short narrative that gives the context of the object's making and its relationship to other pieces within Hamilton's body of work—notably, installations from which a particular object derived. For information about individual installations, see Chronology (pp. 265–277) and *Ann Hamilton* (Harry N. Abrams, 2002). Works are arranged chronologically by year, and alphabetically within a year, with a few exceptions where the order reflects a conceptual sequence for the artist. Entries for editions, multiples, and prints include the name of the publisher and specifics of the edition, but not collection information. Unless otherwise noted, quotations from the artist are from conversations with the author. What appear to be ellipses, points within Hamilton's quotations, are used by the artist to denote pauses, not to denote deletions, as these marks are usually employed. Hamilton uses these marks similarly in her writings.

Titles used here are those confirmed by Ann Hamilton and at times they have been amplified by her for clarity (see Index of Titles, pp. 310–311, which also includes alternate titles Hamilton has used). When a Hamilton object derives from an installation, it employs the same title as the installation; however, the title is framed within parentheses. If an object itself derives from the installation, it bears the date of the installation. If an object from an installation was reconfigured or otherwise remade, it bears the dates of both the installation and the reworking, separated by a slash. Works relating to a particular installation are organized by the year of the installation regardless of the year the object was finalized, in order to give a sense of the multiple works that issued from the same installation or as part of an ongoing series.

Collection credits here are as specified by each institution or private collector. Unless otherwise credited, works are courtesy of the artist and Sean Kelly Gallery, New York. Materials and descriptions are as confirmed by the artist, and at times update, amplify, or correct earlier publications. For film and video works, the materials and equipment listed are those used when the artist first identified the work as an independent object, and reflect her conception of each piece. The artist anticipates changes in how video technology is encoded and conveyed for distribution: while she has used videotape, and laser disc, other forms may be appropriate in the future. Where screen sizes and installation requirements are specified, these conditions remain constant, regardless of innovations in equipment. Film and video entries note the "length" of footage by duration (in minutes and seconds); however, these elements are, by the intention of the artist, looped to play continuously. The publisher has made every reasonable effort to ensure that all information provided herein is accurate. Future editions of *Ann Hamilton: Inventory of Objects* will reflect any corrections and updated information brought to the attention of the publisher.

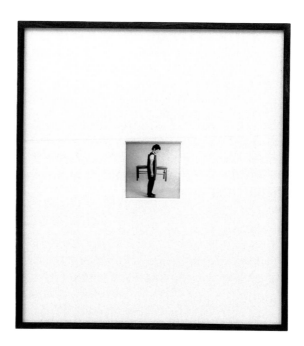

title	*body object series #1 · chair*
date	1984/1991
medium	black and white photograph, rosewood frame
edition	10 with 3 Artist's Proofs. Published in 1991 by Louver Gallery, New York
dimensions	4⅜ × 4⅜ inches / 11.1 × 11.1 cm (image), 22¾ × 20¾ inches / 57.8 × 20.8 cm (framed)

The "body object series" began with Hamilton adopting many of the objects assembled, but unused, in her installation *room in pursuit of a position*, 1984: chair, stool, shoe, basket, paddle, stoveplate, boot, and door. Hamilton continued the practice of taking objects from her installations (or using objects that have a relation to objects within an installation) for this ongoing photographic series: the toothpick suit is from *suitably positioned*, 1984; the airborne white cloth is from *reciprocal fascinations*, 1985; the sagebrush is related to the boxwood bush used in *a bird in the hand*, 1984, and to the sagebrush cuttings that were used in large brushlike masks for the performers in *caught in the middle*, 1985; the megaphone derives from *the map is not the territory*, 1987; the bathtub is from *dissections . . . they said it was an experiment*, 1988; the honey and hat are from *privation and excesses*, 1989; and the flour is from *Ann Hamilton/David Ireland*, 1992.

When Hamilton selected the first set of photographic images to be editioned in 1991, the collection gained the title "body object series," which she continued to use for the second series, published in 1993. The two-part dating (such as 1984/1991) indicates the year the photograph was taken followed by the year the edition was published, the two dates separated by a slash.

Hamilton has often worked with fields of images, selecting and "fixing" them at a particular moment in time. On the occasion of preparing this book and reviewing photographs taken of her in relation to various objects, she has editioned in 2006 *body object series #17*, *#18*, *#19*, and *#20*, which incorporate, respectively, the toothpick suit that Hamilton wore for the installation *suitably positioned* at Yale and its performance variant at Franklin Furnace, New York (both 1984); the fish-lure suit from the installation *the middle place*, 1987; the flashlight suit from *reciprocal fascinations*, 1985; and *duct*, 1987, which was selected from accumulated found objects, similar to those used in the earliest photographs in the series. The photographic images in this latest series, like the two earlier editioned series, are presented in rosewood frames. All of the works in the series except for *body objects series #16* were made working with photographer Bob McMurtry.

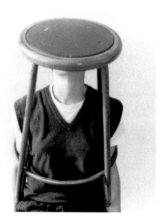 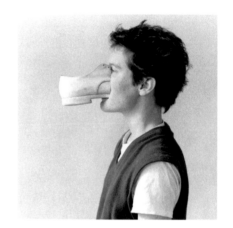

| title | *body object series #2 · stool* | *body object series #3 · shoe* |
|---|---|
| date | 1984/1991 |
| medium | black and white photograph, rosewood frame |
| edition | 10 with 3 Artist's Proofs (each). Published in 1991 by Louver Gallery, New York |
| dimensions | 4⅜ × 4⅜ inches / 11.1 × 11.1 cm (image), 22¾ × 20¾ inches / 57.8 × 20.8 cm (framed) |

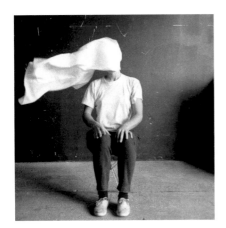 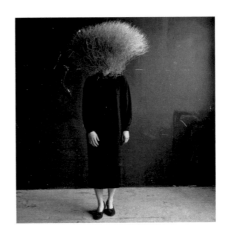

title	*body object series #4 · cloth* \| *body object series #5 · sagebrush*
date	1985/1991 \| 1986/1991
medium	black and white photograph, rosewood frame
edition	10 with 3 Artist's Proofs (each). Published in 1991 by Louver Gallery, New York
dimensions	4 ⅜ × 4 ⅜ inches / 11.1 × 11.1 cm (image), 22 ¾ × 20 ¾ inches / 57.8 × 20.8 cm (framed)

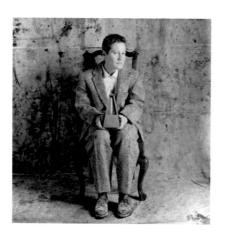 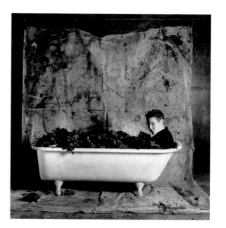

title	*body object series #6 · seed suit	body object series #7 · bathtub*
date	1986/1991	1988/1993
medium	black and white photograph, rosewood frame	
edition	10 with 3 Artist's Proofs. Published in 1991 by Louver Gallery, New York	
	15 with 4 Artist's Proofs. Published in 1993 by Sean Kelly Gallery, New York	
dimensions	4 ⅜ × 4 ⅜ inches / 11.1 × 11.1 cm (image), 22 ¾ × 20 ¾ inches / 57.8 × 20.8 cm (framed)	

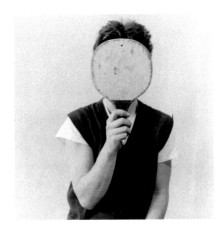 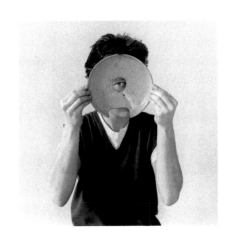

| title | *body object series #8 · paddle* | *body object series #9 · stoveplate* |
|---|---|
| date | 1984/1993 |
| medium | black and white photograph, rosewood frame |
| edition | 15 with 4 Artist's Proofs (each). Published in 1993 by Sean Kelly Gallery, New York |
| dimensions | 4⅜ × 4⅜ inches / 11.1 × 11.1 cm (image), 22¾ × 20¾ inches / 57.8 × 20.8 cm (framed) |

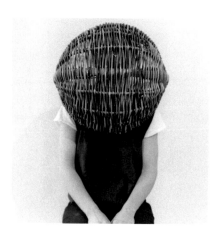 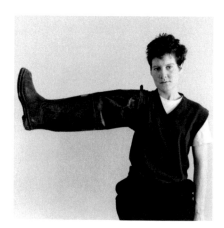

title	*body object series #10 · basket	body object series #11 · boot*
date	1984 /1993	
medium	black and white photograph, rosewood frame	
edition	15 with 4 Artist's Proofs (each). Published in 1993 by Sean Kelly Gallery, New York	
dimensions	4 ⅜ × 4 ⅜ inches / 11.1 × 11.1 cm (image), 22 ¾ × 20 ¾ inches / 57.8 × 20.8 cm (framed)	

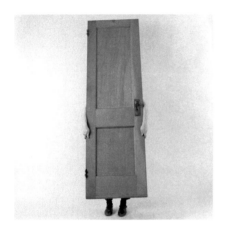 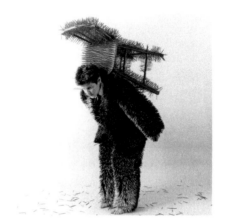

title	*body object series #12 · door*	*body object series #13 · toothpick suit/chair*
date	1984 /1993	
medium	black and white photograph, rosewood frame	
edition	15 with 4 Artist's Proofs (each). Published in 1993 by Sean Kelly Gallery, New York	
dimensions	4 ⅜ × 4 ⅜ inches / 11.1 × 11.1 cm (image), 22 ¾ × 20 ¾ inches / 57.8 × 20.8 cm (framed)	

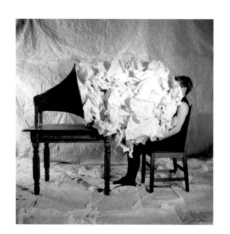 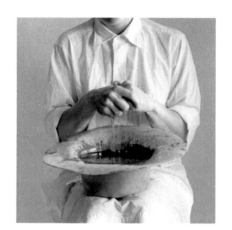

| title | *body object series #14 · megaphone* | *body object series #15 · honey hat* |
| --- | --- |
| date | 1986/1993 | 1989/1993 |
| medium | black and white photograph, rosewood frame |
| edition | 15 with 4 Artist's Proofs (each). Published in 1993 by Sean Kelly Gallery, New York |
| dimensions | 4⅜ × 4⅜ inches / 11.1 × 11.1 cm (image), 22¾ × 20¾ inches / 57.8 × 20.8 cm (framed) |

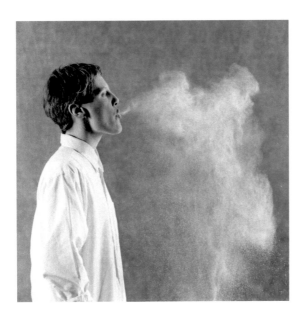

title	*body object series #16 · flour*
date	1993/1993
medium	black and white photograph, rosewood frame
edition	15 with 4 Artist's Proofs. Published in 2006 by Sean Kelly Gallery, New York
dimensions	4⅜ × 4⅜ inches / 11.1 × 11.1 cm (image), 22¾ × 20¾ inches / 57.8 × 20.8 cm (framed)

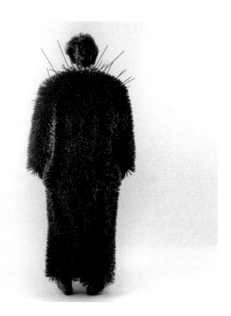

title	*body object series #17 · toothpick suit*
date	1984/2006
medium	black and white photograph, rosewood frame
edition	15 with 4 Artist's Proofs. Published in 2006 by Sean Kelly Gallery, New York
dimensions	4⅜ × 4⅜ inches / 11.1 × 11.1 cm (image), 22¾ × 20¾ inches / 57.8 × 20.8 cm (framed)

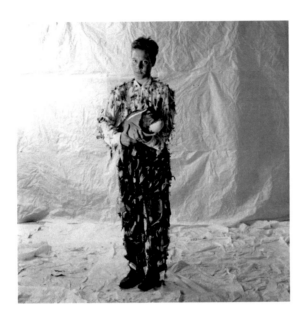

title	*body object series #18 · fish-lure suit*
date	1987/2006
medium	black and white photograph, rosewood frame
edition	15 with 4 Artist's Proofs. Published in 2006 by Sean Kelly Gallery, New York
dimensions	4⅜ × 4⅜ inches / 11.1 × 11.1 cm (image), 22¾ × 20¾ inches / 57.8 × 20.8 cm (framed)

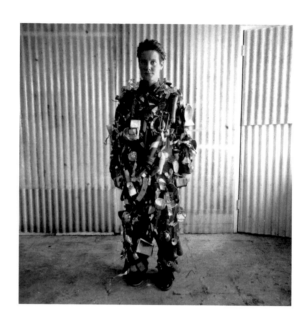

title	*body object series #19 · flashlight suit*
date	1987/2006
medium	black and white photograph, rosewood frame
edition	15 with 4 Artist's Proofs. Published in 2006 by Sean Kelly Gallery, New York
dimensions	4⅜ × 4⅜ inches / 11.1 × 11.1 cm (image), 22¾ × 20¾ inches / 57.8 × 20.8 cm (framed)

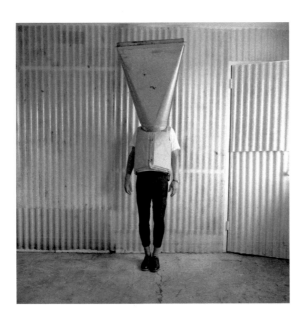

title	*body object series #20 · duct*
date	1987/2006
medium	black and white photograph, rosewood frame
edition	15 with 4 Artist's Proofs. Published in 2006 by Sean Kelly Gallery, New York
dimensions	4 ⅜ × 4 ⅜ inches / 11.1 × 11.1 cm (image), 22 ¾ × 20 ¾ inches / 57.8 × 20.8 cm (framed)

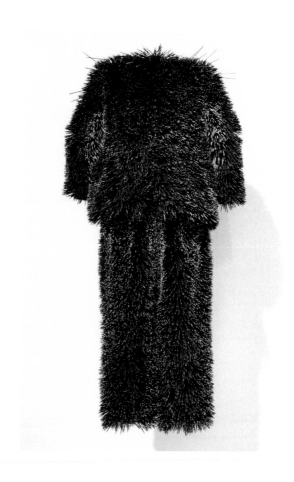

title	*(suitably positioned)*
date	1984
medium	man's suit, wood toothpicks
dimensions	60 × 33 × 10 inches / 152.4 × 83.8 × 25.4 cm
collection	Collection of Richard and Cissy Ross

This first of Hamilton's handmade three-dimensional objects, the toothpick suit, served three related directions that her art would take: it is an object in its own right; it was part of an installation (a "studio tableau," or "installation tableau," in Hamilton's words at the time) in which the artist, wearing the hidelike prickly covering, stood as an object for an extended period of time within the room; and it was used in performance, when worn by Hamilton at Franklin Furnace in 1984. Whether isolated, absent the figure, or "housing" or "framing" the live figure during a temporal event, the toothpick suit epitomizes the performative nature of Hamilton's multi-disciplinary practice.

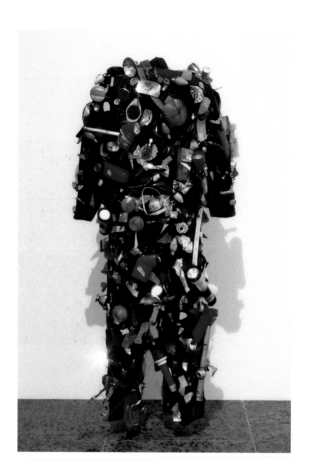

title	(reciprocal fascinations · suit)
date	1985
medium	cotton coveralls, mirror, flashlights, reflectors
dimensions	54 × 29 × 4 inches / 137.2 × 73.7 × 10.2 cm
collection	Collection of Dane Goodman

Hamilton's installation *reciprocal fascinations*, 1985 was the first to invoke both light and sound, and the work generated three independent objects: a suit, a table (pp. 56–57), and a photograph (p. 50). For the suit, Hamilton resurfaced a pair of work coveralls with flashlights and reflectors. She wore it as she took her position in the room, standing on a box made into a foghorn, which she periodically sounded.

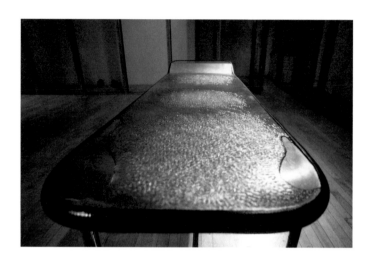

title	*(reciprocal fascinations · table)*
date	1985
medium	stainless steel autopsy table, motor, water
dimensions	32 × 21 × 72 inches / 81.3 × 53.3 × 182.9 cm

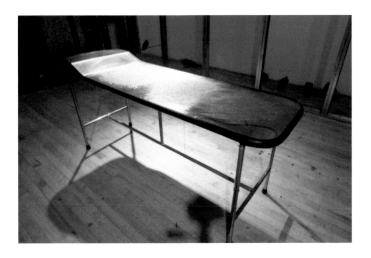

To animate an inanimate object, the artist motorized a stainless steel autopsy table so that its surface skin of water pools, and, in Hamilton's words "roils" and "gathers in a shape that remembers the impression of bodies that had laid on its surface." On the underside of the table, Hamilton mounted a small secondhand motor, causing the table to vibrate. For *(whitecloth · tub)*, 1999 (pp. 184–185), Hamilton would use different equipment to similar effect: she employed a hidden audio tone generator, amplifier, and subwoofer speaker to create vibrations that rippled the surface of the water within the tub.

58

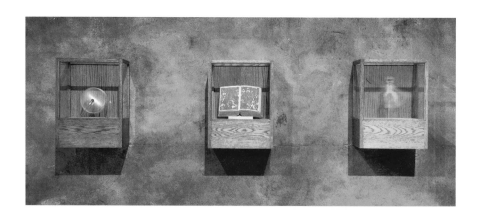

title	*(the earth never gets flat · vitrines)*
date	1987
medium	three wood and glass vitrines; motorized hamster wheel (in left vitrine); book (in center vitrine); motorized bamboo puppet (in right vitrine)
dimensions	17 ½ × 13 ½ × 13 inches / 44.5 × 34.3 × 33 cm (each vitrine)

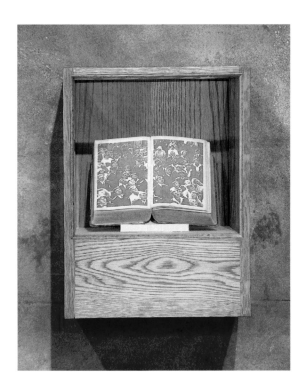

Upon entering Hamilton's 1987 installation *the earth never gets flat*, the visitor saw three vitrines affixed to a paprika-flocked wall to the left. Directly ahead was a similarly surfaced wall onto which was affixed at a height similar to the vitrines a wooden chair, on which a figure, initially Hamilton herself, sat, wearing a grass seed-covered suit and holding a metronome in her lap. The contents of the vitrines are (from left to right): a motorized hamster wheel, a book opened to an aerial photograph of a crowd scene (detail above), and a motorized bamboo puppet whose arms and legs flapped as it rotated back and forth. This was the first occasion of a book used as an object in a Hamilton installation, and it was to become a recurrent motif for the next twenty-plus years.

 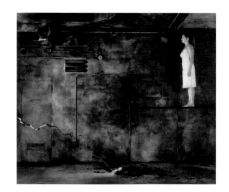

title	*cordova*	*in the time it takes to fry a locust*	*the choice a salamander gave to Hobson*
date	1987		
medium	type C print		
edition	50 with 5 Artist's Proofs (each). Published by the artist in 1987		
dimensions	18 ½ × 22 ½ inches / 47 × 57.2 cm (*cordova*)		
	18 ½ × 22 ½ inches / 47 × 57.2 cm (*in the time it takes to fry a locust*)		
	16 × 23 inches / 40.6 × 58.4 cm (*the choice a salamander gave to Hobson*)		

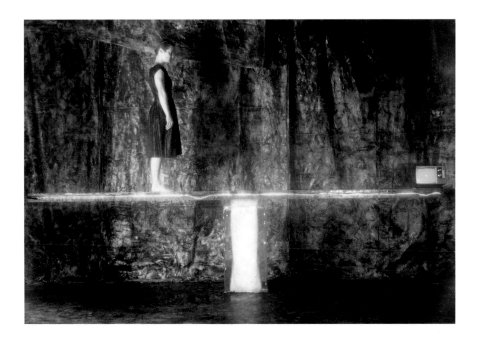

In questioning whether an audience was necessary at all to witness her stagings, Hamilton created three installations in 1987 for the camera alone: *cordova*; *in the time it takes to fry a locust*; and *the choice a salamander gave to Hobson*. In 1987, the artist published these photographs as editions. All three of these photographs relate to what was then her upcoming installation, *dissections . . . they said it was an experiment*, mounted first at Artists Space, New York, in January 1988, and somewhat revised at the Santa Barbara Museum of Art, Santa Barbara, California, in April 1988. As in other work at this time, these images juxtapose functional elements in dysfunctional relation.

title	*(the middle place · film)*
date	1987
medium	8 mm film, color, silent, 03:00 loop; projector

Hamilton's first film, presented as a continuous loop, shows Hamilton walking in place. The point of view has the camera beneath the sheet of glass on which she walks, "looking up" to the soles of her feet and her body beyond. Within Hamilton's *the middle place* installation in 1987, the film was projected from a mount at the front of a stationary bicycle, as if from a headlight illuminating the way. (It is a precursor to Hamilton's series of revolving projections of video, in which images are thrown the way a lighthouse throws a beam of light [p. 20, pp. 202–203, 226–229, 238–239, 248–249, 254–255].) Hamilton herself rode the bicycle while wearing one of her amplified found objects, a fish-lure suit (see *body object series #18 · fish-lure suit*, 1987/2006, p. 49).

Seen as a projection, the plane on which she walks appears to have been shifted 90 degrees, for the glass floor is one with the wall. The illusion created is that of a permeable wall or, in some sense, a window within it. Hamilton, the walker, is perceived to be in a horizontal position, her feet flush to the glass and her body extending into the room on the far side of the wall.

title	*(dissections … they said it was an experiment · video)*
date	1988/1993
medium	video, color, silent, 30:00; LCD screen; laser disc; laser disc player
edition	9 with 2 Artist's Proofs. Published in 1993 by Sean Kelly Gallery, New York
dimensions	3 ½ × 4 ½ inches / 8.9 × 11.4 cm (screen)

Using video as a component within an installation (as she had used a film loop in the prior year) was, for Hamilton, "a way to introduce a gesture that can't be performed live or can't be ongoing." Here, in her first video, one sees water perpetually flowing over and down a neck. The image is framed to reveal the

segment of a body from an upturned chin to the base of the neck. For Hamilton, the relationship depicted was of excess—"no one can swallow that much water"— and in the installation it was paired with a blown-up image of flowers bathed in steam. For Hamilton, the overflow of water signaled "how that which nourishes becomes perilous or destructive in some way."

The installation was first shown in January 1988. When it was exhibited in a somewhat revised form in April 1988, Hamilton added the video. The video was displayed on a standard, though small, box-like monitor high up, projecting from the wall. The monitor housing was surfaced with the same shoe polish that inflected the wall on which it was positioned.

When the video was editioned in 1993, along with three others with related "overflow" imagery—*(the capacity of absorption · video)*, 1988/1993 (water/ear, pp. 74–75); *(linings · video)*, 1990/1993 (water/mouth, pp. 86–87); and *(aleph · video)*, 1992/1993 (marbles/mouth, pp. 106–107)—Hamilton specified that they were each to be shown on a small, flat-screen monitor mounted flush to the face of the wall (see also p. 75). At the time, this was an unusually small screen size for exhibiting video, especially compared to the large, full-wall projections that many artists were beginning to use. The size of the screen recalls Hamilton's familiar use of miniaturization, often in the context of large quantities of small elements set within vast architectural spaces. She chose the screen size because it was "scaled to intimacy," for the image shown in the video was "not much smaller than an actual neck."

66

title	*(dissections … they said it was an experiment · vortex)*
date	1988/2006
medium	glass, water, magnets, copper pipe, battery, steel structure
edition	10 with 3 Artist's Proofs

A water-filled glass is set on a steel structure. The inner water vortex is caused by a magnet spinning at the bottom of the glass in response to another motorized magnet, hidden from view, which is spinning beneath the surface on which the glass rests. (The mechanism was derived by Hamilton from magnetic mixers that are standard equipment in science labs.) This single vortex glass was one element among many in Hamilton's 1988 installation *dissections . . . they said it was an experiment*. Hamilton would soon return to this idea, multiplying the number of vortex glasses to 150, which were then installed on paraffin-and-beeswax surfaced walls, for her 1988 installation *the capacity of absorption* at the Temporary Contemporary, Museum of Contemporary Art, Los Angeles (see the variant scales of vortex glass works, issuing from *the capacity of absorption*, pp. 76–79).

 "The hypnotism of the swirling vortex is in miniature form the pull toward gigantic engulfment," which characterizes the dense material surrounds of the installations and is also a premonition of the circular movement that has come to dominate the form of Hamilton's work beginning in the 1990s—spinning curtains, videos projected to circle a room from a revolving mount, and her circular permanent site work in Northern California, *Tower*, 1994–2006, that has within it a double-helix staircase.

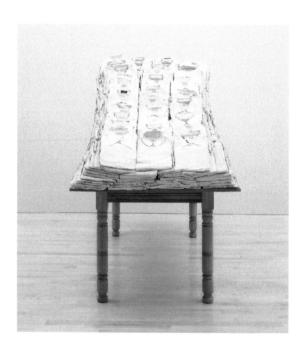

title	*(still life)*
date	1988/1991
medium	white shirts, gold leaf, wood table, chair
dimensions	30 × 42 × 70 inches / 76.2 × 106.7 × 177.8 cm (table), 34 × 18 × 16 ½ inches /
	86.4 × 45.7 × 41.9 cm (chair), 62 × 42 × 87 inches / 157.5 × 106.7 × 221 cm (overall)
collection	The Carol and Arthur Goldberg Collection

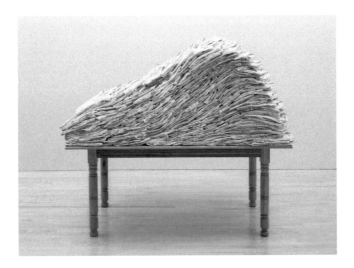

Here, according to Hamilton, is "ironing, mending, tending—the whole laundry process—gone too far, an excess or perversion of scale that is characteristic of all of the work of that period." For the initial installation, created in a private home in Santa Barbara, the white men's dress shirts were laundered, folded, and both singed and gilded on the edges—in effect, adding marks of error and destruction (burning, indelible stain) and marks of golden value. The shirts were massed on the table and attended by a figure seated on a chair facing the ascending pile of shirts. A used table and chair were newly selected in 1991 for the related object, in lieu of those which remained in the private home of the installation. The present work, which isolates the relationships within the installation, comprises shirts, table, and chair (the chair unseen in the photos above).

A wood table would become a recurring figure in Hamilton's oeuvre. Commenting on what would be a proliferation of tables within her body of work, Hamilton says, "Tables are my blank paper, my landscape, my figure, a plane that implies the solitary figure and all that is social . . . two people sitting face-to-face, working together, eating or speaking. . . . All tables inherit a history of their use as a site of communion and sacrifice."

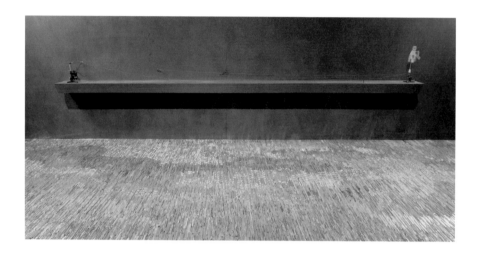

title	*(the capacity of absorption · puppet)*
date	1988
medium	electric motor, calipers, fishing line, bamboo puppet, stick, metal mount
dimensions	variable
collection	Collection of Sean Kelly Gallery, New York

The idea of using the little twisting bamboo puppet figure for her 1988 installation *the capacity of absorption* at the Museum of Contemporary Art, Los Angeles derived from Hamilton's 1987 installation *the earth never gets flat* (see pp. 58–59). The juxtaposition of puppet figure and calipers in the 1988 installation evoked for Hamilton the difficulty in reconciling a physical system of external measurement to an internal psychology. In this work, the miniaturized puppet is a stand-in for the human body.

In Los Angeles, the puppet/calipers piece was sited within a room in juxtaposition with a large-scale comparison of other "internal/external measurements": a reclaimed buoy used to signal ocean depths was etched with lines from a phrenology chart (see p. 14). The nineteenth-century "scientific" practice of phrenology was used to measure the structure of a skull—its surface bumps—from which were read such personal internal states and their social implications as personality, character, or criminal capacity.

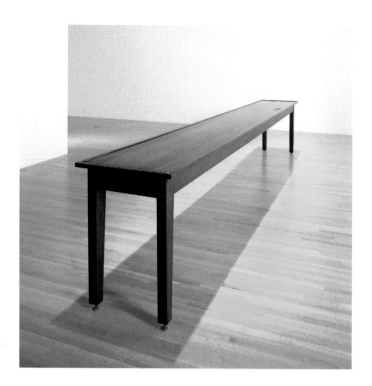

title	*(the capacity of absorption · table)*
date	1988
medium	wood table, pump, water
dimensions	36 ¼ × 27 ¼ × 204 inches / 92.1 × 69.2 × 518.2 cm
collection	Collection of The Museum of Contemporary Art, Los Angeles, CA. Gift of the artist and Louver Gallery, New York

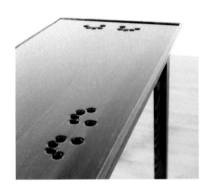

This is the second animated table that Hamilton used in an installation following the water-surfaced autopsy table of *reciprocal fascinations*, 1985 (see pp. 56–57). Here, Hamilton followed the form of a library table but built one anew, exaggerating its length, while specifically requiring that it have only four legs. She also specified that it incorporate beneath its surface a box to collect and recycle the water that flowed across the table. The wood surface was designed so that it could withstand the water yet look like an ordinary, if elongated, table. The table is distinguished by two sets of finger holes placed at 90 degree angles from each other, one at the very end of the table and the other to its left.

Of all of the components in what was a vast three-room installation within the former industrial warehouse space of The Temporary Contemporary, this is the most literally immersive, and it tests the "capacity of absorption" of the project's title. When participants inserted their fingers into the holes, they experienced the water as it flowed along the table's surface. Try as they might to extend their fingers down into the table to have them absorbed, in what they expected to be the depths of water below, they could not fully immerse their fingers in the water of the collection box, for it was set so low as to be out of reach. This is the first of Hamilton's works where the solitary performing figure may be joined by another and thus, as Hamilton notes, it "insinuates the social space of the table."

title	*(the capacity of absorption · video)*
date	1988/1993
medium	video, color, silent, 30:00 (loop); LCD screen; laser disc; laser disc player
edition	9 with 2 Artist's Proofs. Published in 1993 by Sean Kelly Gallery, New York
dimensions	3 ½ × 4 ½ inches / 8.9 × 11.4 cm (screen)

One of three videos that shows a part of the body filled beyond its capacity to absorb a flow of water (see also pp. 64–65, 86–87), *(the capacity of absorption · video)* evidences an ear subject to this immersion. Within the installation, this video was shown on a monitor set within the bell end of a megaphone, based on Athanasius Kirchner's seventeenth-century horn designed for projecting sound over great distances. At its other end was a telephone mouthpiece, which, when spoken into during the installation, had the paradoxical effect of silencing the sound of the swirling water in the 150 wall mounted glasses. See the next two entries for scale variants: *(the capacity of absorption · vortex 30)*, 1988 and *(the capacity of absorption · vortex 100)*, 1988 (pp. 76–77, 78–79). See also the related *(dissections . . . they said it was an experiment · vortex)*, 1988/2006 (pp. 66–67). When the video was editioned in 1993 (along with three other videos), the artist specified a flat-screen monitor, with screen measuring 3½ × 4½ inches / 8.9 × 11.4 cm (above).

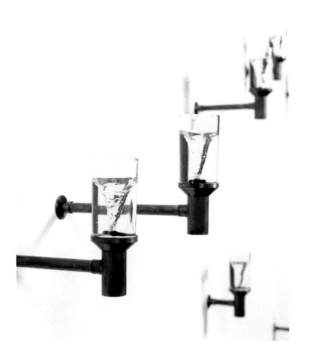

title	*(the capacity of absorption · vortex 30)*
date	1988/1996
medium	30 glasses, water, magnets, copper pipes, old-style handheld telephone receiver, electronic controller
edition	3 with 2 Artist's Proofs
dimensions	variable

The idea of a water vortex in a drinking glass was first used as a lone unit, one of many elements in Hamilton's installation *dissections . . . they said it was an experiment*, 1988 (see pp. 66–67). For *the capacity of absorption* installation in 1988, Hamilton multiplied the number of glasses to 150 and affixed the mounts and their glasses to walls surfaced with paraffin and beeswax. As Hamilton says, "This is the first work where there can be 1 or 800 of these objects—that is the structure of the work. A single vortex could exist; so could a thousand. The choir can grow larger and larger."

Hamilton editioned two variants, one with 30 glasses (p. 76) and one with 100 glasses (pp. 78–79). Both editions have a telephone handset that, as in *the capacity of absorption* installation at the Museum of Contemporary Art, Los Angeles, allows the participant speaking into it to still the spinning water and thereby also silence the sounds. Earlier publication of a unique variant of 90 glasses referred to an exhibition copy of the vortexes, which no longer exists (see *Ann Hamilton*, Harry N. Abrams, 2002).

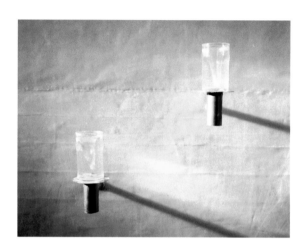

title	*(the capacity of absorption · vortex 100)*
date	1988/1996
medium	100 glasses, water, magnets, copper pipes, old-style handheld telephone receiver, electronic controller
edition	3 with 2 Artist's Proofs
dimensions	variable

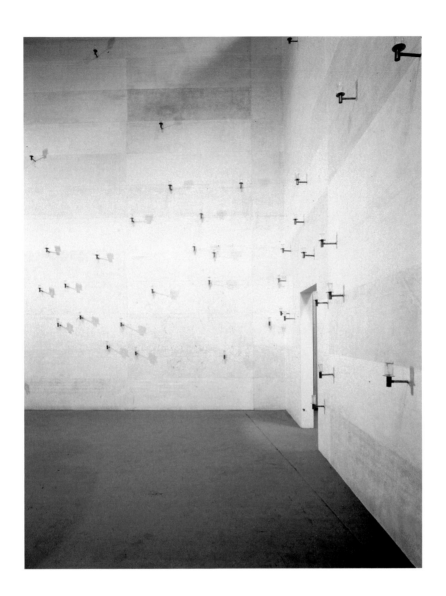

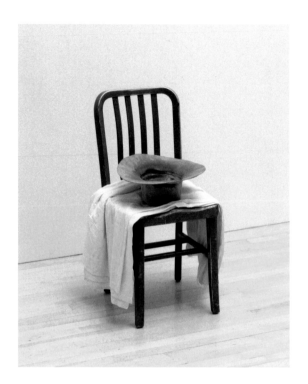

title	*(privation and excesses · chair)*
date	1989
medium	felt hat, honey, cloth, metal chair
dimensions	32 ½ × 18 ½ × 171/2 inches / 82.6 × 47 × 44.5 cm
collection	Collection of Marc Brutten, Switzerland

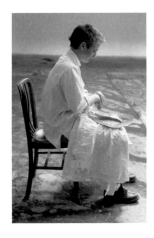

During the installation *privation and excesses*, 1989, an attendant sat in a chair, a cloth across his or her lap, wringing his or her hands in a hatful of honey (above, Margaret Tedesco), looking out toward a field of pennies set into a skin of honey, carpeting the room's concrete floor. This multi-part object is composed of hat, honey, cloth, and chair, and distills materially the relationships of the larger installation even though the performing figure is absent. For Hamilton, the presence of honey—refilled each time the work is exhibited—implies the action performed in the installation.

title	*(privation and excesses · grinders)*
date	1989
medium	two mechanized mortars and pestles, teeth, pennies
dimensions	variable

A component of the installation *privation and excesses*, 1989, was a pair of wall-mounted mechanized mortars and pestles, one of them grinding teeth, the other one grinding pennies. The dematerializing teeth were in contrast to the overriding element of that installation, a 45 × 32 foot field of 750,000 copper pennies-laid into a surface coating of honey on the building's concrete floor. As Hamilton notes, "Where the installation juxtaposed the animal economy of honey to the human economy of money, these grinders similarly juxtapose the biologically produced and the human made."

For her earliest mechanized tables (see pp. 56–57, 72–73), as well as her most recent spinning speakers (see pp. 256–257), Hamilton has tinkered with existing industrial equipment for sculptural and audio effect. The pulverizing sounds of these two grinders within the installation, as Hamilton notes, were "the background to the lathering movement and sloshing sound of hands in honey." (See *(privation and excesses · chair)*, 1989, pp. 80–81.)

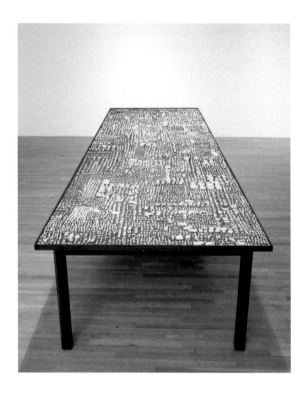

title	*(between taxonomy and communion)*
date	1990/1996
medium	steel table, iron oxide powder, animal and human teeth
edition	unique
dimensions	33¼ × 56 × 168 inches / 84.5 × 142.2 × 426.7 cm (table)
collection	Collection of The Solomon R. Guggenheim Museum, New York. Anonymous gift, 2004

For her installation *between taxonomy and communion*, 1990, Hamilton continued to work with the teeth she had used in *privation and excesses*, 1989 (see pp. 82–83). This time, instead of pulverizing them, she set 14,000 human and animal teeth into an iron oxide powder-surfaced table, following her own taxonomy of form rather than of species. She laid the teeth onto the compressed powder surface in a pristine manner, "but the slightest movements stained the teeth red," as well as stained the artist's hands. For this installation, Hamilton had also configured the table so that water, pigmented with the iron oxide, leeched from the table's undersides and stained the floor below. For Hamilton, the table embodied many of the images and relationships within the installation: "the leeching contamination of a staining material, the material references to earth, blood, water, and wine. The measurement and organizing principle of taxonomy, the larger social and religious organization, the collective interconnected sense of communion."

The table was remade in 1996 for Hamilton's exhibition "the body and the object: Ann Hamilton 1984–1996" at the Wexner Center for the Arts, Columbus, Ohio; the table, as shown at the San Diego Museum of Contemporary Art, La Jolla installation in 1990, was of somewhat different dimensions (ca. 30 × 52 × 196 inches / 76.2 × 132.1 × 497.8 cm) and also had systems for infusing water and a tray that collected it, which was perforated so as to allow the dripping/leeching effect.

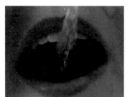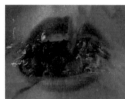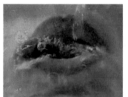

title	*(linings · video)*
date	1990/1993
medium	video, color, silent, 30:00; LCD screen; laser disc; laser disc player
edition	9 with 2 Artist's Proofs. Published in 1993 by Sean Kelly Gallery, New York
dimensions	3½ × 4½ inches / 8.9 × 11.4 cm (screen)

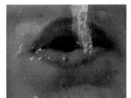

One of the three videos where water floods the body (see also pp. 64–65, 74–75), this one depicts an overflowing mouth. The figure here is not Hamilton, but rather Katherine Gray, a glass artist who at the time was doing an internship at the Headlands Center for the Arts, Sausalito, California. Between 1989 and 1991, Hamilton was working on a commission for the Mess Hall at the Headlands Center for the Arts.

The persistent exploration of thresholds, particularly the ambiguity of what is inside and what is outside, and the slippage of borders are key to these videos—where the water seems to be flowing either in or out of the mouth. This exploration also reoccurs in later Hamilton works as different as *Untitled*, 2000 (see pp. 206–207), where long, dripping hairs seem to be either entering or spilling from a mouth, and Hamilton's *Tower*, completed in 2006 (see p. 28), where entry is gained through a window and not a door, and light enters from an open roof, as well as through window wells.

The monitor used in the installation was a small, round-backed standard television set into the wall so that its screen was flush with the wall's surface; it was in 1993, when the video was editioned, that a flat-screen monitor, measuring 3½ × 4½ inches / 8.9 × 11.4 cm, was specified by the artist.

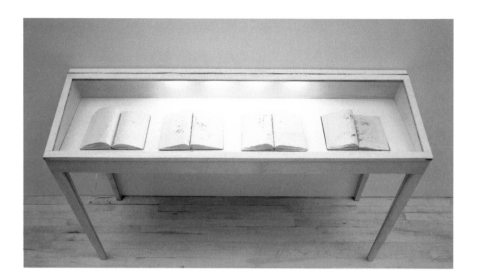

title	*(indigo blue · books)*
date	1991
medium	four altered books, glass and wood vitrine
dimensions	39 ¾ × 68 × 20 inches / 101 × 172.7 × 50.8 cm (vitrine), variable (books)
collection	Collection of Lois Plehn

Hamilton's installation *indigo blue*, in the exhibition "Places with a Past: New Site-Specific Art at Charleston's Spoleto Festival," 1991, was keyed to the historic importance of indigo, both as a plant and as a dye, in the economy of Charleston, South Carolina. The overriding presence in the installation was a mound of 14,000 carefully folded blue work shirts. A figure sat at a desk, back to the mound of shirts, reworking books with blue covers, which Hamilton had found in secondhand stores, and which were in fact military manuals regulating the establishment of legal boundaries between land and water.

The figure in performance sat reading the books back to front, clearing each page, by a gesture of wetting a Pink Pearl eraser with saliva, rubbing out a line of text, and collecting the rubber eraser crumbs in a line parallel to the uppermost edge of the book and the front of the desk. The repetitive gesture, like the anonymous work clothes, echoed Hamilton's readings in American labor history that had informed the making of this installation. Hamilton chose two different sets of books as traces of the event. This set, *(indigo blue · books)*, comprises four books, completely erased, which are encased in a glass and wood vitrine. The second set *(indigo blue · books II)*, 1991 (see next entry, pp. 90–91), comprises five books that are incompletely erased, and lacks the vitrine.

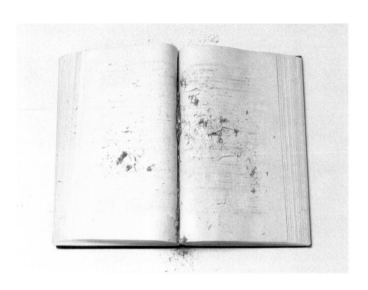

title	*(indigo blue · books II)*
date	1991
medium	five altered books
dimensions	9 × 11 inches / 22.9 × 27.9 cm (each book open)
collection	Private collection

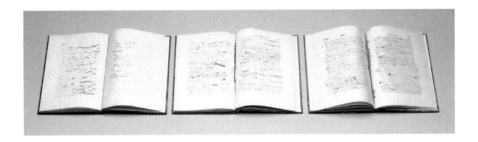

This object, (*indigo blue · books II*), is constituted of a set of five surviving altered books from Ann Hamilton's 1991 installation *indigo blue*. Three of the five are illustrated above. They were chosen by the artist "as incomplete histories," for the books are not completely erased. See also (*indigo blue · books*), 1991 (preceding entry, pp. 88–89), in which the books are completely erased and presented in a glass and wood vitrine.

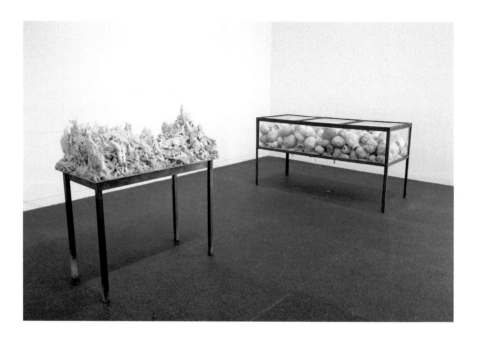

title	*(offerings)*
date	1991
medium	steel and glass vitrine with cast wax heads, heating rods, light fixtures; steel table with ledger book and wax
dimensions	42 × 84 × 35 inches / 106.7 × 213.4 × 88.9 cm (vitrine), variable (overall two-part piece)
collection	Collection of the Carnegie Museum of Art, Pittsburgh, Pennsylvania. A. W. Mellon Acquisition Endowment Fund

A two-part piece consisting of a steel and glass vitrine filled with cast wax votive heads paired with a table bearing a ledger covered with wax drippings, (*offerings*) signals the process of and presents the resulting objects from Hamilton's 1991 *offerings* installation, which was sited in a three-story house at The Mattress Factory's satellite space located at 545 Sampsonia Street in Pittsburgh. Hamilton first saw such wax heads (and other cast body parts) as offerings in the churches in São Paulo, Brazil, when she was working on her installation *parallel lines* for the 21st International São Paulo Bienal in 1991.

In the Sampsonia Street house, where 30 canaries flew freely, Hamilton's vitrine was on the topmost attic floor. At the base of the vitrine (and unseen by the viewer) were heating rods, which caused the lowest strata of wax heads within it to melt, their drippings descending in a cascading form from the table's "underbelly." The wax continued its downward descent from the vitrine to the attic floor, where heat rods set between slits in the floorboards allowed the fall of the melted wax to continue to the second floor, where it collected on and around a ledger book and the table on which it was set. This wood floor was incised to hold similar heating rods so that some of the drippings, falling just outside of the table's edges, continued their descent to the ground floor.

Attentive visitors entering the building may or may not have noticed the bits of wax on the floor, though likely would have recognized their significance upon returning to the ground before exiting: the accumulated wax defined a rect- angle, "the negative space of the table on the floor above." Hamilton had also sooted all of the windows of the house as she had sooted the walls for *parallel lines* and for *accountings* (see *(accountings · soot wall)*, pp. 96–97).

The installation *offerings* was part of the "Carnegie International 1991" exhibition, and was presented in collaboration with The Mattress Factory, a museum that specializes in installations created on-site during its residency program. See also the related *(accountings · vitrine)*, 1992 (pp. 94–95).

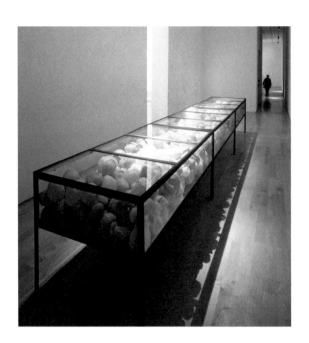

title	*(accountings · vitrine)*
date	1992
medium	three steel and glass vitrines with cast wax heads and light fixtures
dimensions	108 × 36 × 36 inches / 274.3 × 91.4 × 91.4 cm (each vitrine), 324 × 36 × 36 inches / 823 × 91.4 × 91.4 cm (overall 3-part piece)
collection	Ginny Williams Family Foundation, The Collection of Ginny Williams

Cast wax votive heads within glass and steel vitrines were used in Hamilton's installations *offerings*, 1991 (see pp. 92–93), in Pittsburgh and *accountings*, 1992, at the Henry Art Gallery in Seattle. Hamilton first saw such votive offerings of cast wax body parts when she was developing her installation *parallel lines* for the 21st International São Paolo Bienal in 1991.

The Henry Art Gallery was the organizing institution for Hamilton's exhibition in the São Paolo Bienal, which was the official United States entry, and both

offerings and *accountings* were variants of the Bienal's *parallel lines*. While neither of the United States installations included the massive whale-like assembly of white votive tapers from *parallel lines*, both employed the forms of filled vitrines and sooted walls, and both installations offered a turn in Hamilton's practice from the use of vast quantities of materials filling a space, to a pared down use of material and an emphasis on vast, virtually "empty" spaces.

The wax heads used in both *accountings* and *offerings* were cast as multiples from a single set of examples. In *accountings*, the heads were exhibited whole, whereas in *offerings* they were melted down. In *accountings*, the vitrines were centered in a room, which, like the installation's many otherwise "empty" ones, had floors surfaced with metal tags and walls inflected with candle soot (see next entry, pp. 96–97). In Seattle, as in Pittsburgh, the space was animated with free-flying canaries (now 200 of them), whose flight, Hamilton notes, contrasted with the enclosure of the vitrines. Lights within the vitrines not only illuminated the interior contents, but also warmed the metal structure, and thus made it attractive to the birds which tended to accumulate around the vitrines and, in particular, perch on the topmost edges of each case's metal perimeter.

Hamilton, prior to the Henry Art Gallery installation, had worked in a variety of alternative, found (often disused or derelict) quarters, and temporary exhibition spaces. The Henry Art Gallery installation marked the first time she had been invited to work within a more traditional museum building, and in particular with its neo-classical architecture.

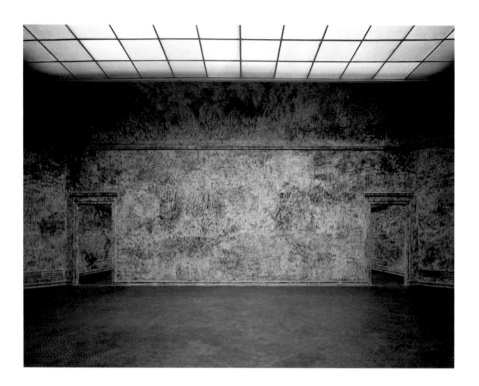

title	*(accountings · soot wall)*
date	1992
medium	candle soot
edition	3
dimensions	variable

For all of the rooms constituting the installation *accountings*, 1992, at the Henry
Art Gallery, Seattle, Hamilton "drew" on the walls by smoking them, as she had
done for a part of *parallel lines*, 1991, at the São Paulo Bienal. "To lick the Henry
Art Gallery's wall surfaces with soot," Hamilton and her co-workers employed
"a gesture of moving the crossed tips of two lit candles across the surfaces of the
room. The air currents of the room drafted in such a way that the soot created
by the joint of the two candles laid onto the wall directly above them. The soot
marks then are a trace of the subtle shift in body rhythms, the angle of hand to
candle to wall, the pace of movement and breath." Hamilton also used the same
process in her related installation, *offerings*, 1991, where she sooted the three-
story building's windows.

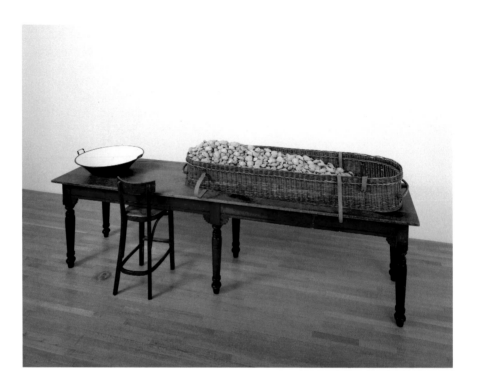

| title | *(malediction)* | *(malediction · voice)* |
| --- | --- |
| date | 1991 | 1991 |
| medium | wood table, wood chair, bowl, wicker casket, bread-dough mouth molds, audiotape, compact disc, compact disc player, mounted car speaker concealed behind a wall *(malediction)* | compact disc, compact disc player, mounted car speaker concealed behind a wall (voice) |
| dimensions | 34 × 30 × 132 inches / 86.4 × 76.2 × 335.3 cm (table) | variable (voice) |
| collection | Collection of the Museum of Art, Rhode Island School of Design, Providence (table) |
| | Mary B. Jackson Fund and Gift of George H. Waterman III |

For the installation *malediction*, 1991, Hamilton sat on a wood chair, at a long wood table (34 × 30 × 132 inches / 86.4 × 76.2 × 335.3 cm), on which rested a large bowl filled with bread dough and a wicker casket—the kind that was used to transport cadavers in the nineteenth century. For the duration of the show, Hamilton, in a repetitive act, carefully took a piece of dough, rolled it in her hand, pressed it into the cavity of her mouth, removed the imprinted mold, and set it into the casket. At the end of each day, the gallery's then director, Sean Kelly, would discretely collect some of the day's production, bake it, and then store the resultant mouth molds.

Among other elements in the *malediction* installation was the barely heard sound of a woman's voice (Mary Kelly's) reading from Walt Whitman's poems "I Sing the Body Electric" and "Song of Myself." (The recorded sound was emitted from speakers set within a wall.) This was the first installation in which Hamilton used the spoken word, and in choosing the elements that would constitute the multi-part "object" that lived on after the temporal event, Hamilton included a copy of the compact disc.

Issuing from the installation *malediction*, 1991, is a unique compact disc—*(malediction · voice)*, 1991. It has an ongoing life apart from the installation and is also distinct from the assemblage of elements for the multi-part object *(malediction)*, 1991 (see left). Mary Kelly reads from Walt Whitman's poems "I Sing the Body Electric" and "Song of Myself." Hamilton would later also isolate, as independent works, the audio components of *tropos*, 1993 (pp. 114–115), *mneme*, 1994 (pp. 118–119), *at hand*, 2002 (pp. 224–225), and *phora*, 2005 (pp. 258–259).

title	(Ann Hamilton/David Ireland)
date	1992
medium	steel comptroller's desk, glass, linen portfolio, pinpricked and oil-stained paper, audiotape, audiotape player
dimensions	45 × 36 ½ × 30 inches / 114.3 × 92.7 × 76.2 cm
collection	Collection of Paul and Gayle Stoffel, Dallas, Texas

Exhibited in Hamilton's show with David Ireland at the Walker Art Center,
Minneapolis in 1992, originally untitled and now titled "Ann Hamilton/David
Ireland," this table was set to the side in a room dominated by the mountain
of flour that accumulated on a pair of library tables from an auger and sifting
system (originating in a different gallery). The table itself has an angled top
and is known as a comptroller's table. On it rests a folio of book pages that
Hamilton had perforated or punched with holes. These holes traced the words
of an index of eighteenth-century Swedish botanist Carolus Linnaeus's sexual
system of plant classification. This paper perforation is a precursor to the picked
and unsewn cloth that would be seen in a later video (pp. 148–149) and in the
similarly worked curtains in Hamilton's 1997 *bounden* installation at the Musée
d'Art Contemporain de Lyon, France. This underlying process of making and
unmaking courses through Hamilton's oeuvre, taking the forms of books read
and erased, texts written and undone, fabric stitched contrasted with its weave
picked apart, and coats unseamed and reseamed. The work includes an unseen
audiotape and player; a woman's voice is heard reading from the Linnaeus
index.

title	*Untitled*
date	1992
medium	book, stones, lacquered birch, glass
edition	40 with 14 Artist's Proofs, 1 prototype. Published in 1992 by The New Museum of Contemporary Art, New York
dimensions	3⅝ × 9¼ × 38⅝ inches / 9.2 × 23.5 × 98.1 cm

Made of book pages and small stones, and published as an edition in 1992 to benefit The New Museum of Contemporary Art, New York, this project continues Hamilton's process of remaking books by unmaking them (see p. 6, pp. 88–89, 90–91, 112–113). On selected pages, words are "absented" by Hamilton's positioning of the stones on the page's surface. As Hamilton says, "The text was obscured, but if you were really determined, you probably could read it." The governing principle for selecting the books was that, as the artist said, "they be palm-sized; the subject didn't matter." Each book in the edition is thus a unique version rather than a replication.

This was the first object Hamilton made wholly independent of an installation. That is, it was not an object made prior to and used in an installation—as was her toothpick suit (see pp. 52–53)—and it was not an object made using elements from or related to those used in an installation, as were her earliest "body object" photographs (see pp. 38–51).

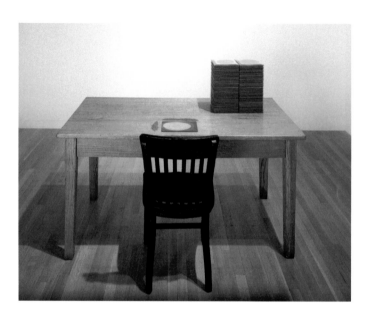

title	*(aleph · table)*
date	1992
medium	wood table and chair, altered mirrors, silvering erasures
dimensions	30 × 32 × 60 inches / 76.2 × 81.3 × 152.4 cm (table), variable (overall)
collection	Collection of Ginny Williams. Courtesy of Ginny Williams Foundation

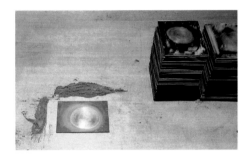

This wood table bears the stack of square mirrors that an attendant, during the course of the installation, had rubbed in a circular movement with wet-dry sandpaper to remove the silver backing, leaving the circular space as clear glass. The silver erasures were left on the table during the installation, and are part of this composite work, which also includes a chair. The mirrors were close in size to the monitor opposite the table at the far end of the gallery in the original installation and, once cleared, would have allowed a view through to the video of the stone marbles rolling around within the mouth seen in *(aleph · video)*, 1992/1993 (pp. 106–107).

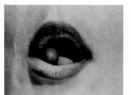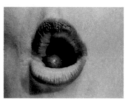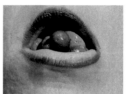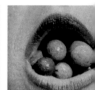

title	*(aleph · video)*
date	1992/1993
medium	video, color, sound, 30:00 (loop); LCD screen; laser disc; laser disc player
edition	9 with 2 Artist's Proofs. Published in 1993 by Sean Kelly Gallery, New York
dimensions	3½ × 4½ inches / 8.9 × 11.4 cm (screen)

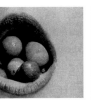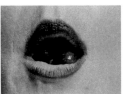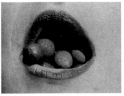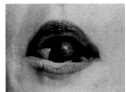

This is the fourth, chronologically, of the set of four videos editioned in 1993, all of which are tightly framed images of body parts potentially or actually overflowing with matter (see pp. 64–65, 74–75, 86–87). This video is of a mouth (Hamilton's) with stone marbles rolling around inside it and almost slipping out—a sensuous, tantalizing, suspenseful gesture—or conversely, almost slipping in—a tense evocation of choking or suffocating. (The scraping sounds of the marbles bumping against each other constitute the soundtrack.) This video was made at the Wexner Center for the Arts during Hamilton's residency, which took place not long after Hamilton had moved to Ohio from California.

The title of the installation derives from the discussion of the letter "aleph" in the book *ABC: The Alphabetization of the Popular Mind* by Ivan Illich and Barry Sanders. Their explication reveals that the sound and the name of the letter "aleph" derive from the shape the larynx takes as it moves from silence to speech.

As first exhibited in Hamilton's installation *aleph*, 1992 at the List Visual Arts Center, Massachusetts Institute of Technology, Cambridge, Massachusetts, it was seen at the end wall of a very long room. Hamilton notes, "I remember cutting into the wall to fit the small round-backed standard television—I am presuming this installation preceded the proliferation of flat-screen monitors." When the four related "overflow" videos were editioned in 1993, Hamilton specified the use of flat-screen monitors measuring 3½ × 4½ inches / 8.9 × 11.4 cm.

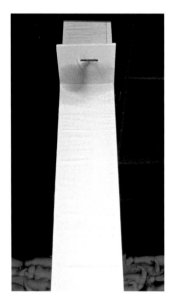 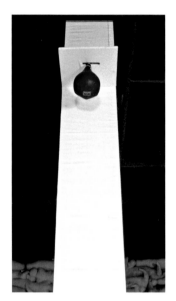

title	*(a round · punching bags)*
date	1993
medium	pair of mechanized punching bags
dimensions	30 × 18 × 20 inches / 76.2 × 45.7 × 50.8 cm (each punching bag)

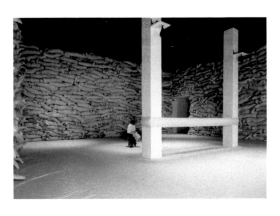

For Hamilton's 1993 instal-
lation *a round* at The Power
Plant, Toronto, two types of
sound animated the space,
despite the absorptive sur-
round of walls surfaced with
sewn and sawdust-stuffed
canvas figures in the shape of
Greek wrestling dummies. At
the top of each of two central
columns was a mechanized
punching bag that would
periodically disrupt the silence, when a timer set the punching bags into motion.
The sounds of the clicking of double-pointed "circular" knitting needles were
also heard. An attendant sat knitting, drawing her wool from an enormous skein
that was wrapped around the columns that Hamilton had called into use as a
pair of gargantuan spindles. The attendant created an "endless" knitted column
whose circumference was the same as that of each of the sewn figures. As the
attendant continued her knitting, she would get up and walk around the columns
to free additional yarn for her work. See also the related knitting gesture video,
(a round · video), 1993/1996, 2006 (pp. 110–111).

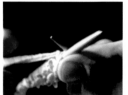 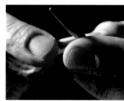 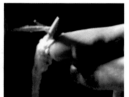 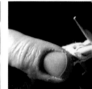

title	*(a round · video)*
date	1993 and 1996/2006
medium	video, color, sound, 30:00 (loop); LCD screen; DVD; DVD player
edition	3 with 2 Artist's Proofs. Published in 2006 by Sean Kelly Gallery, New York
dimensions	15 inches / 38.1 cm (screen)

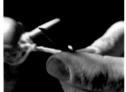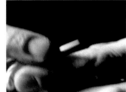

Knitting, "a line of material accreting to become a form," as Hamilton puts it, was not only the signal gesture of the installation *a round*, 1993, but is also "a material process that bears a direct relation to how installations have been made and formed." Hamilton first reenacted the gesture, capturing as well the sounds of metal needles against each other, for a video shot during her residency at the Wexner Center for the Arts, with thoughts of including it in her 1996 installation *reserve* at the Stedelijk van Abbemuseum, Eindhoven, The Netherlands. The video was never used in that installation, and Hamilton returned to its raw materials, re-editing them for *(a round · video)* in 2006.

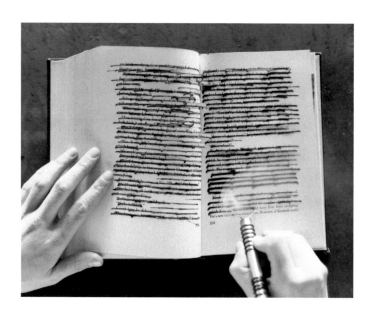

title	*(tropos · books)*
date	1993
medium	48 altered books, shelf
dimensions	overall dimensions variable
collection	Private collection, New York

In this work Hamilton continues her investigation of reading as literal absorption—erasing mechanically reproduced letters with the measured sensory, repetitive acts of the body and adding a new mark of unmaking, or re-writing, the page. For her installation *tropos* at the Dia Center for the Arts, New York in 1993, in a room with a floor covered in horsehair, an attendant read each line of text silently while at the same time, with an electric burner in hand, burned each line from the book as it was read, causing the air to fill with acrid smoke. For Hamilton, the smoke itself is part of the language of remaking, for "the transformation of the text—printed word—to smoke is reabsorbed as smell by the hair of the floor; thus word is again materialized."

The large sum of books in the resulting collective object—48 in total—reflects the duration of the installation, which was in situ for nine months. Each reader chose a book from a selection that Hamilton had purchased from The Strand, New York's landmark secondhand bookstore. She did not choose specific subjects, but rather selected the books for the form of the pages. None of the books had either chapter headings or headers and footers—therefore, there were no indications of chapter title or authorship at the top and bottom of the page. All pages were numbered.

Part of Hamilton's decision in picking books without the identifying lines of text was to deny visitors, reading over the shoulder of the attendant, the possibility of readily identifying the subject matter of each book that personally had been chosen by the reader. The visitor thus focused on the act of reading as opposed to the particular text. Given the number of different readers, and the number of books remade over a considerable period of time, "one sees the trace of time in the weight and individual mark or rhythm of each reader's hand."

114

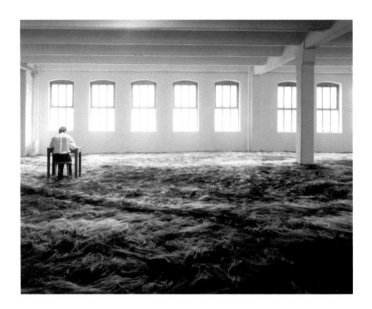

title	*(tropos · voice)*
date	1993
medium	compact disc, compact disc player, mounted car speaker concealed behind a wall
dimensions	variable

This recording of the spoken component of *tropos*, 1993 as an independent work follows from Hamilton's recording of a voice reading in hushed tones Walt Whitman's words in *malediction*, 1991. Here, Hamilton's "purposeful obscuring of words," as she says, and "the recognizability of language, but the elusiveness of comprehension" derive from multiple factors.

The voice is that of Tom Curlew, a professional actor with a mild case of aphasia, which is caused by brain injury or disease resulting in a partial or total loss of the ability to articulate words verbally. Curlew read two passages Hamilton had selected. One was from *ABC: The Alphabetization of the Popular Mind* by Ivan Illich and Barry Sanders, a text also influential for Hamilton's installation *aleph*, 1992 (see (*aleph · video*), 1992/1993 [pp. 106–107], and the related *Untitled*, 1993/1994 [pp. 116–117]). He also read from T. S. Eliot's "Four Quartets," including the "Burnt Norton" section. Curlew's reading of the poem's famous opening line, "time present, time past," had particular currency as Curlew wrestled with his present selective—but unpredictable—speaking abilities in light of his professional training.

As Hamilton recalls of the recording session: "It became extremely emotional for him. The words were so beautiful and it was so difficult for him to say them. What you sense is the effort to come to language. It's not stuttering—some words are very clear. There is just enough there to stay in the rhythm of the voice, but it doesn't fall into form or into meaning." The Curlew recording was played from speakers sited on the exterior of the 19 windows at the Dia Center for the Arts. Not only were the speakers positioned on every other window, but also the source of sound continually changed from speaker to speaker, causing visitors to move around the room to try and keep the sound "within reach."

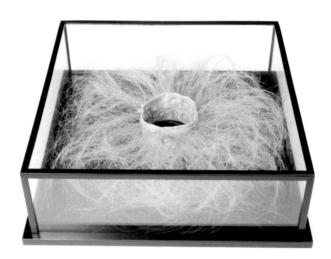

title	*Untitled*
date	1993/1994
medium	linen and horsehair collar with hand-sewn alphabet, wood and glass vitrine
edition	12 with 8 Artist's Proofs (not numbered). Published in 1994 by The Fabric Workshop and Museum, Philadelphia
dimensions	20 inches /50.8 cm (diameter of collar), 6¾ × 22 × 22 inches / 17.1 × 55.9 × 55.9 cm (vitrine)
other	Each of the hand-stitched collars constitutes a somewhat different version rather than an exact replication.

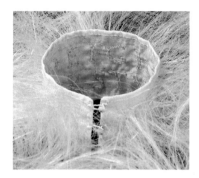

Out of Hamilton's thinking about the forms and meanings of the alphabet for *aleph*, 1992 and *tropos*, 1993 came the untitled alphabetically lined collar, sewn following Giovan Francesco Cresci's "Renaissance Alphabet" using filaments of horsehair that had been used for the oceanic pelts surfacing the irregular topography of the gallery floor at the Dia Center for the Arts for her *tropos* installation. (Hamilton also focused on the neck in one of her miniature videos, *(dissections . . . they said it was an experiment · video)*, 1988/1993 [pp. 64–65]; both the video and this collar turn on the "joint of head and body.") With the sewn alphabet close to the neck, and the extensions from each letter on the opposite site of the cloth splaying out to create a ruff, the internal lettering is invisible (when the collar is worn), while the extended, external lengths of lettering are unreadable.

title	*(mneme)*
date	1994
medium	33 rpm vinyl record, handmade linen clamshell box, letterpress by artist
edition	78 with 22 Artist's Proofs. Published in 1996 by Sean Kelly Gallery, New York
dimensions	12 inches / 30.5 cm (record), ½ × 15 ½ × 15 ¼ inches / 1.3 × 39.4 × 38.7 cm (box closed)

The title of Hamilton's installation *mneme* derives from the Greek *mnemonikos*, meaning "of memory." At the Tate Gallery, Liverpool, the installation took up two floors and was divided into four distinct spaces. On the upper floor, an attendant stood at a wooden table on which sat a large box record player. He turned the record on the turntable by hand so that the sounds wound in and out of recognition. The disc itself was a recording of a human voice precisely articulating the eight cardinal vowels, which are "a matrix of and reference points for all speech," as curator Judith Nesbitt wrote in the catalogue—sounds that are produced by "eight tongue configurations, not aligned with the vowels of any particular language."

As the hand—actually, a single finger—turned the record at different speeds and orientations, the sounds slowed and became indistinct, blurred, or, as Hamilton recalls, "animal-like." The record that had been played during the course of the installation was erased as the needle cut deeper and deeper into the LP recording. The vinyl record that is enclosed in this boxed edition is a recording of the sounds of the record being played during the installation.

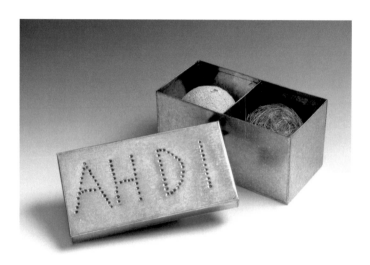

title	*Untitled*
date	1994
medium	handmade galvanized tin box with artists' initials punched in lid; box contains two balls: one of horsehair (Hamilton's), one of concrete (Ireland's)
edition	80 with 20 Artist's Proofs. Published in 1994 by The Fabric Workshop and Museum, Philadelphia
dimensions	4½ × 8¾ × 4½ inches / 11.4 × 22.2 × 11.4 cm
other	collaboration with David Ireland

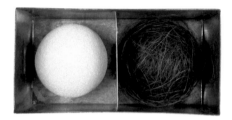

Inspired by Hamilton's and David Ireland's exhibition at the Walker Art Center in 1992, this handmade galvanized tin box with the artists' initials punched in the lid contains two balls, one by each artist made with a characteristic gesture. Both of these balls were fabricated by The Fabric Workshop and Museum, Philadelphia. Hamilton's is a ball of horsehair (the material used in her installation *tropos*, 1993 at the Dia Center for the Arts and in her *Untitled* collar, 1993/ 1994 [see pp. 116–117]). The form is not unlike the one used in *lineament*, 1994 (see p. 123), where long lines of text were excised from books and rolled into balls as if they were lengths of knitting yarn.

"A signature of Ireland's," as Hamilton explains, "is a concrete ball. He tosses wet concrete back and forth until it begins to set. The round concretions are called 'dumbballs.' " These may take up to 15 hours to cure (according to Peter Selz). The artist has made many variants, using them individually and multiplying them as components of other works. For his exhibition with Hamilton at the Walker Art Center, Ireland gouged segments of the lawn and cast concrete in these voids. He displayed a collection of these elements within archival cabinets inside the museum.

122

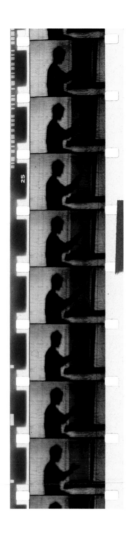

title	*(lineament)*
date	1994
medium	2 wood boxes; 29 altered books; 55 balls wound from strips of text; 16mm film, color, silent, 20:00 loop; projector
dimensions	variable (overall)
collection	Collection of the Miami Art Museum, Miami, Florida. Museum purchase with funds from Carlos and Rosa de la Cruz and Mimi and Bud Floback

A composite of many objects, Hamilton notes that this work "tries to distill the relationships of the elements within the installation" by using new plywood boxes, the actual altered books, and a film with the projector (in the installation, the projector ran without film). During the installation, within a plywood-surfaced gallery, a figure sat on a suspended plywood swing at a similarly suspended plywood table, pulling continuous lines of texts from books that had been precut and wrapping the lengths of text into balls. She then pushed them through a screen before her, so that the balls rested on the table like the "planets" of the Wallace Stevens poem from which the installation derived its title. Stevens's "The Planet on the Table" links poetry to the larger universe: "What mattered was that they should bear / Some lineament or character, / Some affluence, if only half-perceived, / In the poverty of their words, / Of the planet of which they were part."

A movie projector, hidden behind one of the plywood walls and running without film in the apparatus, projected light across the room and onto the figure at work, causing her shadow to be cast on the wall and creating another kind of "moving picture"—something more like the ritual performance of shadow puppetry. Hamilton (and later an attendant, Jennifer Parker) sat behind a three-part semi-transparent screen resting on the table—"a puppet-sized stage curtain."

For *(lineament)*, 1994, Hamilton combined for the first time surviving "relics" and new elements created specifically for this project to create a self-contained sculptural installation. She used the actual books and balls and added two newly made hinged plywood boxes (which recalled the box on which the attendant rested her feet). Hamilton reused the projector, but while in residence at the Wexner Center for the Arts she created a new film reenacting the silhouetted figure, who sat swaying as she worked at the table.

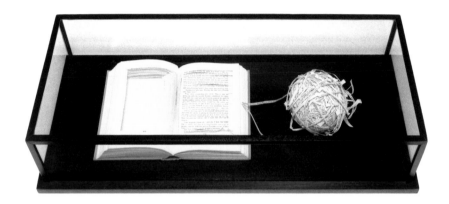

title	*(lineament · book/ball)*
date	1994
medium	ball wound from strips of text, book, wood and glass vitrine
edition	15 with 4 Artist's Proofs. Published in 1994 by Sean Kelly Gallery, New York
dimensions	12½ × 28½ × 5½ inches / 31.8 × 72.4 × 14 cm (vitrine)

Made by the same process used for the balls wound from strips of text in *(linea-ment)*, 1994 (p. 123), this ball was made after the installation specifically for the edition. In *(lineament)*, the balls (as well as the excised books) derive from the installation itself. As the volume emptied, the book becomes a negative space—the two-dimensional plane of the page transformed into a dimensional form. In all cases, the works condense ideas of spinning (wool or a tale), gathering yarn, and the creation of language. Reading the books back to front, lines of text are extracted (from books previously prepared and precut) to reveal language imprinted on both sides of the page.

title	*abc · video*
date	1994/1999
medium	video, black and white, silent, 30:00 (loop); LCD screen; videodisc; videodisc player
edition	3 with 2 Artist's Proofs. Published in 1999 by Sean Kelly Gallery, New York
dimensions	15 inches / 38.1 cm (screen)

For her 1995 installation *seam* at the Museum of Modern Art, New York, Hamilton included a very large wall projection (her first) of a video showing an ambiguous image that in fact was a finger smearing honey on glass. She had intended to use, but did not use, an alphabet printed on glass in water-soluble blue that would be erased as a finger moved along the surface. In 1999, she reshot this video, which became *abc · video*, 1994/1999. (See also *abc · table*, 1994/1999 [pp. 128–129].) The fingertip, "which is the most individuated mark of the body," erases the alphabet and rewrites it. This process is emphasized by the way the video is edited to run forward and in reverse. This video would become a touchstone for Hamilton as a reference to the relationship between written language and tactile experience.

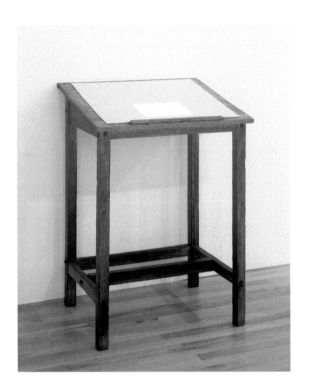

title	*abc · table*
date	1994/1999
medium	wood slant top table; cloth; video, black and white, silent, 30:00 (loop); LCD screen; videodisc; videodisc player
dimensions	9 inches / 22.9 cm (screen), 41 × 30 × 25 inches / 104.1 × 76.2 × 63.5 cm (overall)
collection	Private collection, Dallas, courtesy of Neal Meltzer Fine Art

Hamilton's *abc · video*, 1994/1999 is incorporated into this piece, where it is shown on a monitor set into the surface of a wood dictionary stand. The 9 inch / 22.9 cm screen, larger than the small, palm-sized flat-screen monitors she previously used for her videos, now approximates the size of a page and is covered with a white cloth, the way drawings are protected from the light between viewings at certain museums. In Hamilton's piece, the cloth has a contrarian function: It does not protect her "page's" surface from light but, once lifted, fully reveals light emitted from the video below. (See also *abc · video*, 1994/1999 [pp. 126–127].)

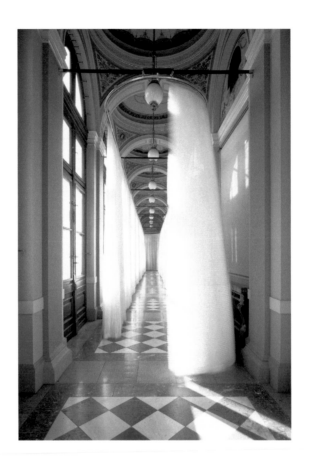

title	*(volumen)*
date	1995
medium	motor-and-chain-driven ceiling track and curtain
dimensions	variable

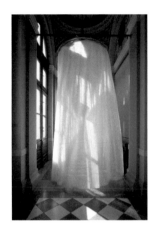

The first of Hamilton's motorized spinning curtains appeared in her installation *volumen*, 1995 at The Art Institute of Chicago (the images to the left show *(volumen)* as installed at Galerie Rudolfinum in Prague). A number of variants issued as objects from the *volumen* installation and were used in combination with other elements for subsequent installations. The curtain used in the *volumen* installation was the first and the largest, taking up a long and narrow room. As it moved around a ceiling-mounted track, the newly created, dynamic, elliptical, translucent room within a room revealed and concealed both the visitors within it and also the view outside. Also seen as a shadow through its translucent fabric, and seen live in the installation when the open doorway of the curtain passed, was a figure who sat making graphite marks on a white board. The room itself had one wall of floor-to-ceiling windows, and as the curtain's opening passed before them, visitors within the curtained space could see glimpses of the train yards beyond. A moving curtain revealing and concealing a view in succession was also part of the 2003 project in Istanbul, *appeals* (see p. 15), where a series of curtains unfurled to block or open passage down a broad corridor.

The curtain itself was made of fabric designed by Jack Lenor Larsen. Though it appeared white from a distance, it was a blend of pink, green, and beige, and its vertical striations were woven into the fabric. The alternate vertical stripes of the curtain—either more transparent or more opaque—created a flickering pattern as it moved and thus related subtly to Hamilton's use of a fabric-paneled zoetrope in *lumen* at Philadelphia's Institute of Contemporary Art in 1995. See also spinning curtain variants *filament · I*, 1996 and *filament · II*, 1996 (pp. 152–153, 154–155); and *bearings*, 1996 (pp. 150–151).

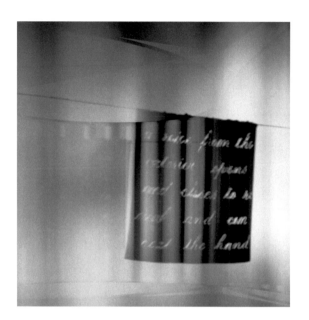

title	*(lumen · curtain)*
date	1995
medium	cotton cloth, cable, pulley, metal ring
dimensions	42 × 39¼ inches / 106.7 × 99.7 cm (curtain); variable (overall installation)

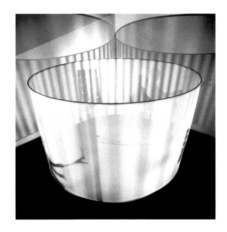

This cloth cut with words (above left) is the first Hamilton-written text materialized in her work. It is suspended on a cable and, like a curtain, it may be opened and closed. As part of Hamilton's *lumen* installation at the Institute of Contemporary Art, Philadelphia, it was suspended at one end of a cable with a hanging metal ring at the opposite end. When the ring was successfully grabbed by a wooden prosthetic hand manipulated by Hamilton (and later an attendant), the curtain opened to fleetingly reveal the text which was self-reflexive to the act of its operation and the larger context of the installation: "A voice from the exterior opens and closes to reveal and conceal the hand." For the installation, the curtain was positioned between a light fixture and a spinning zoetrope (above), so that when light was projected onto the curtain from the rear, the words also appeared (fleetingly) on the zoetrope. See related works, pp. 134–137.

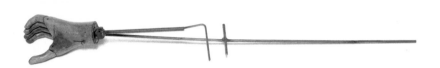

title	*(lumen · hand)*
date	1995
medium	wood, prosthetic hand, steel
dimensions	4½ × 6 × 38½ inches / 11.4 × 15.2 × 97.8 cm

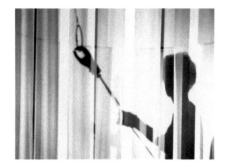

This is the wooden "extension" Hamilton held in the installation *lumen*, 1995, where she used the surrogate hand to try to grab a ring. Though the ring was hanging directly in front of where she sat, her gaze was directed to the side, where the zoetrope caught the shadow image of the suspended metal ring. She tried to catch the actual object by watching only its shadow. The difficulties and failed attempts in gaining access to something out of reach was not unlike that of *(tropos · voice)*, 1993 (see pp. 114–115), where a disability is also privileged, and the hesitations, multiple attempts, and often failures to come to language are acknowledged as another kind of potent speech. In *lumen*, the performer's successful grab of the ring triggered a curtain to open, revealing the following words: "A voice from the exterior opens and closes to reveal and conceal the hand." (See previous entry, pp. 132–133.)

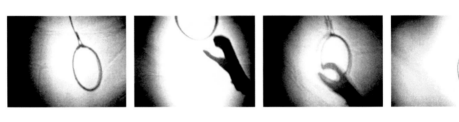

title	*(lumen · hand/ring video)*
date	1995/1996
medium	video, color, silent, 30:00 (loop); laser disc; laser disc player; projector
edition	1 with 1 Artist's Proof
dimensions	variable (projection size)
collection	Collection of Antoine de Galbert, Paris

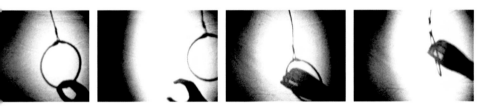

For "the body and the object: Ann Hamilton 1984–1996," a 1996 touring exhibition of Hamilton's independent objects and those issuing from installations, organized by the Wexner Center for the Arts, Hamilton also returned to a number of key gestures in her installations and reenacted them for the catalogue's accompanying CD-ROM. For this video, Hamilton reenacted and isolated the gesture of her holding a wooden prosthetic hand and using it to reach for and attempt to grab a suspended ring. (See also pp. 134–135, 138–139.) As Hamilton notes, "The extension of the hand and the extension of the voice are the two primary ways we extend our presence—the latter to aural space, the former to the tactile. It is around these two loci that the work has amplified and developed its many material and spatial forms." This gesture is abstracted in *(lumen · hand/ring video)*, for, as the artist says, "the 'figure' is always chasing the shadow of the figure—the figure itself never represented except in its absence."

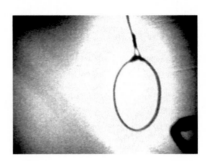

1

title	*(lumen · grab 1–10)*
date	1995/1999
medium	Design Winder print on Arches Cover paper
edition	10 prints each in an edition of 10 with 9 Artist's Proofs. Copublished in 1999 by Sean Kelly
	Gallery, New York and the Institute for Electronic Arts, Alfred, New York
dimensions	13 ⅜ × 10 inches / 8.6 × 25.4 cm (each image), 22 ¼ × 30 inches / 56.6 × 76.2 cm
	(each paper)

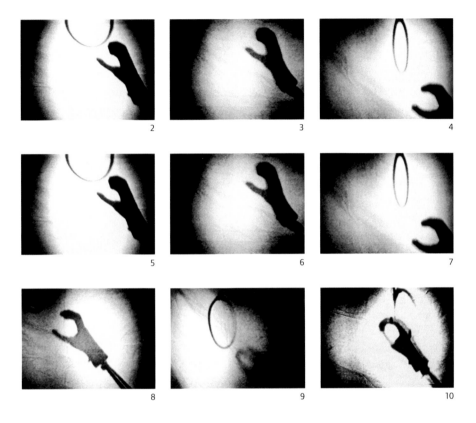

The title of these editioned prints is doubled wordplay. It is a play on the gesture seen in the video, of a hand trying to grab a ring (see *(lumen · hand/ring video)*, 1995/1996 [pp. 136–137]), as well as the technical term of a "grab" to isolate stills from a video. This print was one of Hamilton's first collaborations with the Institute for Electronic Arts, then codirected by artist Jessie Shefrin.

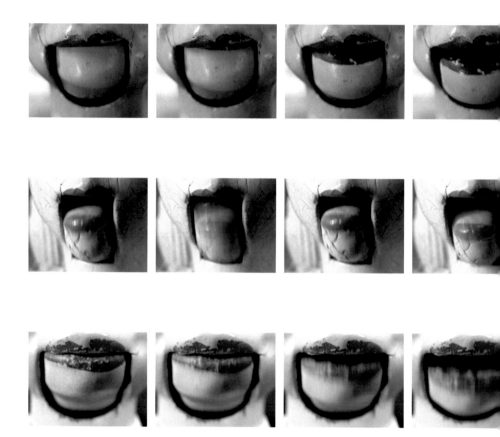

title	*(lumen · vent dummy I)* \| *(lumen · vent dummy II)* \| *(lumen · vent dummy III)*
date	1995
medium	video, color, sound, 30:00 (loop); LCD screens; laser disc; laser disc player (each)
dimensions	3½ × 4½ inches / 8.9 × 11.4 cm (each screen)
other	the number of LCD screens is variable

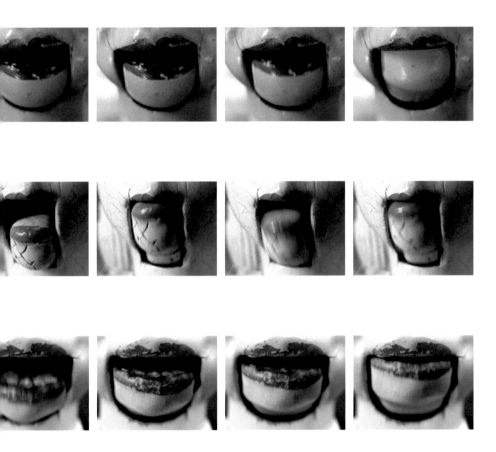

On an upper level of the double-height space of *lumen* at Philadelphia's Institute of Contemporary Art, Hamilton used multiple small monitors to show the three variant *(lumen · vent dummy)* videos. Each focused on the face of a ventriloquist's wooden dummy, showing its jaw snapping open and closed, with the attendant sound of wood against wood. The ventriloquist's dummy is a prosthetic figure or voice relating to the prosthetic wooden hand, which activated and animated the installation below as its shadow image was thrown onto the surface of a spinning zoetrope in the installation (see p. 133). Here, Hamilton once again uses voice at the perimeter of the installation, via the surrogate of the ventriloquist's vent, and she also begins to bring it into a central position with her own text incised into a white curtain (see p. 132).

title	*(handed · video)*
date	1996/2006
medium	video, color, silent, 30:00 (loop); LCD screen; DVD; DVD player
edition	3 with 2 Artist's Proofs. Published in 2006 by Sean Kelly Gallery, New York
dimensions	15 inches / 38.1 cm (screen)

This video issued from Hamilton's installation *handed*, first seen in her exhibition "the body and the object: Ann Hamilton 1984–1996" at the Wexner Center for the Arts in 1996. That installation consisted of a corridor, each of its walls faced with 13 video screens (to make a total of 26, the same sum as the letters in the roman alphabet). Each screen displayed the same video, each playing from a different starting point. Hamilton is seen polishing a plum with a chamois cloth. She polishes so vigorously that in the process the skin is torn from the meat of the fruit. This was the first installation for which Hamilton began with video and then constructed an architectural space to house it.

title	*(reserve · video/writing)*
date	1996/2000
medium	video, color, sound, 30:00 (loop); LCD screen; DVD; DVD player
edition	3 with 3 Artist's Proofs. Published in 2000 by Sean Kelly Gallery, New York
dimensions	15 inches / 38.1 cm (screen)

This video shows a stylus writing the alphabet on a piece of glass, shot from below (like the point of view employed in Hamilton's first film, *(the middle place · film)*, 1987 [see pp. 62–63], which shows her walking on the glass surface, in her *abc · video* [see pp. 126–127], and in the video component of her installation *seam* [described on p. 127]). The lettering seen in this video thus reads in reverse. Heard are the sounds of the making of the letters, a scratching of the stylus on glass. The video was first made for and shown at the exhibition "Ann Hamilton: *reserve*" at the Stedelijk van Abbemuseum, where the video monitors were set into one end of colossally long steel tables. (At the other end of each table were masses of logs, each wrapped in a book page; the tables themselves ran the width of the room and were each built around a structural column.) Each monitor was covered with a hand-stitched, silk-lined wool cloth, as is the video monitor set into a wood desk for *abc · table*, 1994/1999 (see pp. 128–129), *(reserve · table · video/writing)*, 1996/1997 (see pp. 146–147), and the ledger page of *(whitecloth · book)*, 1999 (see pp. 172–173).

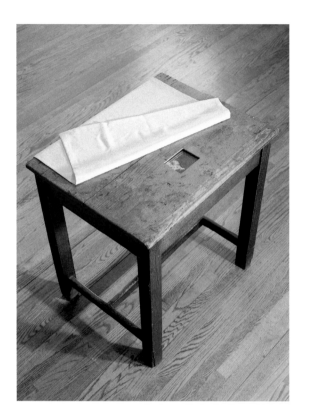

title	*(reserve · table · video/writing)*
date	1996/1997
medium	wood table; wool cloth; video, color, sound, 30:00 (loop); LCD screen; DVD; DVD player
dimensions	30 × 30 × 23½ inches / 76.2 × 76.2 × 59.7 cm (table); 3½ × 4½ inches / 8.9 × 11.4 cm (screen)
collection	Collection of Sean and Mary Kelly, New York

Reminiscent of seventeenth-century Dutch paintings that depicted women reading, writing, or sewing by the light of a window, Hamilton's videos for her installation *reserve* at the Stedelijk van Abbemuseum depicted sewing and writing, evidencing the conjunction of a line of thread and a line of writing, which recur in Hamilton's body of work (see *(salic)*, 1997 [pp. 158–161], *scripted*, 1997 [pp. 162–163], and *slaughter*, 1997 [pp. 164–165]). Also, each video was shown on a screen set into one end of a long steel table.

In the installation, the monitor displayed one of three videos. One of them was a stylus scratching out an alphabet on glass (see *(reserve · video/writing)*, 1996/2000 [pp. 144–145]); another was a needle sewing a circular stitching of cloth, also with the amplified sounds of its making, the needle puncturing the cloth (see *(reserve · video/sewing)*, 1996/2006 [pp. 148–149]); and one showed fingers picking apart the loose weave of white silk gauze (see *(reserve · video/picking)*, 1996/2006 [pp. 148–149]). This is the same gesture that was part of the making of the filament curtain pieces. The use of a video positioned within a table is related also to Hamilton's *abc · video*, 1994/1999 (pp. 126–127) and *abc · table*, 1994/1999 (pp. 128–129). The making of all these videos preceded Hamilton's decision to exhibit them set into tables.

A fourth video of knitting, though originally shot for this installation, was never used and was reworked by Hamilton in 2006. The footage was re-edited by Hamilton and titled *(a round · video)*, 1993 and 1996/2006 (see p. 110). Though no video was shown in that Toronto installation (with which this video shares a title), a live figure was seen there, seated on a chair, knitting an "endless" column.

148

title	*(reserve · video/picking)*	*(reserve · video/sewing)*
date	1996/2006	
medium	video, color, sound, 30:00 (loop); LCD screen; DVD; DVD player	
edition	3 with 3 Artist's Proofs each. Published in 2006 by Sean Kelly Gallery, New York	
dimensions	15 inches / 38.1 cm (screen)	

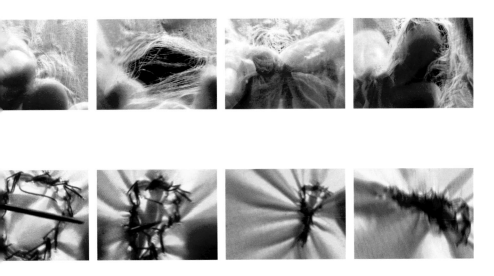

These are two of the three videos shown in Hamilton's 1996 installation *reserve* at the Stedelijk van Abbemuseum, Eindhoven, The Netherlands (see pp. 144–145 for the third video). As Hamilton notes, "The sound of the sewing and the cloth being punctured is particularly aggressive relative to our image of someone sitting still and sewing. The amplified sounds of these processes contain a friction that belies the calm of the still-life genre they evoke. Here is the disjunction between calm exterior and turbulent interior. It is a recognition, not unlike the mouth gnawing and gnashing, which went into my thinking in the San Diego *between taxonomy and communion* project." (See see pp. 84–85.)

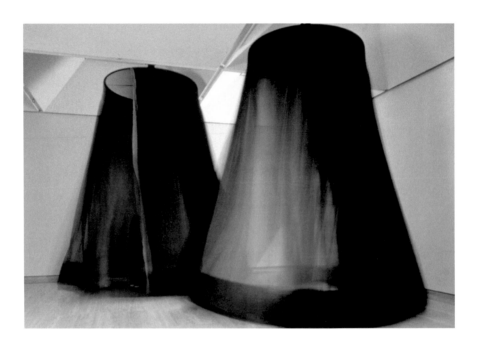

title	*bearings*
date	1996
medium	organza fabric, two steel mounts with two electronic controllers
dimensions	174 inches / 442 cm (height of each curtain), 196 inches / 497.8 cm (approx. diameter of curtain when spinning), 75 inches / 190.5 cm (curtain support ring diameter)
collection	Collection of the Musée d'Art Contemporain de Montréal, Montréal, Quebec, Canada

This pair of black-over-white curtains is larger and more fully room-size than the *filament* curtains. Each has hand-pulled horizontal elements, as if, according to Hamilton, creating "ruled" lines for the space of writings. See also *(volumen)*, 1995 (pp. 130–131), *filament · I*, 1996 (pp. 152–153), *filament · II*, 1996 (pp. 154–155). This series of curtain works is, for Hamilton, "the first time the work creates a form that is both a space that can be occupied and a thing.... Like the body, it is simultaneously an inside and an outside ... hidden and exposed, revealing and concealing ..."

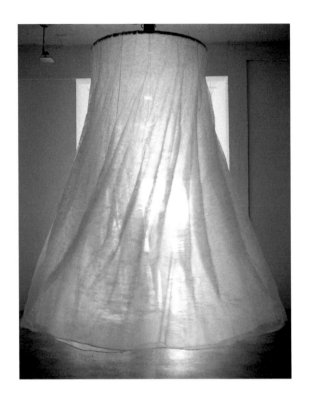

title	*filament · I*
date	1996
medium	organza fabric, steel mount with electronic controller
dimensions	144 inches / 365.8 cm (height of curtain), 12 inches / 30.5 cm (height of mount),
	120 inches / 304.8 cm (approx. diameter of curtain when spinning), 62 inches / 157.5 cm
	(curtain support ring diameter), variable (height of overall installation)
collection	Collection of Akira Ikeda Gallery

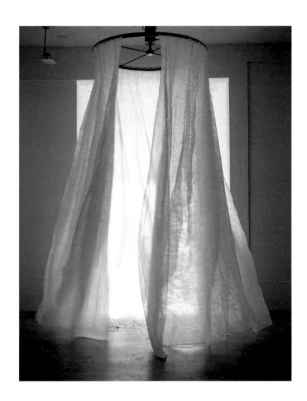

The outer surface of this two-layer spinning curtain is distressed by Hamilton's pulling the weave of the fabric apart (a gesture and mark seen in Hamilton's video *(reserve · video/picking)*, 1996/2006 [pp. 148–149]). The inner surface is untouched, and replays the traditional relation between a curtain and its lining. This spinning curtain was seen as part of the installation *filament* at Sean Kelly Gallery, New York in 1996, where Hamilton's *(lumen · hand/ring video)*, 1995/1996 was also shown. See also *(volumen)*, 1995 (pp. 130–131), *filament · II*, 1996 (pp. 154–155), and *bearings*, 1996 (pp. 150–151).

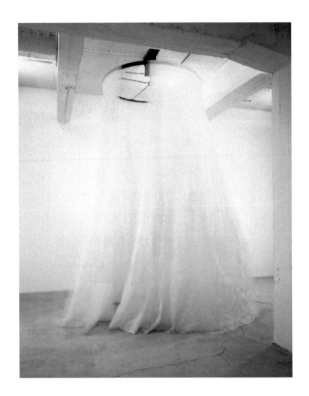

title	*filament · II*
date	1996
medium	organza fabric, steel mount with electronic controller
dimensions	168 inches / 426.7 cm (height of curtain), 12 inches / 30.5 cm (height of mount),
	144 inches / 365.7 cm (approx. diameter of curtain when spinning), 62 inches / 157.5 cm
	(curtain support ring diameter), variable (height of overall installation)
collection	Collection of the Irish Museum of Modern Art, Dublin, Ireland

This white-over-white spinning curtain, its surface like that of *filament · I*, evidencing the marks of its weave picked apart, is taller than *filament · I* and was seen in the 1996 Wexner Center for the Arts exhibition, "the body and the object: Ann Hamilton 1984–1996," and the 1997 exhibition "Hanging by a Thread" at the Hudson River Museum, Yonkers, New York. See also *(volumen)*, 1995 (pp. 130–131), *filament · I*, 1996 (pp. 152–153), and *bearings*, 1996 (pp. 150–151).

title	*(bounden · seeping wall)*
date	1997
medium	wall drilled with approximately 400 minute holes, water, gravity-fed IV drip system
dimensions	variable

Originally exhibited in 1997 at P.S.1 Contemporary Art Center, Long Island City, New York, with the title *(bounden)*, this piece issued from Hamilton's thinking for the Musée d'Art Contemporain de Lyon's multi-part installation *bounden*, 1997 and so derives its title from that installation. The work was also known by the title *welle* when it was installed at the exhibition "être-nature" in 1998 at the Fondation Cartier pour l'Art Contemporain, Paris; as part of Hamilton's 1999 installation *whitecloth* at The Aldrich Museum of Contemporary Art, Ridgefield, Connecticut; in the "1999 Carnegie International" exhibition at the Carnegie Museum of Art, Pittsburgh; and in *kaph*, at the Contemporary Arts Museum, Houston in 1997. The work has also been known as Hamilton's "crying" or "tearing" wall.

A system of "intravenous" PVC tubing is set behind constructed sheetrock walls and conveys water from a gravity-fed system. Water from a storage tank behind and at the top of the wall moves through the circulatory system so as to seep through pinprick-like holes, allowing a single "tear" to emerge and slowly gather enough liquid to form a drop, which, gravity taking its course, then slides down the wall. From afar, this process is almost imperceptible; the view is that of a glistening white wall (which could be read as an illumination of architecture or as a reference to the monochrome surface of a minimalist painting). Up close, it is as mesmerizing as watching a raindrop sliding down a window pane, the effect multiplied to thousands of drops, or watching glistening skin as it heats and erupts into sweat, a second skin of water surfacing the body's protective and porous shelter.

In some installation variants, the water from the wall pooled on the floor and collected there; in others, it drained into a small slit-like drain constructed at the bottom of the wall.

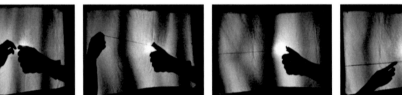

title	*(salic)*
date	1995
medium	four videos, each: black and white, sound, 30:00 (loop); laser discs; laser disc players; LCD projectors
dimensions	variable (projection size)
collection	Collection of Heather and Tony Podesta, Falls Church, Virginia

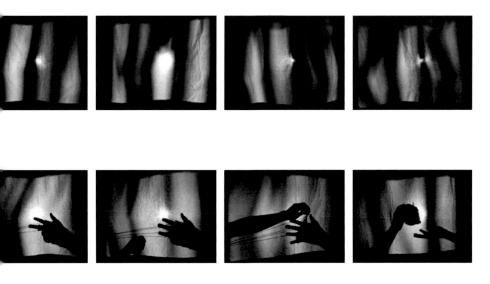

The *(salic)* videos were first projected within a railroad car onto its 22 windows, as part of Hamilton's contribution to the exhibition "Longing and Belonging: From the Faraway Nearby" at SITE Santa Fe in 1995. The setup for making these videos included a suspended sheet blown by a fan and catching the shadow of a miniature zoetope spinning on an old record player in front of an old movie projector, implying variously, in its changing patterns of light, glimpses of the sun, the train's headlight, or the light of the moving picture projector, and, as Hamilton notes, "possibly some combination of all three." Three of the four videos were shot with a figure unfolding an action in shadow, while the fourth video shows only the zoetrope flicker and a light.

What resulted was the flickering effect of early film and a sense of the rhythm of movement in general, rather than that of a train ride specifically. The other

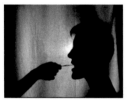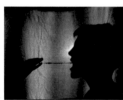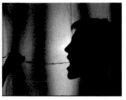

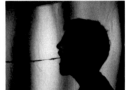

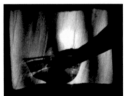

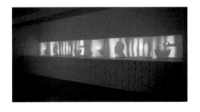

videos show Hamilton in profile, with a length of yarn being extracted from her mouth; Hamilton's gloved hand being unraveled by a second hand winding the lengths of extracted material into a ball and passing it back to her now-ungloved hand; and water flowing through the artist's hands into a bowl, which is then emptied.

The presence of absence here might be recognized in the off-screen figure (Kris Helm), whose hands are performing the action of pulling the yarn of the glove from the hand and mouth.

title	*scripted*
date	1997
medium	gold thimble photo-etched with text of Susan Stewart's poem "Cinder," silver thimble,
	horsehair, wood and glass vitrine
edition	15 Versions with 5 Artist's Proofs. Published in 1997 by Sean Kelly Gallery, New York
dimensions	3½ × 33½ × 7½ inches / 8.9 × 85.1 × 19.1 cm

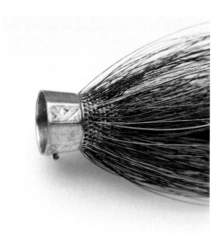

The acts of sewing and speech are embodied in one of the two thimbles that constitute this piece. Susan Stewart's poem "Cinder" appears in the form of a gold thimble photo-etched in filigree. This gold thimble was shown vertically along with the second, silver thimble, oriented horizontally, the latter having a length of horsehair emerging from each of the pore-like points of the thimble, not unlike the way droplets of water emerged from the pore-like holes of the installation *(bounden · seeping wall)*, 1997 (pp. 156–157). The horsehair in this piece derived from the materials used in *tropos*, 1993 (see p. 114).

Hamilton's reading with the fingertip (here inserted into and "wearing" the body of the poem) would continue in related works created by using a small surveillance camera attached to her hand for videos, and for photographs.

title	*slaughter*
date	1997
medium	organza glove embroidered with text of Susan Stewart's poem "Slaughter," wood and glass vitrine
edition	10 versions with 2 Artist's Proofs. Published in 1997 by Sean Kelly Gallery, New York
dimensions	4 × 18½ × 13¾ inches / 10.2 × 47 × 34.9 cm

The bodies of these organza gloves are embroidered with the text of Susan Stewart's poem "Slaughter." In addition, the number of gloves Hamilton used— six pairs—also derives from her reading of the poem, which invokes the slaughter of an animal. (When Hamilton asked Stewart how many people traditionally worked together to do this, Stewart said five or six.) While the complete poem is embroidered on a pair of gloves, they are separated, and displayed each in its own box. As Hamilton notes, "The division is a reference to agency . . . to how we 'own our acts'—work in concert—the notion of pair and double and right and left . . . the poem, like the slaughter, is completed only when the hands act in concert—when they own the visceral consequence of their acts." Stewart's poem is important for Hamilton in "how it critiques a cultural romanticization of sacrifice."

title	*(kaph · gloves)*
date	1997
medium	silk organza, thread, 33 gloves
dimensions	12 × 8 ½ × 1 ½ inches / 30.5 × 21.6 × 3.8 cm (each glove), variable (overall)

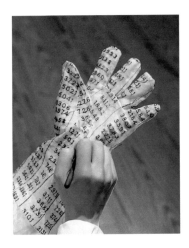

During the installation *kaph* in 1997, an attendant sat on a chair at the end of a
corridor-like pair of curving, "seeping" walls (see pp. 156–157). The attendant
picked out numbers embroidered in blue on the gloves and dropped the bits of
thread to the floor. Hamilton had originally found the numbers on a laundry
ledger. The organza work glove was worn on one hand, while the other hand
deconstructed parts of it. The word kaph is the thirteenth letter of the Phoeni-
cian alphabet. Hamilton chose it for the work's title after having discovered it
in a poem where the word refers also to the hand's palm. As Hamilton notes,
"I was thinking about how the capacity of the hand to hold something is the
larger metaphor behind the structure of this work. The many different forms of
this installation revolve around the hand's palm: the dirt on the tables is patted
into place with the palm, the water drops collect in the basin of the palm, the
body hangs from the support of the palm, and fingers wrapping a suspended bar
(although in this installation the metal trapeze bar is set so high as to be beyond
the grasp of the exhibition's visitors)."

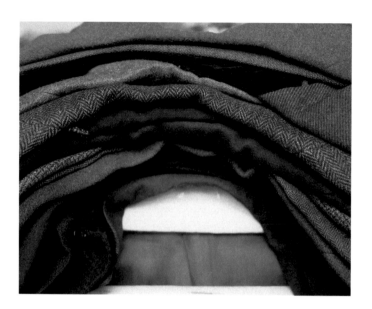

title	*(mantle · coats)*
date	1998
medium	distressed wood and wicker chair, 33 woolen coats, steel weight
dimensions	40 × 30 × 30 inches / 101.6 × 76.2 × 76.2 cm (overall)

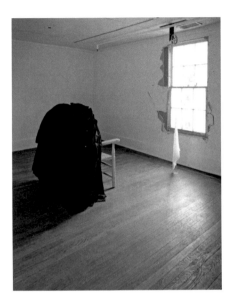

For her 1998 installation *mantle* at the Miami Art Museum, Hamilton (and later
an attendant) sat in a chair before the light of a newly uncovered window, resew-
ing the seams and sleeves onto sleeveless coats (a sleeveless coat being one of the
definitions of mantle). As the work progressed, the finished piece hung on the
back of the chair, each completed coat layered on top of an accumulating stack.
The weight of the accumulated work was counterbalanced by the working figure
during the installation and later by a steel weight placed in the seat of the chair.
This chair and these coats would also be used as part of Hamilton's installation
whitecloth, 1999 (above), where it was sited absent a live presence, similarly facing
a window.

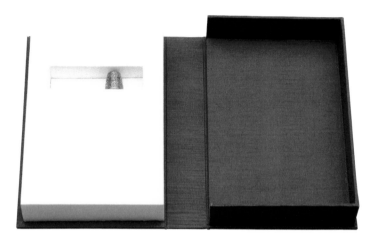

title	*cinder*
date	1999
medium	silver thimble photo-etched with text of Susan Stewart's poem "Cinder," bookbinder's clamshell box
edition	20 with 6 Artist's Proofs. Published in 1999 by Sean Kelly Gallery, New York
dimensions	7 × 6 inches / 17.8 × 15.2 cm (box open)

First exhibited in Hamilton's installation *whitecloth*, at The Aldrich Museum of Contemporary Art in 1999, "Cinder" is a Susan Stewart poem of the same title photo-etched in silver to create its openwork traces. The thimble can be removed from its book-sized box and worn or turned to reveal the script of the poem. This thimble is related to one of the thimbles in Hamilton's two-part object *scripted*, 1997 (see pp. 162–163).

title	(whitecloth · book)
date	1999
medium	wood standing writing desk, altered ledger book, glass, cloth
dimensions	12½ × 17½ inches / 31.8 × 44.5 cm (ledger book), 46 × 42 × 27 inches / 116.8 × 106.7 × 68.6 cm (overall)
collection	Collection of Marc and Livia Strauss, New York

Though in prior works Hamilton "drew" by embroidering on cloth or picking it apart, or wrote with a stylus on glass, or erased water-soluble blue letters, or etched the silver backing of mirrors in a loopy script, or drew in space to create dimensional miniature "housing" whose walls were the poetry of Susan Stewart etched onto a thimble, until *(whitecloth · book)*, Hamilton had not engaged traditional drawing on paper in her practice. Here, using the continuous cursive line of looping script that Hamilton used in the mirrors for her installation *bearings*, 1996, she wrote out a Cotton Mather sermon and inset it under glass on the top of a wood standing writing desk, secreted under a wool and silk cover.

Though it appears that the words themselves are written in white on a red ground, this is not the case. Hamilton's process began with writing in careful script with graphite on a white page. She then used washes of red ink to fill the spaces between her lines, coming close to but not fully reaching the penciled lines, so as to leave the white paper showing through and emphasizing the slight edge between ink and pencil marks. Hamilton's writing thus emphasizes negative rather than positive space, the spaces "between," and the legibility of the words themselves are often obscured in this process. The ledger page is covered with a double-layered cloth, made of cream-white wool lined with white silk, which the visitor must lift in order to access the page, as Hamilton had similarly covered video screens set into wooden tables (see pp. 128–129, 146–147).

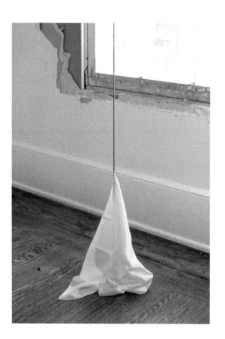 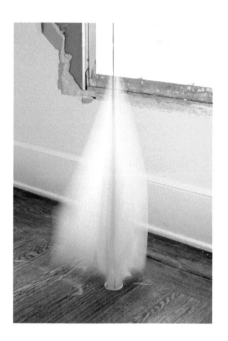

title	*(whitecloth · cloth)*
date	1999
medium	two darting white cloths on cable system, white cloth, pulley, cable, electric drive motor
dimensions	variable

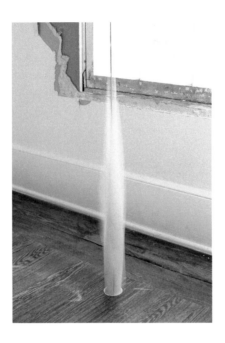

The signature visual and animating gesture of Hamilton's 1999 *whitecloth* installation is this forward and reversing white cloth, attached to a moving cable, that darted through the exhibition space at The Aldrich Museum of Contemporary Art. The cloth dipped in and out of holes in the floor, walls, or ceiling, unpredictably coming into view before disappearing once again as the cable moved. (The illusion is further complicated by the fact that there are actually two white cloths moving along the cable, one just always out of view of the other—another instance of Hamilton's use of pairs, often separated from each other.) The cable is controlled by an electric drive motor with multiple speeds causing changing patterns of movement. At The Aldrich Museum of Contemporary Art, the electronic system was secreted in the attic.

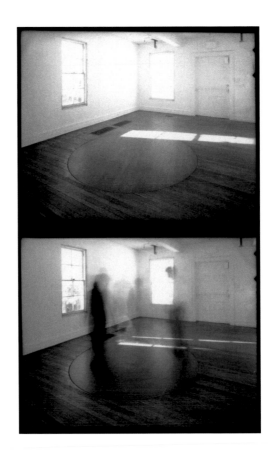

title	*(whitecloth · floor)*
date	1999
medium	flooring, steel plate, mounting wheels and hardware, motor drive and controller, pressure sensors
dimensions	96 inches / 243.8 cm (diameter of wood flooring), variable (surface material and surface for spinning floor)

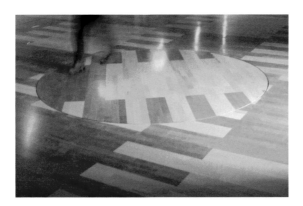

This eight-foot-diameter steel circle was surfaced with wood flooring to match the surface of The Aldrich Museum of Contemporary Art's ground-floor space into which it was set (left). Its revolutions were controlled by an electronic motor and pressure sensors. As the number of visitors who stepped on it for the circular ride increased, the pressure sensors transmitted the information, and thus directed the motion to slow. As in Hamilton's installation *the capacity of absorption*, 1988, where speaking into a microphone had the effect of slowing and then stopping the water vortexes, here the number of people on board first slowed and then stopped the cycle. As Hamilton notes of the floor's revolution speed, it is "just fast enough to be a dare, just slow enough not to hurt you." Here, the emphasis of the overall installation changes. Within this two-story installation, keyed to multiple objects, the visitor's passage through the installation is critical to creating "the overall figure." But as Hamilton notes, "stepping onto the spinning floor, you shift from moving around the room to the room spinning around you." Surfaced in a different pattern of wood, the spinning floor was incorporated into the second floor of the five-floor installation *lignum*, 2002 (pictured above; also see pp. 30–31).

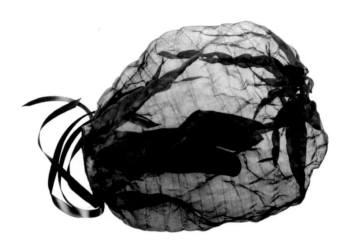

title	*(whitecloth · muff, left)* (above) \| *(whitecloth · muff, right)* (not illustrated)
date	1999
medium	silk organdy, thread, ribbon, glass shelf
dimensions	5 × 7½ × 12 inches / 12.7 × 19.1 × 30.5 cm (muff) (each), ⅜ × 20 × 15 inches /
	0.95 × 50.8 × 38.1 cm (shelf)
collection	The Barrett Collection, Dallas, Texas \| Collection of the Munson-Williams-Proctor
	Arts Institute, Museum of Art, Utica, New York

A pair of black organza gloves, each afloat within a black organza muff, were separated from each other within Hamilton's 1999 *whitecloth* installation. One was exhibited on the ground floor, its mate one flight up. The glove/muff on the ground floor was installed on a low glass shelf. It offered a "veiled view" of the interior glove, and, as a costume implying "widow's weeds," it related to the death-invoking blood-like red ink-stained windows of the same room.

Hamilton had similarly separated the pair of embroidered gloves for *slaughter*, 1997, placing each in a separate vitrine (see pp. 164–165). In addition to physically separating the left and right gloves within their separate muffs, the way the muff is made (one end of what is usually a two-sided entry into the cloth passage is sewn shut) assures, as Hamilton says, that "no single hand can ever meet the warm reciprocal hand that might normally insert from the other end of the muff, evoking the finger holes in the table at the Museum of Contemporary Art, Los Angeles, where you insert your hand but can never touch the water—promises unfulfilled?" (See pp. 72–73.)

title	*(whitecloth · self-portrait)*
date	1999
medium	black and white pinhole-camera photograph
dimensions	1 × 2 inches / 2.5 × 5.1 cm (image), 17 × 13 ½ inches / 43.2 × 34.3 cm (paper)
collection	Private collection

The first of what would become a continuing series, this work is a small self-portrait, taken with a pinhole-camera, which Hamilton fashioned out of a plastic film canister and held inside the cavity of her mouth. She opened her mouth as if to speak, thereby allowing light into this chamber and exposing the film. To set up this shot and capture her own image, Hamilton used a round hand mirror. The small photograph is presented by Hamilton matted within a larger field, a practice she would continue with subsequent pinhole-camera works.

Hamilton herself becomes the camera when making these photographs. She uses her lips as the "camera" shutter, the light having entered the chamber of her mouth and exposing the film through the pinhole in the canister, where the small strip of film is placed. Hamilton's mouth thus becomes, in effect, an eye. In this exchange of one sensory organ for another, the orifice of speech becomes a vehicle for sight. The resulting horizontal image exposes the outline of Hamilton's open lips as a shape resembling an eye, wherein the centered photographic subject replaces the pupil. In the relationship between image and word, Hamilton's work reveals a close reading of Emerson, who in his essay "Circles" wrote, "The eye is the first circle; the horizon which it forms is the second; and throughout nature this primary figure is repeated without end." See also Hamilton's 1999 *portal* series (pp. 194–197) and her 2001 *Face to Face* series (pp. 214–219), and *face...*, 2000–2003 (pp. 234–237).

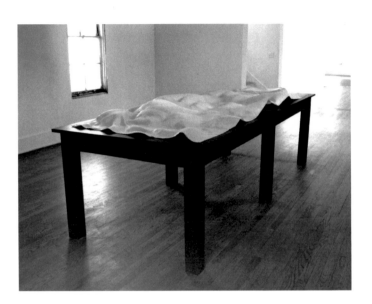

title	*(whitecloth · table)*
date	1999
medium	wood table, steel, silk, magnets, electric blower fan, ducting,
dimensions	33 × 48 × 120 inches / 83.8 × 121.9 × 304.8 cm (table), variable (overall)

Several white cloths characterized The Aldrich Museum of Contemporary Art's installation. One was the darting white cloth (actually a pair of them) moving through the house on a cable (pp. 174–175). Another was the cream white wool cloth lined with white silk that covered a ledger for *(whitecloth · book)* (pp. 172–173) and a similar cloth that covered the video screen set of *(reserve · table · video/ writing)*, 1996/1997 (pp. 146–147). Still another was a large white silk cloth that hovered above a wood table. This silk cloth undulated as it floated just above the surface, held aloft by the air drawn from outdoors and channeled through a subterranean system with an electric blower and ducting, sending the air up through the legs of the table, and finally releasing it through tiny holes drilled in the table's steel surface. Small magnets at strategic points tethered the cloth to the table. In the lineage of Hamilton's animated tables—*(reciprocal fascinations · table)*, 1985 (pp. 56–57) and *(the capacity of absorption · table)*, 1988 (pp. 72–73)—this one played off the nineteenth century's spiritualist séances, "speaking" across the divide to dead souls, with attendants gathered around a table.

title	(whitecloth · tub)
date	1999
medium	copper tub, water, audio tone generator, amplifier, subwoofer speaker, 12 motion detectors
dimensions	11 ¾ × 24 inches / 29.8 × 61 cm (tub diameter)

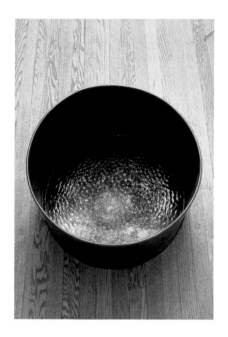

The water in this tub is animated when triggered by the vibrations of a sub-woofer speaker carrying a frequency produced by an audio tone generator that ripples and roils the water's still surface. As installed at The Aldrich Museum of Contemporary Art, the base of the tub was several inches below the floor plane but filled so that the water line was level with the floor. Motion detectors were set at 13 windows, and when the white cloth, moving on its cable, passed one of these motion detectors, it set off sound waves from the underground audio tone generator, which caused the water's movement. Here, as in many of Hamilton's other works, light was linked to touch and voice to water.

title	*(whitecloth · video)*
date	1999
medium	video, color, sound, 30:00 (loop); LCD screen; laser disc; laser disc player
edition	3 with 2 Artist's Proofs. Published in 1999 by Sean Kelly Gallery, New York
dimensions	15 inches / 38.1 cm (screen)

For this video, Hamilton used a pixel vision camera, which is an early plastic video camera manufactured by Fisher Price for children. The image frames the side pocket of a pair of pants from a man's business suit, worn by Hamilton. She is slowly sloshing her hand in a pocket filled to the brim with honey. Over the course of the video, the honey stains and wets the outside of the pants. In the original installation, the sound of the sensuous, thick, wet material sloshing in the pocket was the only sound in that part of the installation, where it was a reference to the sexual, corporeal body markedly absent in the rest of the installation, which was keyed to New England Puritan references and signaled especially in the Cotton Mather sermon against physical displays, including a prohibition against dancing.

title	*crease	fold	furrow	part*
date	1999			
medium	Iris print on Arches Cover Paper			
edition	20 with 8 Artist's Proofs (each). Copublished in 1999 by Sean Kelly Gallery, New York and			
	the Institute for Electronic Arts, Alfred, New York			
dimensions	11 × 17 inches / 27.9 × 43.2 cm (image), 34 × 37 inches / 86.4 × 94 cm (paper)			
other	Printed with an IRIS 2047G Graphics printer using continuous tone technology and			
	Equipoise inks			

These four different and independent works were printed at the Institute for Electronic Arts in 1999. They bear the same texts—Ralph Waldo Emerson's essay "Circles" and Ann Lauterbach's poem "And the Question Of"—written in the cursive hand that Hamilton also used for the writing of a Cotton Mather sermon in *(whitecloth · book)*, 1999 (see pp. 172–173). The titles *crease* and *fold*, according to Hamilton, "describe the process that created the 'joint' that bisects each print vertically. When the right side is right-reading, that is legible (and in beige) and the left side is a mirror image, it is called *crease*. When the left side is right-reading and legible (and in beige) and the right side is in mirror image, it is called *fold*. The texts are the same on the prints *furrow* (right side legible) and *part* (left side legible), which are printed in red."

For these prints, Hamilton scanned and inverted the writing so that the legible original placed either on the right or left side is mirrored on its opposite side, "as if trying to get to something else/more/different than what it is words do as they wind tendrils through our experiences . . . the line of writing extending across the body of the page like a vine growing across a building's surface."

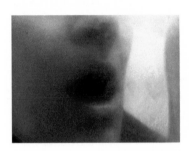

title	*mirrim*
date	1999
medium	Iris print on Arches Cover Paper
edition	40 with 11 Artist's Proofs. Published in 1999 by the Institute for Electronic Arts, Alfred, New York for a fundraiser for Artists Space, New York
dimensions	10 × 13½ inches / 25.4 × 34.3 cm (image), 30 × 22 inches / 76.2 × 55.9 cm (paper)
other	Printed with an IRIS 2047G Graphics printer using continuous tone technology and Equipoise inks

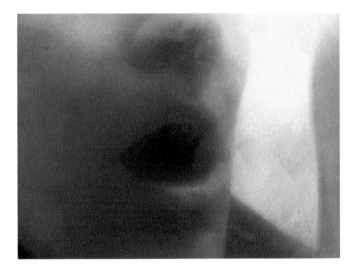

The title, *mirrim*, a palindrome, is a word made up by Hamilton, a "reflection of mirror's first syllable," a "reciprocity" derived from "a whisper of mirror and rim." The image derives from Hamilton breathing onto a copper mirror she had received as a wedding present. One side of the mirror is smooth and polished, and this is the side on which Hamilton was breathing, "to try to gather the image." Hamilton says, "It goes back to an early and failed attempt to do the same thing on a pane of glass in the freezer lockers at the local grocery store distribution center during my Wexner residency." This work is an early instance of Hamilton's preoccupation with the material evidence of breath (see in particular *up*, 2003 [pp. 232–233]) and the variants of the "paper-dropping" machines that Hamilton also associates with this concept (pp. 224–225, 240–241).

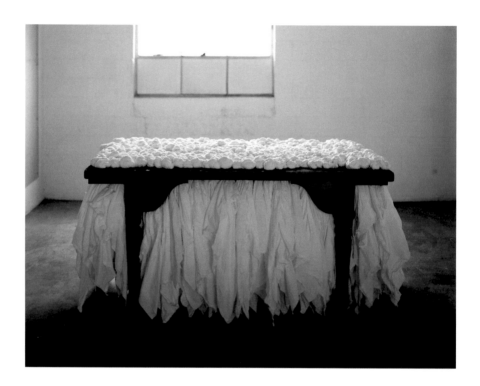

title	*(myein · table)*
date	1999
medium	wood, cotton
dimensions	36 × 72 × 42 inches / 91.4 × 182.9 × 106.7 cm
collection	Private collection, New York

This wood table was sited in the courtyard at the entry to the United States pavilion as part of Hamilton's installation for the 48th Venice Biennale in 1999 (photographed in the artist's studio, left). Its surface was drilled with holes, through which Hamilton threaded white cloths (that were also echoes of her *whitecloth* installation at The Aldrich Museum of Contemporary Art that same year). Here, the number of white cloth elements was multiplied, with each threaded through holes drilled in the table's surface, allowing one part to hang freely below, "dripping" in a sense, as earlier Hamilton tables had "leached" their contents in *between taxonomy and communion*, 1990 (see pp. 84–85) or *offerings*, 1991 (pp. 92–93), yet paradoxically anchored with a knot resting on the table's surface. The large spherical cloth knots create a dense minimal repetition over the top of the table and at the same time recall "the planets on the table" of Hamilton's installation *lineament*, 1994 (see pp. 122–123). For Hamilton, these were also a memory of the ancient quipu tradition in which record-keeping was evidenced by the pattern of knots tied in a string.

1 2

title	*portal 1–20*
date	1999
medium	20 framed and matted black and white photographs
edition	2 with 1 Artist's Proof (each). Published by Sean Kelly Gallery, New York
dimensions	1¾ × 4 inches / 4.4 × 10.2 cm (image), 14½ × 12 inches / 36.8 × 30.5 cm (framed)
other	One of the editions was kept together as a set; the other set has been divided

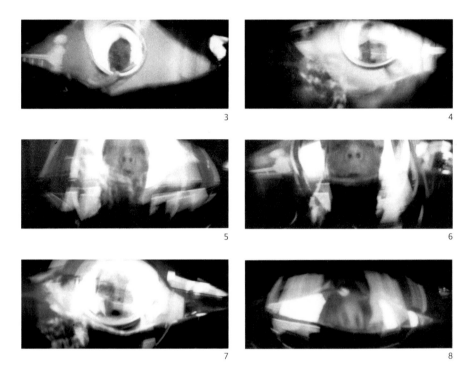

3

4

5

6

7

8

In these works, Hamilton continues the practice of taking photographs by using a mouth-held pinhole-camera that she made by precisely reworking disposable plastic film canisters to create the minute apertures in their surfaces, as she had first done in *(whitecloth · self-portrait)*, 1999. All of the portal photographs are variations, as Hamilton says, "of my looking at myself in the mirror with my mouth falling open to light—the site of language becoming a place of image. I was trying initially to capture an immersive rather than a self-conscious gaze." From a large number of *portal* images, Hamilton selected twenty for this edition. See the earlier discussion of *(whitecloth · self-portrait)*, 1999, pp. 180–181, a work for which Hamilton first used the pinhole-camera. To establish "a portrait size proportion" these images were presented by Ann Hamilton within a large matting similar to how she has presented other of her pinhole photographs (see pp. 214–219).

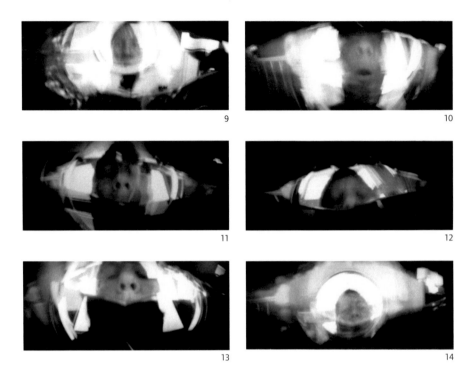

9

10

11

12

13

14

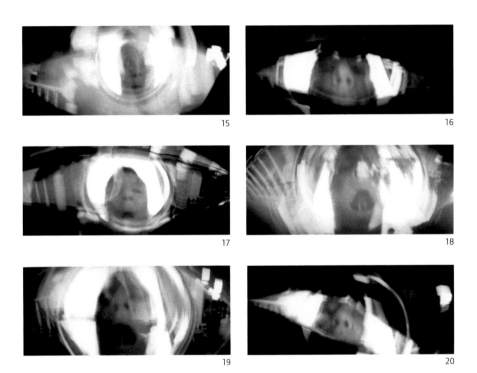

15

16

17

18

19

20

title	*awaken*
date	2000
medium	wool blanket hand-stitched with text of Susan Stewart poem's "Awaken," wool, cotton thread, portfolio box
edition	50 with 10 Artists Proofs. Published by Cypher Editions, New York
dimensions	60 × 84 inches / 152.4 × 213.4 cm (blanket), 22 ½ × 22 ½ × 2 ½ inches / 57.2 × 57.2 × 6.4 cm (box closed)

Embroidered with the words of Susan Stewart's poem "Awaken," this functional blanket recalls the use of multiple blankets Hamilton employed for *appetite*, 1998, a collaboration between Ann Hamilton, Meg Stuart, and the seven dancers in Stuart's dance company Damaged Goods. For *appetite*, each blanket was folded, banded, and placed on theater seats before the performance began. As the members of the audience took their seats, they had to first sort out what to do with these cloths, similar to how the dancers on stage had to engage many different textiles that were part of the dance piece.

For this poetry-faced blanket, Hamilton used the same cursive writing as she had used for the backs of mirrors, thimbles etched with Susan Stewart's poem "Cinder" (see pp. 170–171), organza gloves bearing Stewart's poem "Slaughter," the Cotton Mather sermon used in *(whitecloth · book)*, 1999 (pp. 172–173), and the four different series of prints produced at the Institute for Electronic Arts in 1999 (pp. 188–189). For all of these works, Hamilton says, "The words are written out in one continuous line wherein the line of one letter intersects or touches the adjacent letter and thus collapses the space that gives the letter forms their legibility."

title	*flectere*
date	2000
medium	Iris print on Aquarelle Arches paper
edition	70 with 5 Artist's Proofs. Published in 2000 by the Institute for Electronic Arts, Alfred,
	New York and Ann Hamilton in support of Ann Hamilton's Venice Biennale installation *myein*
dimensions	11 × 11 inches / 27.9 × 27.9 cm (image), 30 × 22 inches / 76.2 × 55.9 cm (paper)

This Iris print was published in 2000 marking the occasion of Ann Hamilton's 1999 Venice Biennale installation, *myein*, for the United States pavilion. It was published by the Institute for Electronic Arts and Hamilton to thank those who helped in the production of *myein*.

Working with a photographer (Aaron Igler) from The Fabric Workshop and Museum, Philadelphia, Hamilton created this image using the glass that was selected to construct the gridded steel and glass wall at the entry to the court-yard of Hamilton's *myein* installation in Venice. Hamilton asked the photographer to hold the camera at her chest so that one wouldn't see it in the reflection, and to aim it at the pile of glass inside the pavilion awaiting installation outside. "There were many, many layers of glass leaning against a table and catching the light coming in from the skylights. The layers of glass were reflective and Hamilton's later series of prints gathers together different moments of shifting light and figure; their titles record the regular time intervals at which the photographs were taken" (see pp. 210–211).

title	*(ghost . . . a border act · spinning video)*
date	2000
medium	variable speed electro mechanical spinning unit with video projector mount, wood and Plexiglas vitrine, DVD player, projector, DVD, 30:00 (looped)
dimensions	15 × 15 × 48 inches / 38.1 × 38.1 × 121.9 cm (vitrine), variable (overall)

For her installation *ghost . . . a border act*, 2000, sited in a recently closed textile factory (as part of the group exhibition "Hindsight/Foresight: Art for the New Millenium" organized by the Bayly Art Museum, University of Virginia, Charlottesville), Hamilton created two suspended nine-foot-high organza rooms,

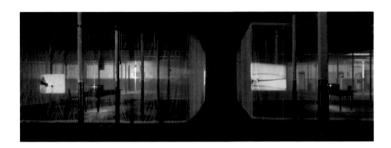

with a corridor between them. In each was a table on which sat a video projector (itself within a zoetrope-like structure) that revolved on a mount. The projectors turned, as Hamilton says, "at the pace of a slow walk."

The visitor standing in the corridor between the two rooms would understand that in one of them, the video projected a line being written (and seen circling the walls of the room beyond, and through, the organza walls, in a counterclockwise fashion). In the other room the video was played backward so that its image was of a line unwritten (the throw of this projector circled the room in a clockwise direction).

For this object, the projected image likewise passes through a Plexiglas vitrine, which surrounds the projector. "Its four-cornered shape," as Hamilton notes, "refracts, doubles, and mirrors, so as the primary projection moves around the room, it is both trailed and chased by its own reflection."

The sounds of the video are of pencil against paper, which was a recording of the sound of the image's making. This video was also used in Hamilton's collaboration with Meredith Monk, *mercy*, 2001, and a variant with a thicker line, this time drawn with a pen with a shiny, highly polished nib (so that it reflects light and in some ways appears like a mirror), titled *(linea · spinning video)*, 2005 (pp. 248–249) was included in Hamilton's installation in Puerto Rico, *linea*, 2005 (p. 25). The same video was also included as part of her next installation, *phora*, at La Maison Rouge, Paris in 2005. See also description, p. 205.

title	*(ghost . . . a border act · video)*
date	2000
medium	video, color, sound, 30:00 (loop); LCD screen; DVD; DVD player; fascia plate
edition	3 with 3 Artist's Proofs. Published in 2000 by Sean Kelly Gallery, New York
dimensions	15 inches / 38.1 cm (screen)

See description of video in *(ghost . . . a border act · spinning video)*, 2000, pp. 202–203. This video was also exhibited as part of Ann Hamilton's collaboration with Meredith Monk, *mercy*, which had its premier at the American Dance Festival, Duke University, Durham, North Carolina, in 2001. A turning point in Hamilton's work, the drawing and the video were made by Hamilton with a newly acquired camera, and by "using a large piece of paper on one of my largest tables." To make the video (and the drawing), Hamilton held the video camera in her left hand and a pencil in her right hand and ran around the perimeter of the table (sometimes being chased by her son, Emmett). "It is my trying to draw . . . finding how hand and breath and live time meet in attention to leave a trace that is unrepeatable." Hamilton similarly found a drawing process of her own, which was used in the installations *parallel lines* in 1991 and *accountings* in 1992 (pp. 96–97), where she smoked the walls with soot.

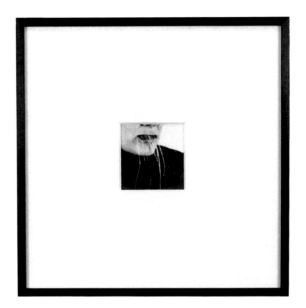

title	*Untitled*
date	2000
medium	black and white photograph
edition	15 with 5 Artist's Proofs. Published in 2000 by Sean Kelly Gallery, New York
dimensions	3⅞ × 3⅞ inches / 9.8 × 9.8 cm (image), 16 × 16 inches / 40.6 × 40.6 cm (framed)

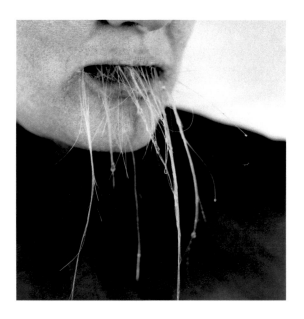

In this photograph, also a self-portrait, Hamilton bears in her mouth not a pinhole-camera (as in her other contemporaneous photo works) but rather an orthodontic mold of the interior of the mouth stitched with strands of horsehair that emerge from her mouth like drippings, an expulsion both surreal and grotesque. "I was thinking here about what happens when something categorically outside, like hair, comes from the interior." Unlike the related object *scripted*, 1997 (pp. 162–163), where hair threaded through minute holes in a thimble extended the fingers' reach in a whip-like form, here the animal hair leaches saliva from the interior of the body, thereby placing at the orifice of spoken language both animal material and bodily fluid.

| title | *written* | *wreathe* |
|---|---|
| date | 2000 | 2001 |
| medium | blind debossment on Hahnemuhle Copperplate paper |
| edition | 80 with 20 Artist's Proofs (each). Published in 2000 by Gemini G.E.L., Los Angeles (*written*) | |
| | 45 with 8 Artist's Proofs (each). Published in 2001 by Gemini G.E.L., Los Angeles (*wreathe*) |
| dimensions | 22 × 30 inches / 55.9 × 76.2 cm (paper), 17 × 21 inches / 43.2 × 53.3 cm (debossment) | |
| | 22¾ × 30½ inches / 57.8 × 77.5 cm (paper), 21 × 28½ inches / 53.3 × 72.4 cm (debossment) |

In these related Gemini G.E.L. editions, *written*, 2000 and *wreathe*, 2001, the
line of Hamilton's looping script is the debossed outline of a space—more com-
monly understood through the bookbinding term blind-stamped, which notes
a shallow negative space, an impression into the work's surface. The process
began with Hamilton writing out her own associative, stream-of-consciousness
flow of words, including repetitions and reversals (and, related to the latter, a
change of direction in the writing itself to confound the top and bottom of the

page). Hamilton perceives the printing process as that of "biting the paper," not
unlike the process she used in her installation *between taxonomy and communion*,
1990, where she hammered metal letter stamps into the wall, leaving their deep
impressions to write the titles of hundreds of animal fables and folktales.

The writings here relate to Hamilton's unbroken line of writing for the
Cotton Mather sermon written and inked in a ledger for *(whitecloth · book)*, 1999
and the writings for her 1999 series of four prints, *crease*, *fold*, *furrow*, and *part*
(see pp. 188–189). Hamilton has likened the field created by these continuous
connecting lines to branching organic forms, tendrils of plants, sinuous veins of
a circulatory system—and she continues with these works to further emphasize
the space "between" so that "the words lose the space that separates and makes
them legible to become one more engulfment—like the vortexes, or the spinning
curtains . . . here swarming across the page's surface."

Both *written* and *wreathe* are written using the same stream-of-consciousness
flow to elicit the wording, but the texts are different in each print. For *written*,
the image is of a single debossment of its plate. For *wreathe*, the image is a
double impression or debossment of its plate "blind-stamped twice;" the plate
used for the first impression was turned 180 degrees and stamped again.

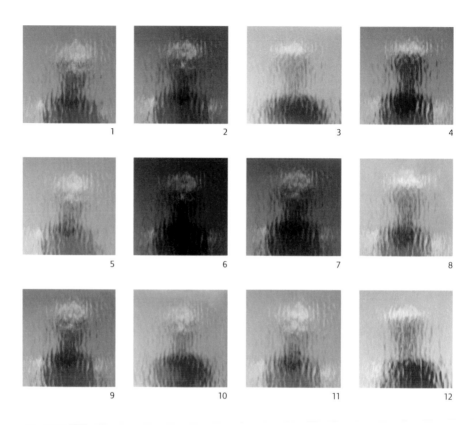

title	*reflection (12:00, 12:05, 12:10, 12:15, 12:20, 12:25, 12:30, 12:35, 12:40, 12:45, 12:50, 12:55)*
date	2000
medium	Iris print on Arches watercolor paper
edition	12 prints, each in an edition of 10 with 5 Artist's Proofs. Copublished in 2000 by Sean Kelly Gallery, New York and the Institute for Electronic Arts, Alfred, New York
dimensions	24 × 24 inches / 61 × 61 cm (image), 47 × 34 inches / 119.4 × 86.4 cm (paper)

For her installation *myein* in the United States pavilion for the 1999 Venice Biennale, Hamilton worked with the building's structure, its recently renovated and unmasked skylights, and its parallel wings extending to form an open

courtyard bounded at three sides. Hamilton created a fourth room of sorts, open to the sky, by building a freestanding fourth wall of gridded steel and glass. When the glass was stacked inside the pavilion under the skylights awaiting installation, Hamilton, used to thinking about the glass's transparency, was struck by its reflectivity. She worked with a photographer (Aaron Igler) from the Fabric Workshop and Museum, Philadelphia, to record the reflection she saw of herself in the cache of glass (without showing the camera itself in the reflection). While Hamilton used one of these images for her print *flectere*, 2000 (see pp. 200–201), for this *reflection* edition she selected twelve images, shot at intervals and titled in five-minute increments. Each literally captures shifting light, and the thereby changing figure.

Collectively, the images carry a trace of the slow time of attention made present in material marks within the installation where cascades of fuchsia-pigmented powder filtered down the walls, dusting them, collecting on the topmost surface of plaster dots (that bespoke in Braille a Charles Reznikoff poem), and pooling on the floor (see p. 13). All of this was perceived in the changing "weather" conditions of the room's atmosphere, amplified by the shifting illuminations under the room's skylight.

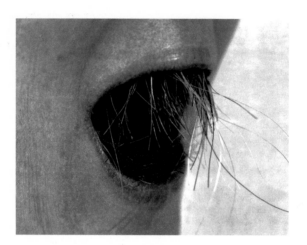

title	*commute · I*	*commute · II*
date	2001	
medium	Iris print on Arches watercolor paper	
edition	10 with 6 Artist's Proofs (each). Copublished in 2001 by Sean Kelly Gallery, New York and the Institute for Electronic Arts, Alfred, New York	
dimensions	30 × 39 inches / 76.2 × 99.1 cm (image), 34 × 46 inches / 86.4 × 116.8 cm (paper)	30 × 41¼ inches / 76.2 × 104.8 cm (image), 34 × 46 inches / 86.4 × 116.8 cm (paper)

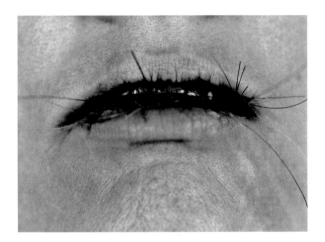

The Iris prints *commute · I*, 2001 and *commute · II*, 2001 are made from photographic images taken at the same time as *Untitled*, 2000 (see pp. 206–207), where Hamilton held in her mouth an orthodontic mold stitched with horsehair. In particular, *commute · I* looks like an "eye," evidence of Hamilton's ongoing concern with exchanging the productive functions and visual implications of sensory sites, the "shifting of eye, mouth, vision, speech."

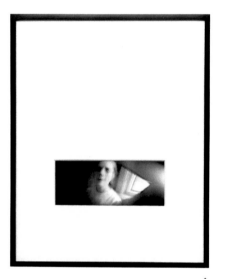

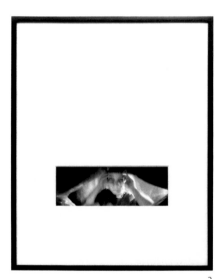

1 2

title	*Face to Face · 1–67*
date	2001
medium	pigment print in wood frame
edition	3 with 2 Artist's Proofs (each). Published in 2001 by Sean Kelly Gallery, New York
dimensions	variable × 10 inches / variable × 25.4 cm (image), 22 × 18 inches / 55.9 × 45.7 cm (framed)

For *(whitecloth · self-portrait)*, 1999 (pp. 180–181) and the related *portal* series of photographs from 1999 (pp. 194–197), Hamilton placed a pinhole-camera within the cavity of her mouth to capture her reflection in a handheld mirror. For the *Face to Face* series, Hamilton uses the same process but directs her focus outward. As in the previous works, "The orifice of language becomes the orifice of sight. . . . A small pinhole-camera is placed within the mouth's interior. When the cavity of my mouth opens to light, the film is exposed. The resulting image is a trace presence of the time of standing or sitting face-to-face with a person . . . or a landscape."

The process of taking these photographs puts the subject and artist in an equivalent space, in a sense mirroring or miming each other's position, and, critically, in an intimate distance from one another (less than a foot apart). For some, this is an uncomfortably close distance, for others an impressive silent exchange, the arrested moments of a dance duet. Hamilton notes the cultural taboo of the "open mouth, which should never be left agape," which is here put to use as a productive function.

One might also note, from the point of view of the subject, a different kind of disjunction: seeing "eye"-to-"eye" with Hamilton in this paired posture, one stands face-to-face, connected by a mutual, breath-holding, eye-to-eye contact, the "stare" (in most other contexts, also impolite) here integral to the process while also inflected by a curious scanning (so as to take in the larger field-importantly, also her mouth, a competing "eye"). Within the time it takes for the exposure to register (between 5 and 20 seconds)—light passing through the pinhole in the plastic film canister to the small piece of hand-cut film therein—one finds one's attention doubled, and shifting. One shares a mutual gaze, looking at and with, while also momentarily looking away, and breaking that concentration or eliding it as part of a larger focal view. In looking at someone else "face-to-face," a direct address is evident that had not been present in Hamilton's work before.

This selection of 67 *Face to Face* prints, of which 34 are reproduced here, are from an ongoing series of photographs. Though the "camera" and method used here are the same as in the self-scrutinizing *portal* series (each photograph as finally printed measured 1¾ × 4 inches / 4.4 × 10.2 cm [see p. 194]), the images in the *Face to Face* series are larger (reflecting the variability of hand-cut film, the image heights are variable but are printed to have a consistent width of 10 inches / 25.4 cm). In the *Face to Face* prints, Hamilton continued the investigations of the *portal* series, but the turn in gaze is critical.

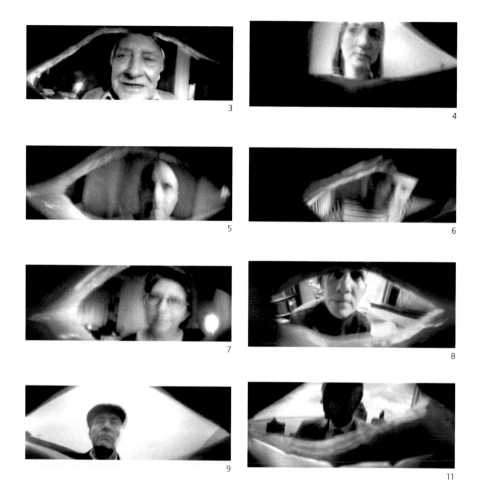

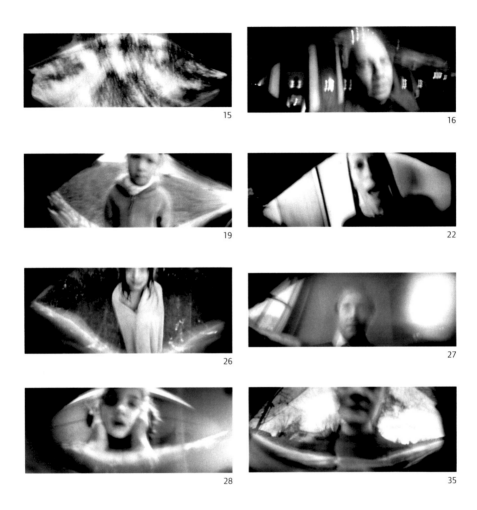

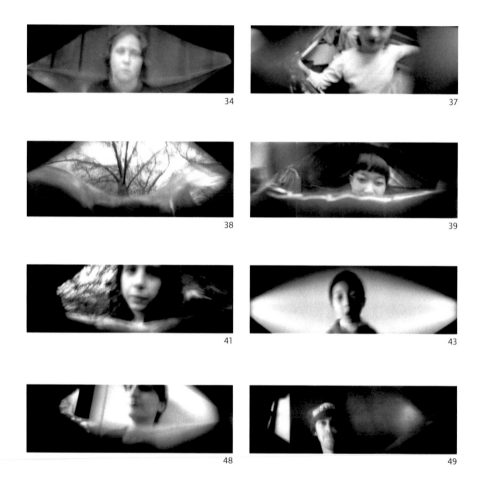

34

37

38

39

41

43

48

49

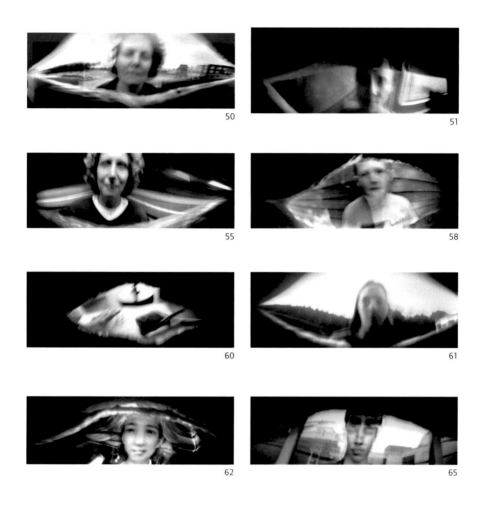

50

51

55

58

60

61

62

65

title	*(the picture is still · video)*
date	2001
medium	video, black and white, sound, 12:00 (loop); LCD screen; DVD; DVD player; fascia plate
edition	3 with 2 Artist's Proofs. Published in 2001 by Sean Kelly Gallery, New York
dimensions	15 inches / 38.1 cm (screen)

For her installation *the picture is still* at Akira Ikeda Gallery, Taura, Japan in 2001, Hamilton, using an inexpensive single-chip surveillance camera for the first time, made videos by moving her hand slowly over the surface of a black and white photograph—"almost caressing the image, as if touching or probing its flat surface to yield something more bodily." Hamilton has likened the fluidity of using the tiny video surveillance camera to working with a pencil in the hand. Here, the appendage of touch becomes the "eye" just as the organ of speech, the mouth, became an "eye" in her pinhole-camera series (see pp. 194–197, 214–219).

For *(the picture is still · video)*, Hamilton applied her technique of "hand-seeing"—reading, recording, and in effect rewriting—the image by running her hand over the photograph of a child (her son, Emmett). As a consequence of the camera's proximity to the image, it is impossible to recognize a full face or figure. The resulting video image is of an abstracted figure with an open mouth, marking a conceptual shift from the particular to the general.

The close focal distance between hand/camera/eye and image also causes the picture to come in and out of focus, and the flat image of the face to appear to be dimensional. For Hamilton, the process of scanning over the photograph "returns time . . . to what is still . . . as in the title *the picture is still* . . . as in not moving . . . but also as in 'still here' . . . the way history haunts and inhabits the present."

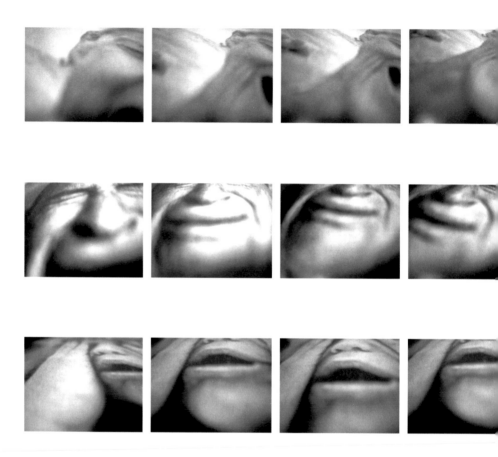

| title | *still · 1 (woman)* | *still · 2 (man)* | *still · 3 (child)* |
| --- | --- |
| date | 2001 |
| medium | video, black and white, sound, 20:00 (loop); LCD screen; DVD; DVD player; fascia plate |
| edition | 3 with 2 Artist's Proofs (each). Published in 2001 by Sean Kelly Gallery, New York |
| dimensions | 15 inches / 38.1 cm (screen) |

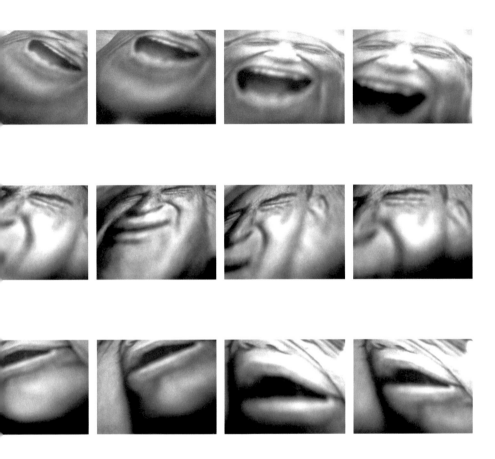

For these three editioned videos, Hamilton used the same process as she had for *(the picture is still · video)*, 2001 (pp. 220–221), holding a small video surveillance camera and running her hand over the surface of a still photograph. Here, however, she used found images rather than a picture of her son. (In the resulting four works, though, all of the images are seen as abstracted and anonymous.) For *still · 1 (woman)*, Hamilton began with a photograph of two women; for *still · 2 (men)*, a photograph of two men; and for *still · 3 (child)*, a photograph of a child. What links them is the ambiguous position of their mouths. "The mouth as much as the eyes is where we read emotion, but here in these images a mouth scanned by the camera can alternately fall from glee to terror, from laughter to a scream."

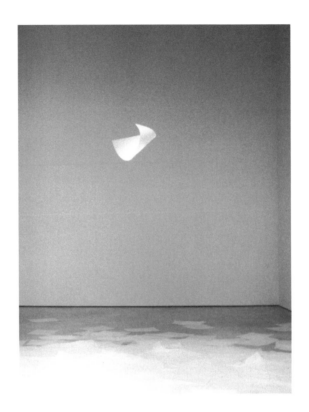

title	*(at hand · voice)*
date	2002/2006
medium	compact disc, 30:00 (loop); compact disc player; amplifier; two cone speakers
edition	3 with 2 Artist's Proofs (each)
dimensions	8 inches / 20.3 cm (each speaker)

For Hamilton's installation *at hand*, 2001, the sounds of a voice (Hamilton's) are heard quietly reading a list of the capacity of the hand and mouth "to act or say or form or do"—such as "a hand offers" or "a mouth opens." During the installation, the sounds of the voice moved from speaker to speaker around the perimeter of a room that was also filled by the sounds of air-powered mechanisms that dropped sheets of thin white paper to float to the floor. The mechanical sounds were generated by the ceiling-mounted device that used air suction to lift a single sheet of white paper (whose edges had been tinted maroon) from a pile, move it across a track, pause, and release it to fall and accumulate with other sheets of paper on the floor.

For the inauguration of this installation at Sean Kelly Gallery, New York, two women (Hamilton and Mary Kelly) performed the text. They were seated on chairs, facing each other, separated by a distance of 15 feet. Hamilton wore a headset with an attached microphone and very quietly read the phrases aloud from a stack of papers on her lap; the papers were then dropped by hand to the floor. The microphone picked up her voice and transmitted it to the pair of cone speakers Kelly held, angling Hamilton's voice with the movement of her hands. Kelly's eyes were closed as she was doing this, as if to better access the faculty of hearing.

In the installation, the same text (recorded separately) was played via 16 speakers set around the room, which were programmed so that the voice changed from speaker to speaker, as Hamilton had done with the presentation of the recorded voice in *tropos*, 1993 (pp. 114–115) and in *myein*, 1999 (p. 13). For this edition, the recording that had been played on each of the speakers during the installation at Sean Kelly Gallery has been edited to play between two cone speakers. From one speaker are heard the phrases which describe the actions of the hand, from the other speaker the phrases referring to the actions of the mouth or voice.

This installation and this text set new directions for Hamilton's work. The installation, like that at the Venice Biennale, engaged the volumetric emptiness of the space, and here, importantly, Hamilton used a text she herself had written, and which she herself read aloud. (The text was a descriptive list of the capacities of the mouth and hand to act: a mouth opens · a hand lifts · a hand signals · a mouth waits · a hand guides · a voice names.) Further, the paper-dropping mechanisms would become elements she continued to use in different quantities in other installations, including *corpus* at MASS MoCA, North Adams, Massachusetts in 2005 (pp. 240–241), where the sheets of paper were white (in comparison to the tinted edges of the papers used at Sean Kelly Gallery).

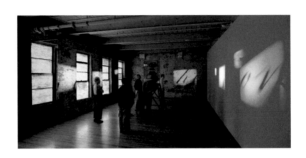

title	*across*
date	2002
medium	three DVD videos: top projector video 13:33 (loop) (boat), middle projector video 17:31 (loop) (carte de visite and calligraphy), bottom projector video 32:59 (loop) (calligraphy), color, sound; variable speed electro mechanical revolving mounts; steel; Lexan enclosure; three DVD players; three LCD projectors; two amplified speakers
dimensions	94 × 48 × 48 inches / 236.4 × 121.9 × 121.9 cm (overall steel tower), variable (room)

Working with materials found in the archives of SPNEA (The Society for the Preservation of New England Antiquities), which collaborated with MASS MoCA on the 2003 group exhibition "Yankee Remix" in which *across* was exhibited, Hamilton made three videotapes and a structure to integrate this video material and its revolving projectors. The structure was a functional steel tower, wider at the bottom, with the legs splayed (in overall form, it is not unlike the wooden lifeguard chair Hamilton used in her 1984 installation *the lids of unknown positions*).

At the topmost part was a clear plastic enclosure, within which were three shelves. Each held a motorized platter, which slowly turned a video projector in a 360 degree revolution. Each of the three projectors displayed a different video—one of a boat, another of a pair of faces from a carte de visite, and the third of a hand writing out a penmanship exercise. With each video looped at a different point, projected at a different scale, and moving at a different speed (though all turn in a clockwise direction), the images pass through and around each other in continually changing relations.

The images move around the room "like revolving planets," as Hamilton says, "the projected images sometimes overlapping, passing through and over each other . . . the light passing through the plastic housing further causes the images to split and refract . . . particularly striking are the passages when two reflected shadows or ghost images of the same subject move in opposite directions toward each other to disappear the moment where they both might meet. . . . Thus the past images slip into invisibility at the moment of the present."

The image of the boat derives from a series of photographs in the SPNEA archive ("Photographs of Sailing Vessels by Nathaniel Stebbins, New England"; silver gelatin prints; Library and Archives Acquisitions); the image of the faces derives from the archive's collection of cartes de visite (Group of Cartes de Visite Portraits, multiple photographers, probably New England, 1860–70; albumen prints mounted on cards; Library and Archives Acquisitions). The SPNEA archive also houses a collection of early penmanship practice books (Group of School Copybooks, 1830–1880; paper). For this project, Hamilton did not videotape the found objects of the copy books but rather recorded an exercise of transcribing them in an engrosser's script, working with calligrapher Sandy Mundy, who also wrote out the text for Hamilton's video *my love*, 2003 (see pp. 238–239).

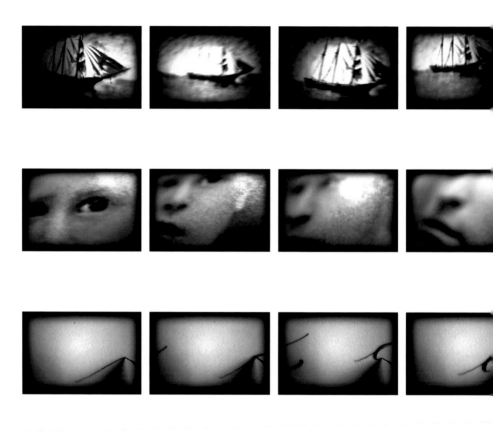

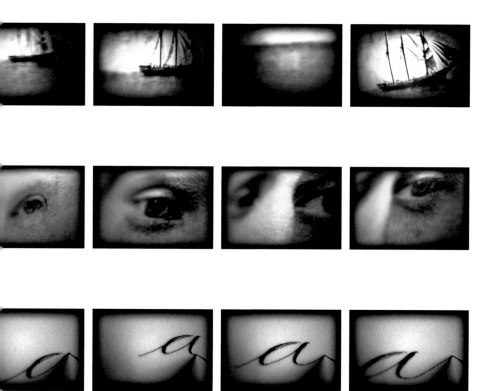

title	*draw*
date	2003
medium	video, color, sound, 70:00 (loop); LCD screen; DVD; DVD player; fascia plate
edition	3 with 2 Artist's Proofs. Published in 2003 by Sean Kelly Gallery, New York
dimensions	15 inches / 38.1 cm (screen)

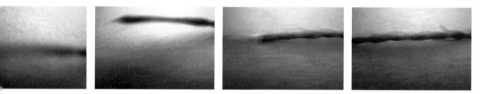

Recorded with a miniature single-chip surveillance video camera, this video follows a running line of red thread as it moves under, up, and under a piece of silk organza. Shot from above the cloth, Hamilton notes, "It is following the tail of the thread." The sound is of the work's making, and at close range amplifies the puncturing of the cloth, as Hamilton "draws" the thread up through the fabric (and also graphically draws a resulting, cumulative, erratic red line). See also Hamilton's *(reserve · video/sewing)*, 1996/2006 (pp. 148–149).

title	*up*
date	2003
medium	video, color, sound, 5:29 (loop); LCD screen; DVD; DVD player; fascia plate
edition	3 with 2 Artist's Proofs. Published in 2003 by Sean Kelly Gallery, New York
dimensions	15 inches / 38.1 cm (screen)

Related to the image of breath taken form in Hamilton's print *mirrim*, 1999 (pp. 190–191), this video was made with a miniature video camera held at the tip of Hamilton's nose. At the same time, Hamilton holds in her mouth a children's toy—an air pipe, which, when blown, buoys a small blue plastic ball aloft at the other end.

In editing the video, Hamilton put together "many single breaths . . . the spastic and erratic movement of the ball is massively turbulent in relation to one's sense or experience of one's breath as a steady stream of air . . . the speed is not manipulated in the video editing . . . the only sound in the video is when the ball drops, and bounces on the floor."

Hamilton's suggested installation height for the 15-inch flat-screen is that it be shown relatively high on the wall—that is, relative to the standard height of hanging a picture. In this configuration, the viewer is looking up somewhat toward the image, unself-consciously assuming the posture of the figure in the video, who is unseen but breathing the ball aloft.

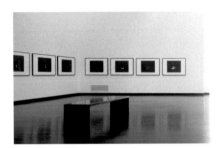 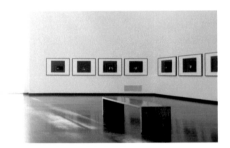

title	*face . . .*
date	2000–2003
medium	color photogravure
edition	20 with 4 Artist's Proofs (each). Published in 2003 by Gemini G.E.L., Los Angeles
dimensions	29½ × 42 inches / 74.9 × 106.7 cm (paper)

ann 1

bobby

carnegie

catherine

emmet

harry p

The images for these editioned works were drawn from an ongoing series of photographs taken by Hamilton with a pinhole-camera in her mouth and standing face-to-face with her subjects (see pp. 214–219). While the images were printed for the *Face to Face* series at 3½ × 10 inches / 8.9 × 25.4 cm and then matted and framed within a field whose outer dimensions are 22 × 18 inches / 55.9 × 45.7 cm (p. 214), they are used here not only in larger format but printed so as to appear to be emerging from an overall black field.

harry r

inigo

jessie

kanae

kristin

mr. innui

mrs.innui

sean

susan

taura 1

taura 2

tom

title	*my love*
date	2003
medium	video, color, sound, 2:46 (loop); ceiling-mounted variable speed electro mechanical spinning mount; DVD; DVD player; LCD projector
dimensions	22 × 18 × 72 inches / 55.9 × 45.7 × 182.9 cm (mechanism), variable (image)
other	collaboration with Michael Mercil

This ceiling-mounted spinning projector was presented for the first time during the summer of 2003 in a collaborative exhibition by Ann Hamilton and Michael Mercil at the North Dakota Museum of Art, Grand Forks. The projected video depicts the Shaker text "my love is increasing," which is from a sacred token, or spiritual gift, dictated in 1857 to Polly Laurence of Hancock, Massachusetts by the deceased Mother Ann Lee and presented to Nancy Oaks, a Shaker disciple.

Mercil used text as material in a number of his works for this exhibition, including a work titled *your dress*, in which a fragment from another Shaker text

was painted onto wallpaper. Hamilton's works in the exhibition included the video *my love*, her *face...* prints from 2000–2003 (see pp. 234–237), and a selection of her earlier work.

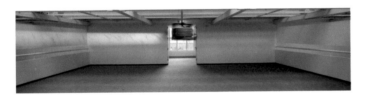

Hamilton's and Mercil's *my love* video, cast across the walls of the room by a spinning projector, depicts an engrosser's pen point very slowly scribing the words "my love is increasing," played as a continuous loop that repeats the sequence from the beginning, to follow, as Hamilton says, "the trajectory of the writing." In her other looped videos, by comparison, a sequence plays forward, then in reverse, then forward again; then it repeats this sequence. (Sandy Mundy, a calligrapher, wrote out the text here and also scribed the penmanship exercises for Hamilton's *across*, 2002 [pp. 226–229].) The mechanism turning the projector changed speed as it rotated in a clockwise direction, from 2 rpm to 33½ rpm (that of a long-playing vinyl record). As Hamilton recalls, it "went from slow to a speed that blurred the image before it slowed again to the pace of the hand writing."

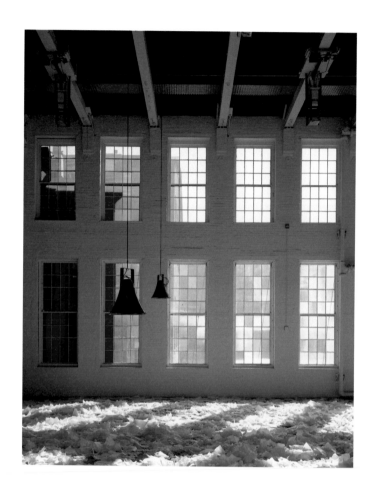

| title | *(corpus · paper dropper)* | *(corpus · sound)* |
|---|---|
| date | 2003/2006 | 2003/2006 |
| medium | ceiling-mounted paper-drop mechanism consisting of a computer-controlled, pneumatically moved vacuum paper lift actuator; compressor; paper (paper dropper) | recorded sound; amplifiers; 24 bell-shaped speakers (sound) |
| edition | 10 with 3 Artist's Proofs (paper dropper) | 2 (sound) |
| dimensions | 48 × 12 × 18 inches / 121.9 × 30.5 × 45.7 cm (paper dropper) | variable (sound) |

This solo "paper-dropping" machine issues as a single element from Hamilton's installation *corpus*, 2004 at Mass MoCA, North Adams, Massachusetts, where she used forty of them. Like the sheets dropped in that installation, these are white (as compared to the stained edges of those used similarly in *at hand*, 2001 at Sean Kelly Gallery). Asked often about the paper's blankness, Hamilton has

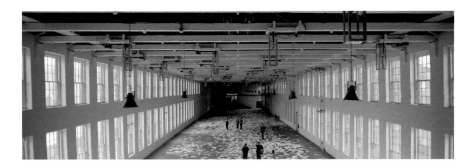

said: "You can see the paper as empty of words or full of space . . . for the blank paper, like the open mouth, is the possibility of speaking or writing."

An audio work—(*corpus · sound*), 2003/2006—also issued from this installation in which sound played a critically important role. In the main hall at Mass MoCA, where the papers were falling, a recording of a 24-part unison vocal piece issued from 24 megaphone-type speakers, slowly raised and lowered together from the ceiling. As Hamilton notes of this complex language/sound/installation sculpture, it employed "a text that I had written, or found, and here this gets complicated because the writing is made up of fragments and slips of words lifted from my reading . . . three words from there, a phrase from here . . . the beginning and ongoing exploration of how the act of reading might become the material of the work . . ."

While the 24-part unison vocal piece by Hamilton is, thus far, the only aural object issuing from *corpus*, the installation also included a second aural component, sited in a different room. To give the installation its full audio dimension, the second component was a song from *mercy*, Hamilton's 2001 collaboration with Meredith Monk. This five-part vocal piece was played on multiple spinning speakers with each of four voices (Katie Kissinger, Theo Bleckmann, Ching Gonzalez, and Meredith Monk) emitted from an individual speaker and the fifth voice (Allison Sniffin) moving between all of the speakers.

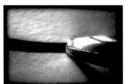 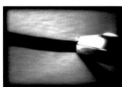 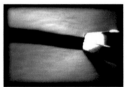

title	*(linea · spinning video)*
date	2004/2005
medium	video, color, sound, 29:00 (loop); ceiling-mounted variable speed electro mechanical
	spinning mount; DVD; DVD player; LCD projector
edition	2
dimensions	22 × 18 inches × variable height / 55.9 × 45.7 cm × variable height (mechanism),
	variable (image)

This video shows a thick black ink line being drawn from the wide stylus of a metal nib pen (distinguishing it from the earlier video used in the installation *ghost . . . a border act*, 2000, where the line is thinner and drawn in pencil [pp. 202–205]). This video was first presented in Hamilton's permanent installation *linea*, 2004, in the Cabo Rojo Lighthouse in Puerto Rico. As in *phora*, 2005, this video was projected from a video projector spinning on a mechanized ceiling-mount; the line moved around the room forming an ellipse (rather than a circle, given the room's rectangular proportion) and was fleetingly "inscribed" on the walls.

The video is edited to play forward, then reverse, then forward, adding to the sense of ongoingness as well as to a sense of vertigo for the visitor watching the changing image from within the surrounding, "circling" line. In the *phora* installation, the video was silent; the accompanying sounds were emitted from four ceiling-mounted spinning speakers (see *(phora · spinning speakers)*, 2005 [pp. 256–257]). As an independent object, *(linea · spinning video)* has sound—the sound of the line's making.

244

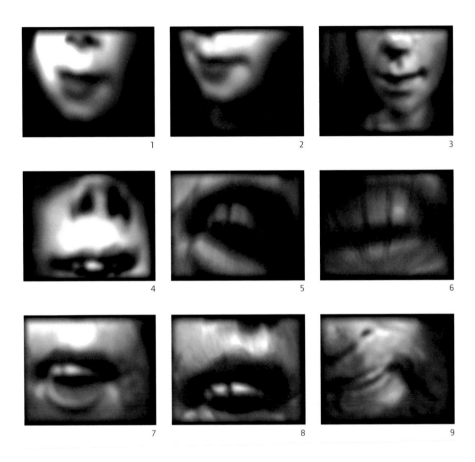

1 2 3

4 5 6

7 8 9

title	*(aloud)*
date	2004/2006
medium	174 Iris Prints on Somerset Velvet paper (Radiant White 330g/sgm)
edition	2
dimensions	33¾ × 46⅛ inches / 85.7 × 117.2 cm (paper)

For each image, Hamilton, with a tiny surveillance camera attached to her hand, passed her hand over the faces of small painted medieval altarpiece sculptures at Stockholm's Museum of National Antiquities. These 174 digital prints, of which the first 39 are reproduced with this entry, are a complete set of all the images that constitute the artist's book *Ann Hamilton: aloud* (Stockholm: Museum of National Antiquities, 2004) (above). A telling example of the relation of object to field in Hamilton's vocabulary (both visual and procedural), this work of 174 images constitutes the "field"—as does the artist's book with the same number of images. The dozen images chosen for *(phora · 1–12)*, 2005 (see pp. 250–253) were selected by Hamilton from the larger, complete field.

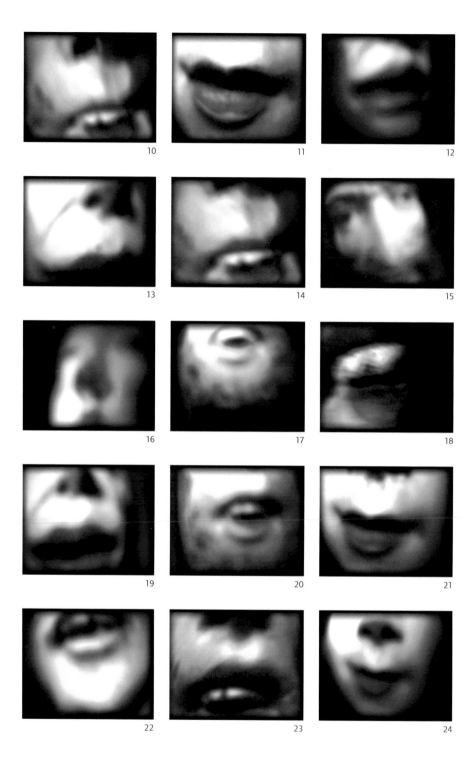

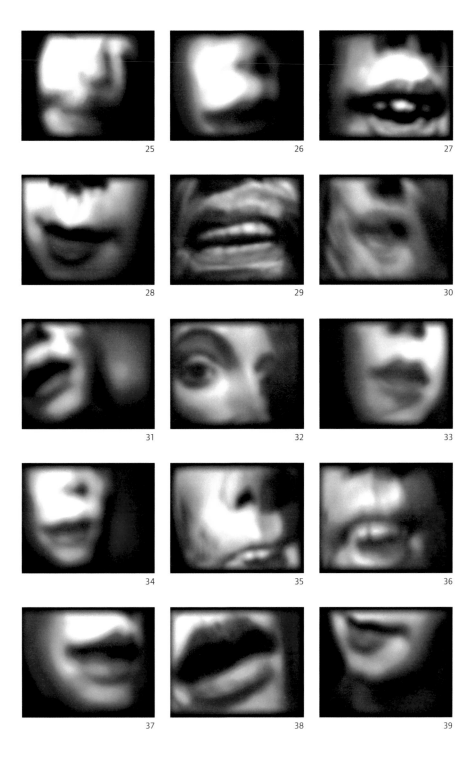

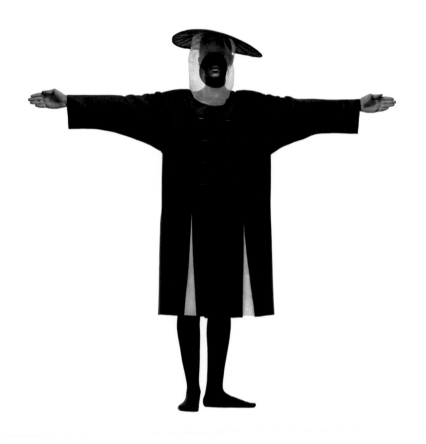

title	*(aloud · coat/hat)*
date	2004/2006
medium	wool felt and silk organza
edition	14 with 2 Artist's Proofs
dimensions	44 × 62 × 1 inches / 111.8 × 157.5 × 2.5 cm (coat), 24 inches / 61 cm (hat diameter), 12 inches / 30.5 cm (veil)

 This edition is based on the 14 wool felt coats with hats that were part of Hamilton's 2004 project *aloud*, set in the Gothic Hall at the Museum of National Antiquities in Stockholm that had been commissioned by Sweden's Statens konstråd (the National Public Art Council). Ann Hamilton worked in collaboration with HV Studio, Marie-Louise Sjöblom, Anna Eriksson, and Gun Aschan to design and construct these wool felt coats and hats. They also custom-dyed the silk cloth which covered the barrel of each wind machine and created a surface friction which filled the hall with the sound of a large and sometimes howling volume of wind.

Hamilton used these fourteen wind machines to form an aisle in the Gothic Hall of the museum, seven per side. The wind machines were hand-cranked by volunteers to "sound the volume of the museum's space." The assembly of volunteers wore these coats and hats, each with a transparent veil, and a large round red circle with a hole over the mouth. As Hamilton's work has turned in new directions—toward voice and an interest in collective or unison speaking—she has at the same time turned back toward her "first hand" and its training in textiles.

250

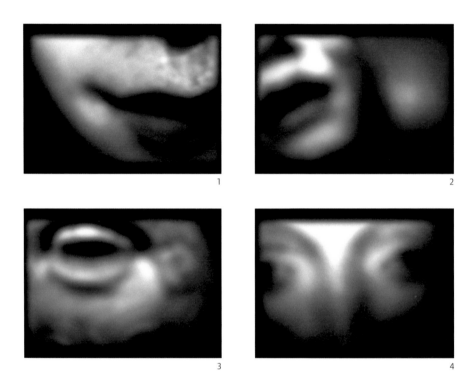

title	*(phora · 1–12)*
date	2005
medium	Iris print on Somerset Velvet paper (Radiant White 330g/sqm)
edition	12 prints each in an edition of 10 with 5 Artist's Proofs. Copublished in 2005 by Sean Kelly Gallery, New York and the Institute for Electronic Arts, Alfred, New York
dimensions	33¾ × 46¼ inches / 85.7 × 117.5 cm (image and paper), 36 × 48½ inches / 91.4 × 123.2 cm (framed)
other	unusual for this printing process, these images are printed edge to edge

These are Hamilton's selections of 12 images from the 174 published in the artist's book *Ann Hamilton: aloud* (Stockholm: Museum of National Antiquities, 2004). Each is a close-up image of the mouth, often distorted, of a painted, medieval sculpture. By recording the images with her miniature video camera at such a close focal distance, Hamilton has turned a conventional figurative religious icon to grotesque animation (further emphasized by the intensely saturated color of the prints, which also strangely "enlivens" them), as she had also turned the genre of self-portrait to invented grotesque figure in *Untitled*, 2000 (pp. 206–207).

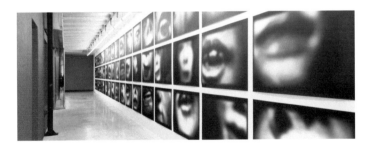

For the 2005 installation *phora* at La Maison Rouge, Hamilton presented the images as 33¾ × 46¼ inch / 85.7 × 117.5 cm Iris prints. Though her intention was to use all 174 images—or as many of them as possible—she ultimately printed 130 of the Iris prints at the Institute for Electronic Arts, the number of units necessary to fill the existing architectural space that surrounds the centrally located red house, from which the foundation, La Maison Rouge, takes its name.

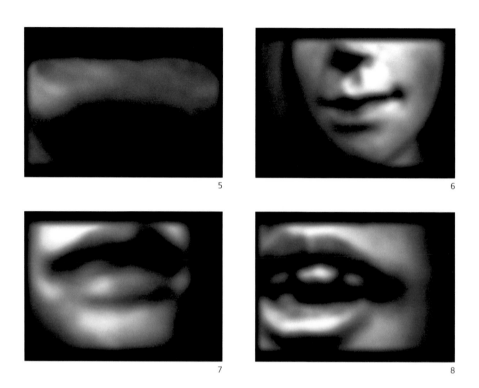

5

6

7

8

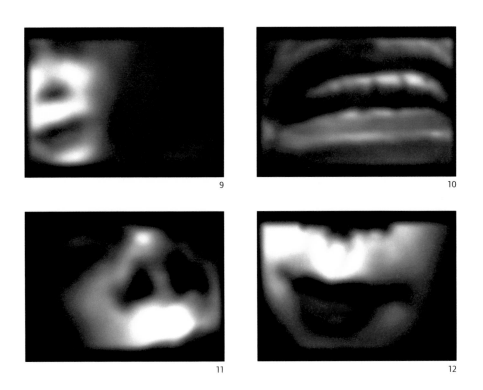

9

10

11

12

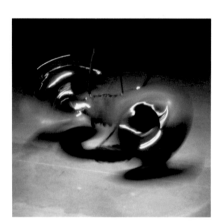 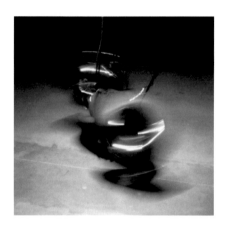

title	*(phora · spinning sousaphone)*
date	2005
medium	ceiling-mounted variable speed electro mechanical spinning unit; double bell sousaphone;
	elastic cord; speakers; CD loop; CD player; amplifier
edition	3 with 2 Artist's Proofs
dimensions	17 × 13 × 20 inches / 43.2 × 33 × 50.8 cm (unit), variable (overall height)
	66 × 30 × 30 inches / 167.6 × 76.2 × 76.2 (sousaphone)

The sounds from this single, partial sousaphone—made from joining the bell ends from two sousaphones so that each "mirrors" the other—are from Hamilton's re-recording of marching bands (for which John Philip Sousa was famous).

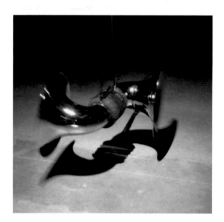 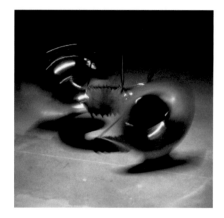

To make the recording, Hamilton used a hand-cranked tube Victrola, which, as its mechanism "wound down," played the sounds ever more slowly and thereby became more and more distorted.

This sousaphone, as originally shown in one of the rooms in Hamilton's *phora*, 2005 installation, was suspended on a line from the ceiling, amidst a surround of clothing donated by the community. The dense layers of clothing were also suspended, but instead of the vertical black elastic line used for the sousaphone, the clothing hung from crosswise lines of sisal rope which originated at wall-mounted tie-offs and passed through ceiling-mounted pulleys. The sousaphone rotated slowly in response to the twisting of the elastic cord suspending it. When the cord twisted taut it stopped, the momentum of stored energy caused the cord to unwind—a movement not unrelated to the winding and playing out of the Victrola.

The polished chrome of the bell ends of the paired sousaphone parts also served as revolving mirrors catching the reflected figure of the visitor standing in front of it, as well as the larger context of the surrounding room. These images alternately appeared right side up or upside down, a sequence of mirroring and of inversion seen elsewhere in Hamilton's work, particularly in the four 1999 prints *crease*, *fold*, *furrow*, and *part* (see pp. 188–189).

title	*(phora · spinning speakers)*
date	2005
medium	two ceiling-mounted variable speed electro mechanical spinning units with tethered
	speakers
edition	3
dimensions	17 × 13 × 26 inches / 43.2 × 33 × 66 cm (each unit), variable from 72–96 inches /
	182.9–243.8 cm (length of speaker arm), 8 inches / 20.3 cm (each speaker), variable (image)

This object is constituted of recorded audio and two spinning speakers (instead of the four speakers that were used in the generative *phora* installation at La Maison Rouge [see pp. 250–253]). The sounds are those of "the harmonics of voices"—three voices (Hamilton's, Dinah Diwan's, and Anne Calas's)—"finding and sounding a common tone." In the *phora* installation at La Maison Rouge, the sounds played from spinning speakers in the same gallery where Hamilton's revolving projector "threw" a line continuously drawing itself around the room (see *(linea · spinning video)*, 2005 [pp. 242–243]).

258

There, here, now, you, I
in this place, speaking,
the things we offer, how
to account, for, each
other, to attend the order
Sounding.

LA. ici - maintenant, VOUS.
moi, nous, je, dans ce lieu,
parlant, ce que nous donnons
comment compter l'un pour l'autre
comprendre l'ordre des choses,
en résonnance, son.

هُناكَ، هَنا، الذَّ نا، أنتَ،
أنتِ، أنتُم، أنتِما، أنا، فِي
هذَ المكان، مُتَّمِتَ سي،
الأشياء التّي نقدّمُها، كيف
نقدّم السماب، لبعضّم البعضّى،
يُتَفِّعُ الأمرَ، يَدُقّ .

title	*(phora · voice)*
date	2006
medium	compact disc, 30:00 (looped); compact disc player; amplifier; three cone speakers
edition	3 with 2 Artist's Proofs
dimensions	8 inches / 20.3 cm (diameter, each speaker)

This audio work is Hamilton's re-editing of one of the audio components of her installation *phora*, 2005 (pp. 32–33). In this recording, three voices speak permutations of a text that Hamilton had written and that had been said aloud in English, French, and classical Arabic. In the installation *phora*, this voice component was heard issuing from spinning sousaphone units in a gallery where the dominant object was a large refugee tent suspended from the ceiling. Ann Hamilton, Dinah Diwan, and Anne Calas are the speakers. (Their three voices, though not the same sounds, were heard emitted from spinning speakers in another gallery of the installation and accompanied the video of the drawn line circling the room. See *(phora · spinning speakers)*, 2005 [pp. 256–257].)

The text of *(phora · voice)* in English is:
there, here, now, you, I, in this place, speaking, the things we offer, how to account, for each other, to attend the order, sounding

The text in French is:
la, ici, maintenant, vous, moi, nous, je, dans ce lieu, parlant, ce que nous donnons, comment compter l'un pour l'autre, comprendre l'ordre des choses, en résonance, son

The text in Arabic is:
*hounàka, houná, El ana,
anta, anti, antoum, antoumà,
ana, Fi hazal makán, moutahaddes,
el achya allati nouquâddimouha,
káyfa nouquaddimou el hisab,
libaadouhoum elbaad, yatatabbaou't
amrou, yattabaou el aṁrou*

"These 24 words in English can be spoken in infinite variants or combinations and some of these possible combinations are what we improvised in three languages . . . we each spoke our own first language and also each other's languages (of the three speakers, only one is trilingual) . . . in this process and through this recording, I came to understand how . . . learning another person's language, learning to speak, is to learn new physical patterns of the mouth, the tongue, the palate . . . how the act of speaking and learning another language is an embodied act . . . an act of empathy . . . is the taking into the body another sound, shape, history . . . might this be the future of the work?"

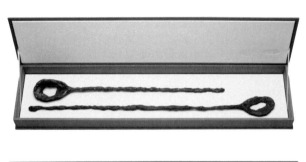

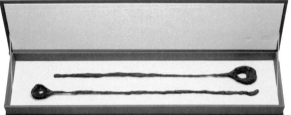

title	*Reach (#1 thru #7)*
date	2005
medium	each work: cast steel, rusted
edition	15 with 2 Artist's Proofs. Published in 2005 by Gemini G.E.L., Los Angeles
dimensions	spoons ranging from the shortest (#1), 24 × 2¾ inches / 61 × 7 cm, to the longest (#5), 30½ × 2¾ inches / 77.5 × 7 cm (both in the upper left box pictured above); 2⅜ × 7¾ × 34 inches / 6 × 19.7 × 86.4 cm (box)
other	Hamilton titled each individual spoon with a graphic mark rather than words: each is titled by the shape of the hole in the bowl of the spoon.

261

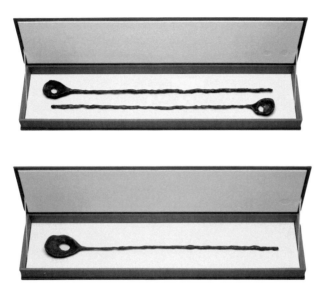

This set of seven spoons, each, according to Hamilton "as long as" her arm is made from clay she modeled and which was cast in steel, then rusted. Each of the seven—one for each of the days of the week—has a hole in its "bowl." As Hamilton notes, "These spoons . . . are part of a history of functional objects that don't quite function and which take their meaning in their manners of dysfunction."

They are set out in three pairs, with the odd spoon remaining alone. Like the prosthetic hand of *(lumen · hand)*, 1995 (see pp. 134–135), each serves to extend reach. Paradoxically, however, by being "at arm's length" (and with a hole in its "bowl"), each also conveys the sense of something kept at bay, deliberately beyond one's grasp.

The spoons are presented in a clamshell box, which Hamilton has used previously as the housing for a poetry-embroidered blanket, *awaken*, 2001 (see pp. 198–199), and for thimbles constructed of photo-etched poetry, *scripted*, 1997 (pp. 162–163) and *cinder*, 1999 (pp. 170–171). Here, as Hamilton says, the spoons "are arranged in the box as if your arms were crossed." With each spoon individually titled with the shape of its hole, this is the first time Hamilton has used an image to title a work.

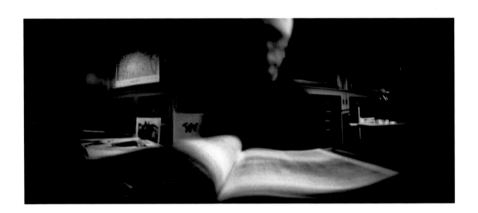

title	*Free Library of Philadelphia, reading · 1, June 2006* \| *Free Library of Philadelphia, reading · 2, June 2006*
date	2006
medium	digital pigment print on Hahnemühle German Etch 330 gsm paper
edition	1 with 1 Artist's Proofs (each). Published in 2006 by Sean Kelly Gallery, New York
dimensions	36 × 84 inches / 91.4 × 213.4 cm

Invited to participate in "Taken with Time," a camera obscura project organized by The Print Center, Philadelphia, Hamilton pursued her ongoing interest in images made as a consequence of a particular circumstance or duration and worked again with a pinhole camera. During several visits to Philadelphia she brought portable pinhole box cameras to historic sites to record the duration of a text read aloud or silently, alone or in a group, privately or to an audience.

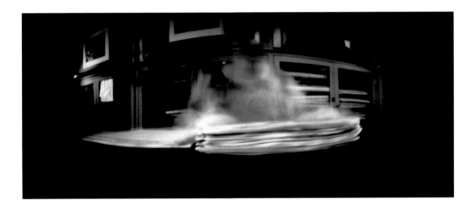

Hamilton's interest in the institutions and locations that house public speaking and reading led to working with individual readers in the Free Library of Philadelphia and with the congregations of Old Saint George's Church and Gloria Dei (Old Swede's) Church in Old City. She also attended and photographed the audience and succession of readers who took part in the Bloomsday celebration at the Rosenbach Museum and Library.

For a series of readings at Carpenters' Hall, Hamilton employed a circular table large enough to seat 10 or 12 people. Participants at the table read out loud and in unison a text of their collective selection. In the middle of the table a panoramic pinhole camera with multiple apertures (built to replace the table's existing "lazy Susan") exposed an image over the duration of a 20 to 30 minute reading. While the architecture remains fixed in these images, the movements of the readers register as ghost-like presences in the foreground.

The five groups who read included a group of religious leaders organized by Old Saint George's Church Reverend Fred Day, art students from Moore College of Art, and librarians from the central branch of The Free Library Philadelphia. Susan Stewart and her family read from the Constitution with Hamilton and her family. Volunteers from The Rosenbach Library read a selection of Phillis Wheatley's poetry.

Chronology
Bibliography
Index of Titles

Ann Hamilton
Chronology

1956	Born in Lima, OH; family moves to Columbus, OH two years later.
1974–1976	Attends St. Lawrence University, Canton, NY.
1977–1979	Attends University of Kansas, Lawrence, KA. Receives BFA in Textile Design, Spring 1979.
1980–1981	Moves to Canada and studies at Banff Centre for the Arts. Marries photographer Bob McMurtry; they separate in 1986 and later divorce.
1981–1983	Lives and works in Montreal.
1983–1985	Attends Yale School of Art and Architecture. Receives MFA in Sculpture, Spring 1985.
1985–1991	Moves to Santa Barbara, where she is Assistant Professor at the University of California, Santa Barbara; leaves California in 1991 to establish residence and studio in Columbus, OH. Represents the United States in 1991 at the 21st International São Paulo Bienal.
1993	Marries artist Michael Mercil; their son Emmett is born in 1995.
1994–1995	Wexner Center for the Arts Residency, Columbus, OH.
1997–1998	Collaborates with Meg Stuart and dance company Damaged Goods; later also collaborates on performances with Meredith Monk (2000–2001) and Alice Waters (2004).
1999	Represents the United States in the 48th Venice Biennale.
2001–	Professor, Ohio State University, Columbus, OH.
2006	Completes commission *Tower*, 1994–2006, Oliver Ranch, Alexander, CA. Between 1989 and 2006 does public commissions in Sausalito, CA; San Francisco, CA; Pittsburgh, PA; New York, NY; Seattle, WA; and San Juan, Puerto Rico.

Commissioned Projects

1989–90	Mess Hall, Headlands Center for the Arts, Sausalito, CA.
1990–95	San Francisco Public Library Commission, The Arts Commission of San Francisco, CA, Ann Hamilton in collaboration with architects James Freed and Kathy Simon and artist Ann Chamberlain.
1994–2001	Allegheny Riverfront Park, The Pittsburgh Cultural Trust, Pittsburgh, PA, Ann Hamilton in collaboration with Michael Van Valkenburgh and Michael Mercil.
1994–2006	*Tower*, Oliver Ranch, Alexander Valley, CA.
1999–2004	Teardrop Park, Battery Park City Commission, New York, NY, Ann Hamilton in collaboration with Michael Van Valkenburgh and Michael Mercil.
2001–03	Seattle Central Library Commission, Seattle, WA.
2003–04	Cabo Rojo Lighthouse, The Public Art Project of Puerto Rico, San Juan, Puerto Rico.

Honors and Awards

1979–80	Scholarship, The Banff Centre for the Arts, Alberta, Canada.
1984	Schnickle-Collingwood Prize, Yale University School of Art, New Haven, CT.

1987 Meet the Artists Fellowship, Santa Barbara Museum of Art, Santa Barbara, CA.

1988 New York Performing Arts Award ("Bessie" award), Creator Category, New York, NY.

1989 Guggenheim Memorial Fellowship, New York, NY.

1990 Louis Comfort Tiffany Foundation Award, New York, NY.
Awards in the Visual Arts 9, Southeastern Center for Contemporary Art, Winston-Salem, NC.

1991 United States Representative, 21st International São Paulo Bienal, São Paulo, Brazil.

1992 Skowhegan Medal for Sculpture, Skowhegan School of Painting and Sculpture, Skowhegan, ME, and New York, NY.

1992 Artist Award for a Distinguished Body of Work, College Art Association, New York, NY.

1993 John D. and Catherine T. MacArthur Fellowship, Chicago, IL.
Visual Art Fellowship, National Endowment for the Arts, Washington, D.C.

1995 Wexner Center Residency Award, Wexner Center for the Arts, Ohio State University, Columbus, OH.

1996 Emil Radok Prize, Multimedia Art, Prague, Czech Republic.

1997 Progressive Architecture Citation Award with Michael Van Valkenburgh Associates and Michael Mercil for the design of the Allegheny Riverfront Park, Pittsburgh, PA.

1998 Larry Aldrich Foundation Award, Ridgefield, CT.

1999 Inductee, Ohio Women's Hall of Fame, Columbus, OH.
United States Representative, 48th Venice Biennale, Venice, Italy.

2000 White House Conference on Culture/Diplomacy, Washington, D.C.
Alumna of the Year Award, Columbus School for Girls, Columbus, OH.

2001 Artist Award of Distinction, National Council of Art Administrators, hosted by Virginia Commonwealth University School of Arts, Richmond, VA.

2002 Honorary Doctorate, Rhode Island School of Design, Providence, RI.
EDRA/Place Design Award, Allegheny Riverfront Park, with Michael Van Valkenburgh, Michael Mercil, and the Pittsburgh Cultural Trust, Pittsburgh, PA.

2003 Honorary Doctorate of Fine Arts, California College of Arts and Crafts, Oakland, CA.

2004 Honorary Doctorate of Fine Arts, Maryland Institute College of Art, Baltimore, MD.
Honorary Doctorate of Fine Arts, Massachusetts College of Art, Boston, MA.

2005 Honorary Doctorate, School of The Art Institute of Chicago, IL.
Governor's Awards for the Arts, Individual Artist Category, Columbus, OH.
Second Place, Award for Best Show in an Alternative or Public Space, International Association of Art Critics, New York, NY.

2006 Ohioana Citation in Arts and Humanities, Ohioana Library Association Annual Award

Solo Exhibitions and Performance Collaborations

An asterisk (*) indicates an accompanying publication in which Hamilton's work is treated (see Bibliography for details of publication). In the case of a traveling exhibition, the organizing institution is listed first, unless otherwise noted.

1981 Walter Phillips Gallery, The Banff Centre for the Arts, Alberta, Canada, May.
Installation: *ground*, 1981. N.B.: This work was untitled until Hamilton named it in 1998.

1985 *The Santa Barbara Contemporary Arts Forum*, Santa Barbara, CA, November 6–17.
Installation: *reciprocal fascinations*, 1985.

1986 *Caught in the Middle*, P.S. 122, New York, NY, March 21–23. Performance/Dance concert in collaboration with Susan Hadley, Bradley Sowash, and Bob de Slob.

1988 *Ann Hamilton: the capacity of absorption*, The Temporary Contemporary, Museum of Contemporary Art, Los Angeles, CA, December 13, 1988–February 26, 1989.
Installation: *the capacity of absorption*, 1988.*

1989 Capp Street Project, San Francisco, CA, March 10 – April 22. Installation: *privation and excesses*, 1989.

1990 *Ann Hamilton*, San Diego Museum of Contemporary Art, La Jolla, CA, April 7 – June 3. Installation: *between taxonomy and communion*, 1990.*

Ann Hamilton in collaboration with Kathryn Clark; Artemisia Gallery, Chicago, IL, June 1 – June 30. Installation: *palimpsest*, 1989. Traveled to: Arton A. Galleri, Stockholm, Sweden, August 24 – September 23.

1991 *WORKS* series, Ann Hamilton in collaboration with Kathryn Clark; Hirshhorn Museum and Sculpture Garden, Smithsonian Institution, Washington, D.C., March 20 – June 23. Installation: *view*, 1991.*

21st International São Paulo Bienal, São Paulo, Brazil, September 21 – December 10. Installation: *parallel lines*, 1991.*

Ann Hamilton: malediction, Louver Gallery, New York, NY, December 7, 1991 – January 4, 1992. Installation: *malediction*, 1991.

1992 *Ann Hamilton: accountings*, Henry Art Gallery, University of Washington, Seattle, WA, January 22 – April 5. Installation: *accountings*, 1991.*

Ann Hamilton/David Ireland, Walker Art Center, Minneapolis, MN, March 22 – July 5.*

Ann Hamilton: aleph, List Visual Arts Center, Massachusetts Institute of Technology, Cambridge, MA, October 9 – November 22. Installation: *aleph*, 1992.*

1993 *Ann Hamilton: a round*, The Power Plant, Toronto, Ontario, Canada, May 7 – September 6. Installation: *a round*, 1993.*

Ann Hamilton: tropos, Dia Center for the Arts, New York, NY, October 7, 1993 – June 19, 1994. Installation: *tropos*, 1993.*

1994 *Ann Hamilton: mneme*, Tate Gallery Liverpool, Liverpool, England, January 21 – March 6. Installation: *mneme*, 1994.*

Ann Hamilton: lineament, Ruth Bloom Gallery, Santa Monica, CA, June 4 – July 17. Installation: *lineament*, 1994.

Projects 48: Ann Hamilton: seam, Museum of Modern Art, New York, NY, November 10, 1994 – January 3, 1995. Installation: *seam*, 1994.*

1995 *Ann Hamilton: lumen*, Institute of Contemporary Art, University of Pennsylvania, Philadelphia, PA, May 12 – 21. Installation: *lumen*, 1995.*

1996 *Ann Hamilton: reserve*, Stedelijk Van Abbemuseum, Eindhoven, The Netherlands, February 3 – April 8. Installation: *reserve*, 1996.

Ann Hamilton: filament, Sean Kelly Gallery, New York, NY, May 1 – 31. Installation: *filament*, 1996.

the body and the object: Ann Hamilton 1984 – 1996, Wexner Center for the Arts, The Ohio State University, Columbus, OH, May 18 – August 4. Traveled to: Wood Street Galleries, Pittsburgh Cultural Trust, Pittsburgh, PA, September 5 – October 26; Carnegie Museum of Art, Pittsburgh, PA, October 11, 1996 – January 5, 1997; Krannert Art Museum, University of Illinois at Urbana-Champaign, IL, August 26 – November 2, 1997; Miami Art Museum of Dade County, Miami, FL, March 26 – June 7, 1998; Musée d'Art Contemporain de Montréal, Quebec, Canada, October 15, 1998 – January 17, 1999.*

1997 *Ann Hamilton: present–past 1984 – 1997*, Musée d'Art Contemporain de Lyon, France, November 26, 1997 – February 6, 1998. Installations: *bounden*, 1997 and *mattering*, 1997.*

Ann Hamilton: kaph, Contemporary Arts Museum, Houston, TX, December 13, 1997 – January 25, 1998. Installation: *kaph*, 1997.*

1998 *Ann Hamilton: mantle*, Miami Art Museum, Miami, FL, April 2 – June 7. Installation: *mantle*, 1998.* This installation was created for the site of the Miami Art Museum

and exhibited there concurrently with the Wexner Center's 1996 traveling
exhibition *the body and the object: Ann Hamilton 1984–1996.*

appetite, Ann Hamilton in collaboration with Meg Stuart & Damaged Goods; opened
at Lunatheater, Brussels, Belgium, September 9. Dance project: *appetite,* 1998.
Traveled to: Monty, Antwerp, Belgium, September; Wexner Center for the Arts,
Columbus, OH, October 21–24; Walker Art Center, Minneapolis, MN, November;
On the Boards, Seattle, WA, November; Genève Association de Danse
Contemporaine, Geneva, Switzerland, January 1999; Frankfurt Mousonturm,
Frankfurt, Germany, February 1999; Klapstuk Festival, Leuven, Belgium, February
1999; Pumpenhaus Theatre, Münster, Germany, February 1999; Théâtre de la Ville,
Paris, France, March 1999; Centre de Développement Choréographique, Toulouse,
France, March 1999; Kunstencentrum Vooruit, Ghent, Belgium, March 1999;
Théâtre National de Bretagne, Rennes, France, March 1999; Teatro Municipal,
Rivoli, Portugal, April 1999; Centro Cultural de Belém, Lisbon, Portugal, April
1999; Springdance Festival, Utrecht, The Netherlands, April 1999; Wiener
Festwochen, Vienna, Austria, June 1999; Tanz im August, Berlin, Germany, August
1999; Edinburgh International Festival, Edinburgh, Scotland, August 1999; Berner
Tanztage, Bern, Switzerland, August 1999; Schouwburg, Rotterdam, The
Netherlands, September 1999; L'Hippodrome, Douai, France, October 1999; Dance
Umbrella, London, England, November 1999; Cultural Centrum de Velinx,
Tongeren, Belgium, November 1999; Leonardo da Vinca/L'Opéra de Rouen,
Rouen, France, November 1999; Kaaitheater, Brussels, Belgium, November 1999;
Art.image Conference, Graz, Austria, November 1999; Cultureel Centrum,
Brugge, Belgium, November 1999; Schauspielhaus, Zürich, Switzerland, November
2000; Maison de la Culture, Bourges, France, November 2000; Deutsches
Nationaltheater, Weimar, Germany, November 2000; Le-Maillon Théâtre,
Strasbourg, France, December 2000.

Ann Hamilton: mattering, Musée d'Art Contemporain de Montréal, Quebec, Canada,
October 9, 1998–January 17, 1999. Installations: *mattering,* 1997; *bearings,* 1996.
These works were shown in Montréal concurrently wth the Wexner Center's 1996
traveling exhibition *the body and the object: Ann Hamilton 1984–1996.*

1999 *Ann Hamilton: whitecloth, The 1998 Larry Aldrich Foundation Award Exhibition,*
The Aldrich Museum of Contemporary Art, Ridgefield, CT, January 17–May 31.
Installation: *whitecloth,* 1999.*

Ann Hamilton: myein, The United States Pavilion, 48th Venice Biennale, Venice, Italy,
June 13–November 7. Installation: *myein,* 1999.*

Ann Hamilton, Vancouver Art Gallery, Vancouver, British Columbia, Canada,
October 16, 1999–January 23, 2000.*

2000 *Ann Hamilton,* Perimeter Gallery, Chicago, IL, April 28–May 27.

2001 *Ann Hamilton: Recent Works,* Akira Ikeda Gallery, Nagoya, Japan, May 19–June 30.

Ann Hamilton Taura Project 2001: the picture is still, Akira Ikeda Gallery, Taura, Japan,
May 19, 2001–June 30, 2002. Installation: *the picture is still,* 2001.*

mercy, Ann Hamilton in collaboration with Meredith Monk/The House; opened at
the American Dance Festival, Page Auditorium, Duke University, Durham, NC,
July 19–21. Performance/music-theater piece: *mercy,* 1997. Traveled to: Wexner
Center for the Arts, Ohio State University, Columbus, OH, October 12; Miami
University of Ohio, Oxford, OH, October 15; Connecticut College, New London,
CT, October 20; UCLA–Royce Hall, Los Angeles, CA, February 14, 2002; Walker
Art Center, Minneapolis, MN, February 23, 2002; Washington Library Theatre,
Chicago, IL, March 1–2, 2002; Gusman Center, Miami, FL, March 6, 2002;
Brooklyn Academy of Music, New York, NY, October 1–December 22, 2002;

Singapore Arts Festival, Singapore, 2003; Krannert Center for Performing Arts, Urbana-Champaign, IL, 2004.

Ann Hamilton: at hand, Sean Kelly Gallery, New York, NY, October 27 – December 1. Installation: *at hand*, 2001.

By Mouth and Hand: Ann Hamilton, 1990 – 2001, Museum of Art, Rhode Island School of Design, Providence, RI, November 9, 2001 – January 20, 2002.*

2002 *Ann Hamilton: tracing language*, The College of Wooster Art Museum, Ebert Art Center, Wooster, OH, August 27 – October 6.*

Ann Hamilton: at hand, Irish Museum of Modern Art, Dublin, Ireland, March 27 – July 14. Installation: *at hand*, 2001.

By Mouth and Hand: Ann Hamilton, 1990 – 2001, Indianapolis Museum of Art, Indianapolis, IN, March 30 – June 23.*

Ann Hamilton: lignum, The Wanås Foundation, Knislinge, Sweden, May, 2002 – 2006. Installation: *lignum*, 2002.*

Ann Hamilton: (reserve · video/writing), Catherine Clark Gallery, San Francisco, CA, December 5, 2002 – January 11, 2003.

2003 *Ann Hamilton at Gemini 2003*, Gemini G.E.L., Los Angeles, CA.*

Ann Hamilton: corpus, MASS MoCA, North Adams, MA, December 13, 2003 – October, 2004. Installation: *corpus*, 2003.*

2004 *Ann Hamilton: aloud*, Gothic Hall, Museum of National Antiquities, Stockholm, Sweden, September 30, 2004 – April 3, 2005. Installation: *aloud*, 2004.*

2005 *Ann Hamilton: phora*, La Maison Rouge, Fondation Antoine de Galbert, Paris, France, February 18 – May 22. Installation: *phora*, 2005.*

2006 *An Empty Space*, Akira Ikeda Gallery, New York, NY, January 1 – June 30.

Ann Hamilton: voce, Contemporary Art Museum, Kumamoto, Japan, February 25 – June 4. Installation: *voce*, 2006.*

Group Exhibitions

1980 Walter Phillips Gallery, The Banff Center for the Arts, Alberta, Canada, August 13 – 24.

Fibre Interpretation, Alberta Culture Traveling Group Exhibition, October.

Marietta College Crafts National, Marietta, OH, November.

Peter Whyte Gallery, Banff, Alberta, Canada.

1981 *Work*, The Exit Gallery, Banff, Alberta, Canada, February 16 – 23.

Fibre Studio, Walter Phillips Gallery, The Banff Center for the Arts, Alberta, Canada, April 2 – 12.

Peter Whyte Gallery, Banff, Alberta, Canada, April.

1982 Alexander Carlson Gallery, New York, NY.

1983 *3 Artists*, Twining Gallery, New York, NY, June 7 – July 1.

1984 *SNAP* (Sunday Night at the Performances) series, Franklin Furnace, New York, NY, April 22. Performance: *suitably positioned*, 1984.

Stuff and Spirit: The Arts in Craft Media, Twining Gallery, New York, NY, May 2 – June 16.

1985 *Rites of Spring*, Twining Gallery, New York, NY, March 2 – 30. Installation: *the lids of unknown positions*, 1984. At Twining, the installation was reconfigured from the original installation at Yale in 1984. The head of the figure sitting in the lifeguard chair came close to the gallery ceiling but did not penetrate it (as it had at Yale), for it was not possible to cut a hole in the Twining Gallery's concrete ceiling.

MFA Thesis Exhibition, Art Gallery, Yale University Art and Architecture Gallery, New Haven, CT, Spring. Installation/Performance: *left-footed measures*, 1985.

Faculty Exhibition, Art Museum, University of California, Santa Barbara, CA, Fall.

State of the Art: Software Invades the Arts, Part I, Twining Gallery, New York, NY, November 16–December 4.

1986 *Set in Motion*, Gallery One, San Jose State University, San Jose, CA, February 25–March 24. Installation: *circumventing the tale*, 1986.

1987 *Tangents: Art in Fiber*, Maryland Institute College of Art, Baltimore, MD, February 4–March 1. Traveled to: The Oakland Museum, Oakland, CA, August 15–October 31; CIA Gallery, Cleveland Institute of Art, Cleveland, OH, February 12–March 4, 1988. Installation: *the middle place*, 1987.* N.B.: Hamilton's installation appeared only at the Maryland Institute College of Art venue. Hamilton's photographs and installation-related objects traveled to the other venues.

The Level of Volume, Carl Solway Gallery, Cincinnati, OH, April 3–May 16. Window installation: *the map is not the territory*, 1987.

Arts Festival, organized by the Santa Barbara Arts Council, exhibited at the Santa Barbara Contemporary Arts Forum, Santa Barbara, CA, April 18–May 2. Window installation: *rites*, 1987.

Elements: Five Installations, Whitney Museum of American Art at Philip Morris, New York, NY, December 18, 1987–February 18, 1988. Installation/Performance: *the earth never gets flat*, 1987.*

1988 *Social Spaces*, Artists Space, New York, NY, January 14–February 13. Installation: *dissections . . . they said it was an experiment*, 1988.*

Five Artists, Santa Barbara Museum of Art, Santa Barbara, CA, April 30–June 26. Installation: *dissections . . . they said it was an experiment*, 1988.* This work, originally exhibited in *Social Spaces*, Artists Space, New York, was shown at the Santa Barbara Museum of Art with the addition of a steel floor and a new video work installed overhead and protruding from the wall.

Home Show: 10 Artists' Installations in 10 Santa Barbara Homes, Santa Barbara Contemporary Arts Forum, Santa Barbara, CA, September 10–October 9. Installation: *still life*, 1988.* N.B.: This installation used the existing dining-room table and chair of the Santa Barbara home where the work was sited. A used table and chair were newly selected in 1991 for the related object, *(still life)*, 1988/1991.

1989 *Strange Attractors: Signs of Chaos*, Ann Hamilton in collaboration with Kathryn Clark; Museum of Contemporary Art, New York, NY, September 14–November 26. Installation: *palimpsest*, 1989.*

1990 *Awards in the Visual Arts 9*, organized by the Southeastern Center for Contemporary Art (SECCA), Winston-Salem, NC. Opened at: New Orleans Museum of Art, New Orleans, LA, May 5–July 1. Traveled to: Southeastern Center for Contemporary Art (SECCA), Winston-Salem, NC, August 4–October 7; Arthur M. Sackler Museum, Harvard University, Cambridge, MA, November 24, 1990–January 13, 1991; The BMW Gallery, New York, NY, Spring, 1991. Installation: *linings*, 1990.*

SPLASH!, Twining Gallery, New York, NY, Summer.

Images in Transition: Photographic Representation in the Eighties, The National Museum of Modern Art, Kyoto, Japan, September 23–November 2. Traveled to: National Museum of Modern Art, Tokyo, Japan, November 20–December 16.*

New Works for New Spaces: Into the Nineties, Wexner Center for the Visual Arts, Ohio State University, Columbus, OH, October 6, 1990–January 6, 1991. Installation: *dominion*, 1990.*

1991 *El Jardín Salvaje: El Paisaje Como Metáfora en Instalaciones Americanas Recientes*, Sala de Exposiciones, Fundación Caja de Pensiones, Madrid, Spain, January 22–March 10. Installation: *between taxonomy and communion*, 1990.* Compared to the original 1990 installation at the San Diego Museum of Contemporary Art, La Jolla, CA, the installation in Spain did not include the wrought-iron birdcage and all four of the room's interior walls (rather than a single exterior wall) were incised with text.

Places with a Past: New Site-Specific Art at Charleston's Spoleto Festival, Charleston, SC, May 24–August 4. Installation: *indigo blue*, 1991.*

Carnegie International 1991, Carnegie Museum of Art, Carnegie Institute, Pittsburgh, PA, in collaboration with The Mattress Factory, Pittsburgh, PA, October 19, 1991– February 16, 1992. Installation: *offerings*, 1991.*

1992 *Doubletake: Collective Memory and Current Art*, Hayward Gallery, South Bank Centre, London, England, February 20–April 20. Traveled to: Kunsthalle, Vienna, Austria, January 8–February 28. Installation: *passion*, 1992.* The installation *aleph*, 1992, originally installed at List Visual Arts Center, Massachusetts Institute of Technology, Cambridge, MA, was shown in Vienna in lieu of *passion*.

Habeas Corpus, Stux Gallery, New York, NY, April 4–25.

Dirt & Domesticity: Constructions of the Feminine, Whitney Museum of American Art at Equitable Center, New York, NY, June 12–August 14. Installation: *(still life)*, 1988/1991.*

Photographies d'Hier et d'Aujourd'hui, ArtsSutton Gallery, Sutton, Quebec, Canada.

1993 *Small Works in Fiber: The Mildred Constantine Collection*, Cleveland Museum of Art, Cleveland, OH, January 27–March 28.*

Projects 40: readymade identities, Museum of Modern Art, New York, NY, April 3–May 15.*

Future Perfect, Hochschule für Angewandte Kunst in Wien, Heiligenkreuzerhof, Vienna, Austria, April 7–May 15.*

Sonsbeek '93, Arnhem, The Netherlands, June 5–September 26. Installation: *attendance*, 1993.*

Skowhegan '93, Colby College Museum of Art, Waterville, ME, July 14–September 26.

1994 *Outside the Frame: Performance and the Object*, Cleveland Center for Contemporary Art, Cleveland, OH, February 11–May 1.*

Cool & Multiples: Work from the Fabric Workshop's Permanent Collection, The Fabric Workshop and Museum, Philadelphia, PA, July 15–September.

Parts, University of Hawaii at Manoa Art Gallery, Honolulu, HI, August 28–September 30.

The Lure of the Local, University of Colorado Art Gallery, Boulder, CO.*

1995 *About Place: Recent Art of the Americas*, The 76th American Exhibition, Art Institute of Chicago, Chicago, IL, March 11–May 21. Installation: *volumen*, 1995.*

Avant-Garde Walk à Venezia, International Contemporary Art Consulting, New York, NY, June 8–12.*

Longing and Belonging: From the Faraway Nearby, SITE Santa Fe, Santa Fe, NM, July 14–August 8. Installation: *salic*, 1995.*

Micromegas, American Center, Paris, France, March 10–June 4. Traveled to: Israel Museum, Jerusalem, Israel, July 18–October 8.*

Temporarily Possessed: The Semi-Permanent Collection, The New Museum of Contemporary Art, New York, NY, September 15–December 17.

3rd Biennale d'Art Contemporain de Lyon: installation, cinéma, vidéo, informatique, Musée d'Art Contemporain, Lyon, France, December 20, 1995–February 18, 1996.*

Being Human, Museum of Fine Arts, Boston, MA, December 1995–April 1996.*

1996 *diary of a human hand*, Center for Curatorial Studies, Bard College, Annandale-on-Hudson, NY, March 17–31. Traveled to: Saidye Bronfman Centre for the Arts, Montréal, Canada, December 7, 1995–January 19, 1996.*

Along the Frontier: Ann Hamilton, Bruce Nauman, Francesco Torres, Bill Viola, The State Russian Museum, St. Petersburg, Russia, June 14–August 20. Traveled to: Galerie Rudolfinum, Prague, Czech Republic, September 18–November 24; National Gallery of Contemporary Art Zacheta, Warsaw, Poland, December 16, 1996–

January 20, 1997; Soros Center for Contemporary Art, Kiev, Ukraine, March 8–18, 1997. Installation: *(volumen)*, 1995/1996.*

Thinking Print: Books to Billboards 1980–95, Museum of Modern Art, New York, NY, June 19–September 10.*

Biennale of Sydney: Jurassic Technologies Revenant, Art Gallery of New South Wales, Sydney, Australia, July 27–September 22. Installation: *bearings*, 1996.*

Objects of Personal Significance: Women Stretching the Definition of Still Life, Tarble Arts Center, Eastern Illinois University, Charleston, IL, September 1–October 14. Traveled to: Museum of Texas Tech University, Lubbock, TX, January 28–March 1, 1997; Hyde Collection Art Museum Complex and Historic House, Glen Falls, NY, June 9–August 11, 1997; Knoxville Museum of Art, Knoxville, TN, September 1, 1997–January 8, 1998; Hunter Museum of American Art, Chattanooga, TN, February 7–March 16, 1998; Wichita Center for the Arts, Wichita, KS, April 6–May 19, 1998; Dunedin Fine Art Center, Dunedin, FL, June 9–August 11, 1998; Metro Center for the Visual Arts, Denver, CO, September 1–October 14, 1998.*

Vidéo Sans Titre, Galerie Froment & Putman, Paris, France, September 17–October 26.

Blurring the Boundaries: Installation Art 1969–1999, San Diego Museum of Contemporary Art, La Jolla, CA, September 21, 1996–January 26, 1997. Traveled to: Memorial Art Gallery, Rochester, NY, February 28–May 3, 1998; Worcester Art Museum, Worcester, MA, October 4, 1998–January 3, 1999; Ringling Museum of Art, Sarasota, FL, January 30–May 2, 1999; Scottsdale Center for the Arts, Scottsdale, AZ, May 27–September 5, 1999; Davenport Museum, Davenport, IA, October 10, 1999–January 23, 2000; University of Texas, Austin, TX, February 19–April 9, 2000; San Jose Museum of Art, San Jose, CA, May 14–August 13, 2000. Installation: *linings*, 1990.*

Contemplation: Five Installations, Ann Hamilton in collaboration with Kathryn Clark; Des Moines Art Center, Des Moines, IA, October 12, 1996–January 12, 1997. Installation: *palimpsest*, 1990.*

Making Pictures: Women and Photography, 1975–Now, Nicole Klagsbrun Gallery, New York, NY, November 1–December 7.

1997 *Common Threads*, University of Kansas Art & Design Galleries, Lawrence, KS, May 20–June 6.

Present, Past, Future, 1965–1997, 47th Venice Biennale, Venice, Italy, June 15–November 9. Installation: *the spell*, 1997.*

Envisioning the Contemporary: Selections from the Permanent Collection, Museum of Contemporary Art, Chicago, IL, June 21, 1997–April 5, 1998.

Changing Spaces: Artists' Projects from The Fabric Workshop and Museum, Philadelphia, a touring exhibition of The Fabric Workshop and Museum, Philadelphia, PA, in collaboration with the Arts Festival of Atlanta, Gallery 100, Atlanta College of Art at Woodruff Arts Center, Atlanta, GA, September 5–21.*

Thread, Cristinerose Gallery, New York, NY, September 5–October 5.*

Hanging by a Thread, The Hudson River Museum, Yonkers, NY, October 3, 1997–February 17, 1998. Installation: *filament*, 1996.*

Artists Projects, P.S.1 Contemporary Art Center, Long Island City, NY, October 26, 1997–April 26, 1998. Installation *(bounden)*, 1997. This work was exhibited at P.S.1 in advance of its intended home in the installation *bounden* in November 1997 at The Musee d'Art Contemporain de Lyon, France. In 1998 it was installed as *welle* at Fondation Cartier pour l'Art Contemporain, Paris, France. In 2005 it was retitled *(bounden · seeping wall)*.

20:20: CAF Looks Forward and Back, Santa Barbara Contemporary Arts Forum, Santa Barbara, CA.

1998 *Growing Obsession*, Dorsky Gallery, New York, NY, January 20 – February 28.*

Then and Now and Later: Art Since 1945 at Yale, Yale University Art Gallery, New Haven, CT, February 10 – July 31.

Art for Today, Indianapolis Museum of Art, Indianapolis, IN, February 14 – March 8.*

Inner Eye: Contemporary Art from the Marc and Livia Straus Collection, Samuel P. Harn Museum of Art, University of Florida, Gainesville, FL, March 22, 1998 – January 3, 1999. Traveled to: Knoxville Museum of Art, Knoxville, TN, Spring 1999; Georgia Museum of Art, Athens, GA, Summer 1999; The Chrysler Museum of Art, Norfolk, VA, Fall 1999; Neuberger Museum of Art, Purchase College, State University of New York, Purchase, NY, January 30 – April 16, 2000. Installation: *(capacity of absorption · vortex 30)*, 1988.* N.B.: Hamilton's installation was shown only in Gainesville and did not travel to the exhibition's other venues.

êtrenature, Fondation Cartier pour l'Art Contemporain, Paris, France, June 17 – September 20. Installation: *welle*, 1997.*

Connections, Contradictions: Modern and Contemporary Art from Atlanta Collections, Michael C. Carlos Museum, Emory University, Atlanta, GA, August 15 – October 4.*

Artists Online for ACOR, Gagosian Gallery, New York, NY, September 10 – December 9.

corpus virtu, Sean Kelly Gallery, New York, NY, September 11 – October 24.

Addressing the Century: 100 Years of Art & Fashion, Hayward Gallery, Royal Festival Hall, London, England, October 8, 1998 – January 11, 1999. Traveled to: Kunstmuseum, Wolfsburg, Germany, February 26 – May 23, 1999.*

Webs://Textiles and New Technology, Design Gallery, Department of Environmental Design, University of California, Davis, CA, January 18 – February 13, 1998.

1999 *Avoiding Objects*, Apex Art Curatorial Program, New York, NY, January 8 – February 6.*

Prime, Dundee Contemporary Arts Center, Dundee, Scotland, March 20 – May 9.*

Macht ünd Fersorge: Das Bild der Mutter in der Zeitgenössischen Kunst, Trinitatiskirche, Cologne, Germany, August 21 – October 16. Installation: *bearings*, 1996.*

Dreaming III: Contemporary American Art & Old Japanese Ceramics, Akira Ikeda Gallery, New York, NY, September 1 – December 23.*

Impact: Revealing Sources for Contemporary Art, Contemporary Art Museum, Baltimore, MD, September 25, 1999 – January 3, 2000.

Carnegie International 1999, Carnegie Museum of Art, Carnegie Institute, Pittsburgh, PA, November 6, 1999 – March 26, 2000. Installation: *welle*, 1997.*

House of Sculpture, Modern Art Museum of Fort Worth, TX, May 23 – August 8. Traveled to: MARCO, Monterrey, Mexico, November 19, 1999 – February 20, 2000.*

Skin, Cranbrook Art Museum, Bloomfield Hills, MI, November 20, 1999 – January 16, 2000.*

Permanent Change: Contemporary Works from the Collection, Williams College Museum of Art, Williamstown, MA, December 11, 1999 – April 22, 2001.

ethno-antics, The Nordiska Museum, Stockholm, Sweden.*

2000 *Remnants of Memory*, Asheville Art Museum, Asheville, NC, January 29 – April 8.*

Outbound: Passages from the 90s, Contemporary Arts Museum, Houston, TX, March 4 – May 7. Installation: *bearings*, 1996.*

Biennale of Sydney, Sydney, Australia, May 26 – July 30.

On Language, Sean Kelly Gallery, New York, NY, April 29 – June 10.

The Egg Dream Museum, Nutrition Pavilion, Expo 2000, Hannover, Germany, June 1 – October 31.

2000 Biennial, Fort Wayne Museum of Art, Fort Wayne, IN, June 3 – August 20.*

Hindsight/Foresight: Art for the New Millennium, Bayly Art Museum, University of Virginia, Charlottesville, VA, June 15 – September 17.*

Collecting: Passion and Perspective of Jodi Carson, Sandy Carson Gallery, Denver, CO, June 17 – August 19.

Ethereal and Material, Delaware Center for the Contemporary Arts, Wilmington, DE, September 21–November 21.*

S.O.S: Scenes of Sounds, The Tang Teaching Museum and Art Gallery, Skidmore College, Saratoga Springs, NY, October 28, 2000–January 28, 2001.*

Soft Core, Joseph Helman Gallery, New York, NY, December 13, 2000–January 20, 2001.

2001 *Now Playing: Audio in Art*, Susan Inglett Gallery, New York, NY, January 11– February 17.

Humid, Spike Island Artspace, Bristol, England, February 24–March 25. Traveled to: Australian Center for Contemporary Art, Melbourne, Australia, October 11– November 25; Auckland Art Gallery Toi o Tamaki, Auckland, New Zealand, February 16–May 26, 2002.*

The Lenore and Burton Gold Collection of 20th Century Art, High Museum of Art, Atlanta, GA, March 3–May 27.*

BitStreams, Whitney Museum of American Art, New York, NY, March 22–June 10.*

Boston Cyberarts Festival, Davis Museum, Wellesley, MA, April 21–May 6.

Digital: Printmaking Now, 26th edition in the Prints National series, Brooklyn Museum of Art, Brooklyn, NY, June 22–September 2.*

domestic acts, Sean Kelly Gallery, New York, NY, June 23–August 3.

Work: Shaker Design and Recent Art, The Tang Teaching Museum and Art Gallery, Skidmore College, Saratoga Springs, NY, July 7–September 16.*

ArtCité: Quand Montréal Devient Musée, Musée d'Art Contemporain de Montréal, Montréal, Quebec, Canada, August 10–October 8.*

The Book as Image and Object, Senior & Shopmaker Gallery, New York, NY, September 13–November 10.

Works on Paper, Evo Gallery, Santa Fe, NM, November 13, 2001–December 4, 2002.

The Inward Eye: Transcendence in Contemporary Art, Contemporary Arts Museum, Houston, TX, December 7, 2001–February 17, 2002.*

The Fabric Workshop and Museum, Philadelphia, au Centre d'Art Contemporain, Genève, Centre d'Art Contemporain, Geneva, Switzerland, March 8–May 6.

Open Source: Artists from the Institute for Electronic Arts, Institute for the Electronic Arts, Alfred University, Alfred, NY. Traveled to: Central Academy of Fine Arts, Beijing, China; Luxun Museum of Art, Shenyang, China.*

Fusion, G Fine Art, Washington, D.C.

2002 *Between Language and Form*, Yale University Art Gallery, New Haven, CT, January 29– March 30.

Oxygen, Whitebox Art Gallery, New York, NY, February 8–March 9.

Material World: From Lichtenstein to Viola, 25 Years of The Fabric Workshop and Museum, Museum of Contemporary Art, Sydney, Australia, February 28–April 28.

Connections: Ohio Artists Abroad, Riffe Gallery, Columbus, OH, April 25–July 7. Traveled to: Spaces Gallery, Cleveland, OH, September 13–October 25; Alice F. and Harris K. Weston Art Gallery, Cincinnati, OH, November 22, 2002–January 18, 2003.*

Oral Fixations, Center for Curatorial Studies, Bard College, Annandale-on-Hudson, NY, May 12–26.

Parallels and Intersections: Art/Women/California 1950–2000, San Jose Museum of Art, San Jose, CA, June 1–November 3.*

The Shock of September 11 and the Mystery of the Other, Haus am Lützowplatz, Berlin, Germany, June 10–July 21.*

Moving Pictures: Contemporary Photography and Video from the Guggenheim Collection, Solomon R. Guggenheim Museum, New York, NY, June 28, 2002–January 13, 2003.*

Private Eyes: Image and Identity, University Gallery, University of Massachusetts at
Amherst, Fine Arts Center, Amherst, MA, September 14–October 25 and
November 2–December 13.

The Unblinking Eye: Lens-Based Work from the IMMA Collection, Irish Museum of
Modern Art, Dublin, Ireland, September 18, 2002–February 16, 2003.*

New York, New Work, Now, The Currier Museum, Manchester, NH, September 28,
2002–January 13, 2003.

Miami Currents: Linking Collection and Community, Miami Art Museum, Miami, FL,
October 30, 2002–March 2, 2003.

Life Death Love Hate Pleasure Pain, Museum of Contemporary Art, Chicago, IL,
November 16, 2002–April 20, 2003.*

2003 *Air*, James Cohan Gallery, New York, NY, January 10–February 15.

Upon Reflection Sean Kelly Gallery, New York, NY, January 10–February 15.

Magic Markers, Des Moines Art Center, Des Moines, IA, February 2–April 20.
Installation: *(whitecloth · table)*, 1999.*

New Material as New Media: 25 Years of the Fabric Workshop and Museum, The Fabric
Workshop and Museum, Philadelphia, PA, February 10–April 19.*

Self and Soul: The Architecture of Intimacy, Asheville Art Museum, Asheville, NC,
March 7–May 25.*

Agitate: Negotiating the Photographic Process, SF Camerawork, San Francisco, CA,
May 13–June 14.

Yankee Remix: Artists Take On New England, MASS MoCA, North Adams, MA,
May 24, 2003–Spring 2004. Installation: *across*, 2003.*

Living with Duchamp, The Tang Teaching Museum and Art Gallery, Skidmore College,
Saratoga Springs, NY, June 27–September 28.

Legacy: Capp Street Project Alumnae Benefit Exhibition, Anthony Meier Fine Arts,
San Francisco, CA, July 11–August 22.

Ann Hamilton, Michael Mercil, North Dakota Museum of Art, Grand Forks, ND,
August 3–September 28. Installation: *my love*, 2003.*

Gyroscope: Selections from the Permanent Collection, Hirshhorn Museum and Sculpture
Garden, Washington, D.C., August 1, 2003–January 4, 2004. Installation: *at hand*,
2003.*

Pins and Needles, John Michael Kohler Arts Center, Sheboygan, WI, September 2003–
January 2004.

8th International Istanbul Biennial, Istanbul, Turkey, September 19–November 16.
Installation: *appeals*, 2003.

The Disembodied Spirit, Bowdoin College Museum of Art, Brunswick, ME,
September 25–December 7. Traveled to: Kemper Museum of Contemporary Art,
Kansas City, MO, March 5–23, 2004.*

The Not-So-Still Life: A Century of California Painting and Sculpture, San Jose Museum of
Art, San Jose, CA, November 22, 2003–February 15, 2004.*

The Metaphoric Body: Contemporary Sculpture from Munson-Williams-Proctor Arts Institute,
Coyne Gallery, Everson Museum of Art, Syracuse, NY, December 9, 2003–
February 22, 2004.

Pages, Cristinerose/Josee Bienvenu, New York, NY, December 12, 2003–January 17,
2004.

2004 *Better Still: Looking at Still Life in the Museum Collection*, Museum of Art, Rhode Island
School of Design, Providence, RI, February 6–May 2. Installation: *(malediction)*,
1991.

Reordering Reality: Collecting Contemporary Art, Columbus Museum of Art, Columbus,
OH, April 10–August 29.

Art by MacArthur Fellows, Carl Solway Gallery, Cincinnati, OH, May 7–July 31.

Los Usos de la Imagen: Fotografía, Film y Video en La Colección Jumex, Malba-Colección Costantini, Museo de Arte Latinoamericano de Buenos Aires, Buenos Aires, Argentina, September–November.*

International Fine Print Dealers Association Print Fair, Gemini G.E.L. at Joni Moisant Weyl, New York, NY, November 3–7.

Two O O One, Exit Art, New York, NY, December 4, 2004–February 13, 2005.

2005 *Seeking Transcendence*, UWA Perth International Arts Festival, Art Gallery of Western Australia, Perth, Australia, February 13–April 24. Installations: *(ghost . . . a border act · spinning video)*, 2004 and *(corpus · spinning sound)*, 2003.*

Franklin Furnace Alumni Art Sale, Marian Goodman Gallery, New York, NY, May 2–7.

Marking Time: Moving Images, Miami Art Museum, Miami, FL, May 13–September 11.

YOKOHAMA 2005: International Triennial of Contemporary Art ("Art Circus—Jumping from the Ordinary"), Yokohama, Japan, September 28–December 18. Performance collaboration with six rock climbers: *line*.*

Nostalgia, The Hudson Valley Center for Contemporary Art, Peekskill, NY, September 24, 2005–March 20, 2006.

Me, Myself and I: Artist Self-Portraits from the Heather and Tony Podesta Collection, Curator's Office, Washington, D.C., October 29–December 17.

Gyroscope: Selections from the Permanent Collection ("From Ordinary to Extraordinary"), Hirshhorn Museum and Sculpture Garden, Washington, D.C., November 3, 2005–January 2006. Installation: *palimpsest*, 1989.

Art: 21–The Artists, Bentley Projects, Phoenix, AZ, December 2, 2005–January 31, 2006.

Melancholia, Jensen Gallery, Auckland, New Zealand.

2006 *Walking & Falling*, Magasin 3 Stockholm Konsthall, Stockholm, Sweden, February 11–May 28.

Women Only! In Their Studios, Museum of Texas Tech University, Lubbock, TX, February 5–April 16, 2006. Traveling to: Polk Museum of Art, Lakeland, FL, July 30–October 15, 2006; Fort Wayne Museum of Art, Fort Wayne, IN, February 4–April 15, 2007; Avampato Discovery Museum, Inc., Charleston, WV, June 17–August 26, 2007; Muskegon Museum of Art, Muskegon, MI, September 13–November 18, 2007; Lowe Art Museum, University of Miami, Miami, FL, February 16–March 30, 2008; Eleanor D. Wilson Museum, Hollins University, Roanoke, VA, April 20–June 29, 2008.

Full House: Views of the Whitney's Collection at 75, Whitney Museum of American Art, New York, June 29–September 3, 2006.

Taken with Time, The Print Center, Philadelphia, PA, September 7–December 11.*

The Quiet in the Land, Luang Prabang National Museum, Laos, October 7–April 2007.

Selected Collections

Baltimore Museum of Art, Baltimore, MD
Birmingham Museum of Art, Birmingham, AL
Carnegie Museum of Art, Pittsburgh, PA
Cincinnati Art Museum, Cincinnati, OH
Columbus Art Museum, Columbus, OH
Davis Museum and Cultural Center, Wellesley College, Wellesley, MA
Dayton Art Institute, Dayton, OH
Des Moines Art Center, Des Moines, IA
Guggenheim Museum, New York, NY
Harvard University Art Museums, Cambridge, MA
Hirshhorn Museum and Sculpture Garden, Washington, D.C.
Indianapolis Museum of Modern Art, Indianapolis, IN
Irish Museum of Modern Art, Dublin, Ireland
La Maison Rouge, Fondation Antoine de Galbert, Paris, France
Los Angeles County Museum of Art, Los Angeles, CA
Metropolitan Museum of Art, New York, NY
Miami Art Museum, Miami, FL
Modern Art Museum of Fort Worth, Fort Worth, TX
Munson-Williams-Proctor Arts Institute, Museum of Art, Utica, NY
Musée d'Art Contemporain de Lyon, Lyon, France
Musée d'Art Contemporain de Montréal, Montréal, Quebec, Canada
Museum of Art, Rhode Island School of Design, Providence, RI
Museum of Contemporary Art, Chicago, IL
Museum of Contemporary Art, Los Angeles, CA
Museum of Contemporary Photography, Chicago, IL
Museum of Fine Arts, Boston, MA
Museum of Modern Art, New York, NY
National Gallery of Art, Washington, D.C.
National Museum of Women in the Arts, Washington, D.C.
New Museum of Contemporary Art, New York, NY
San Diego Museum of Contemporary Art, La Jolla, CA
University of Michigan Museum of Art, Ann Arbor, MI
Virginia Museum of Fine Arts, Richmond, VA
Walker Art Center, Minneapolis, MN
Whitney Museum of American Art, New York, NY
Williams College Museum of Art, Williamstown, MA

Ann Hamilton
Bibliography

Solo Exhibition Catalogues

Columbus, OH. Wexner Center for the Arts, The Ohio State University. *the body and the object: Ann Hamilton 1984–1996.* 1996. Foreword by Sherri Geldin. Text by Sarah J. Rogers. Checklist annotations by Ann Bremer, Ann Hamilton, and Karen Silk. Includes CD-ROM.

Houston, TX. Contemporary Arts Museum. *Ann Hamilton: kaph.* 1998. Text by Lynn M. Herbert.

Knislinge, Sweden. The Wanås Foundation. *Wanås 2002: Ann Hamilton Charlotte Gyllenhammar.* 2002. Texts by Lynne Cooke and Ingela Lind.

———. *Ann Hamilton: lignum.* 2005. Texts by Mirjam Schaub, Mark C. Taylor, Björner Torsson, and Marika Wachtmeister. Interview by Lynne Cooke. Published in association with Atlantis, Stockholm, Sweden.

Kumamoto, Japan. Contemporary Art Museum, Kumamoto. *Ann Hamilton: voce.* Texts by Hiroshi Minamishima, Yoshiko Honda. Interview with David Elliott by Hiroshi Minamishima.

La Jolla, CA. San Diego Museum of Contemporary Art. *Ann Hamilton.* 1991. Introduction by Lynda Forsha. Text by Susan Stewart. Interview by Hugh M. Davies and Lynda Forsha.

Liverpool, England. Tate Gallery Liverpool. *Ann Hamilton: mneme.* 1994. Texts by Judith Nesbitt and Neville Wakefield. Published in association with Tate Gallery Publications, London, England.

Los Angeles, CA. Gemini G.E.L., LLC. *Ann Hamilton at Gemini 2003.* 2003. Eighteen postcards. Text by Ann Hamilton.

Los Angeles, CA. The Temporary Contemporary, Museum of Contemporary Art. *Ann Hamilton: the capacity of absorption.* 1989. Edited by Catherine Cudis. Introduction by Richard Koshalek and Mary Jane Jacob.

Lyon, France. Musée d'Art Contemporain de Lyon. *Ann Hamilton: Present–Past 1984–1997.* 1998. Preface by Thierry Raspail. Texts by Jean-Pierre Criqui, Patricia C. Phillips, and Thierry Prat. Published in association with Skira Editions, Milan, Italy.

Miami, FL. Miami Art Museum. *Mantle by Ann Hamilton.* 1998. Text by Ann Hamilton. Includes audio CD.

Minneapolis, MN. Walker Art Center. *Ann Hamilton/David Ireland.* 1992. Publication of a cloth drawstring envelope with eight postcards. Text by Ann Hamilton.

Montréal, Canada. Musée d'Art Contemporain de Montréal. *Ann Hamilton: mattering.* 1998. Text by Paulette Gagnon.

New York, NY. Dia Center for the Arts. *Ann Hamilton: tropos.* 1993. Text by Lynne Cooke. Brochure.

———. *Ann Hamilton: tropos.* 1995. Edited by Lynne Cooke and Karen Kelly. Preface by Michael Govan. Texts by Lynne Cooke, Bruce Ferguson, Dave Hickey, and Marina Warner.

New York, NY. Museum of Modern Art. *Projects 48: Ann Hamilton.* 1994. Interview by Robert Storr. Brochure.

North Adams, MA. MASS MoCA. *Ann Hamilton: corpus.* 2004. Text by Lawrence Raab.

Philadelphia, PA. Institute of Contemporary Art, University of Pennsylvania. *Ann Hamilton: lumen.* 1995. Text by Judith Tannenbaum. Brochure.

Providence, RI. Museum of Art, Rhode Island School of Design. *By Mouth and Hand: Ann Hamilton, 1990–2001*. Text by Judith Tannenbaum.

Ridgefield, CT. The Aldrich Museum of Contemporary Art. *Ann Hamilton: whitecloth, The 1998 Larry Aldrich Foundation Award Exhibition*. 1999. Text by Nancy Princenthal. Poetry by Ann Lauterbach.

San Francisco, California. Friends of the Library, San Francisco Public Library. *Ann Hamilton Ann Chamberlain San Francisco Public Library Public Art Project* 1996. Text by Ann Hamilton and Ann Chamberlain. Set of 27 postcards.

São Paulo, Brazil. 21st Bienal Internacional de São Paulo. *Ann Hamilton: 21st Bienal Internacional de São Paulo, Brazil*. 1991. Edited by Deborah Easter. Introduction by Chris Bruce. Text by Joan Hugo. Published in association with Henry Art Gallery, Seattle, WA.

Seattle, WA. Henry Art Gallery, University of Washington. *Ann Hamilton: São Paulo/Seattle*. 1992. Texts by Chris Bruce, Rebecca Solnit, and Buzz Spector.

Stockholm, Sweden. Gothic Hall, Museum of National Antiquities. *Ann Hamilton: aloud*. 2004. Text by Lawrence Raab. Published in association with the National Public Art Council, Sweden.

Taura, Japan. Akira Ikeda Gallery. *Ann Hamilton: the picture is still*. 2003. Texts by Tomoaki Kitagawa, Bernhart Schwenk, and Takeo Ueda. Published in association with Hatje Cantz, Germany.

Toronto, Canada. The Power Plant. *Ann Hamilton: a round*. 1993. Text by Louise Dompierre.

Vancouver, British Columbia, Canada. Vancouver Art Gallery. *Ann Hamilton*. 1999. Introduction by Daina Augaitis and Josephine Mills. Brochure.

Venice, Italy. The United States Pavilion, 48th Venice Biennale. *Ann Hamilton: myein*. 1999. Texts by Katy Kline and Helaine Posner.

Washington, D.C. Hirshhorn Museum and Sculpture Garden, Smithsonian Institution. *WORKS* series. 1991. Foreword by Ned Rifkin. Brochure.

Wooster, OH. The College of Wooster Art Museum, Ebert Art Center. *Ann Hamilton: tracing language*. 2002. Text by Kathleen McManus Zurko. Brochure.

Group Exhibition Catalogues

Alfred, NY. Institute for the Electronic Arts, Alfred University. *Open Source: Artists from the Institute for Electronic Arts*. 2001. Texts by Gerar Edizel and Pauline Oliveros.

Annandale-on-Hudson, NY. Center for Curatorial Studies, Bard College. *diary of a human hand*. 1995. Text by Regine Basha.

Arnhem, The Netherlands. *Sonsbeek 93*. 1993. Edited by Jan Brand, Catelijne de Muynck, and Valerie Smith. Published in association with Snoeck-Ducaju and Zoon, Ghent, Belgium.

Asheville, NC. Asheville Art Museum. *Remnants of Memory*. 2000. Text by Ann Batchelder. Brochure.

———. *Self and Soul: The Architecture of Intimacy*. 2003. Text by Pamela L. Myers. Brochure.

Atlanta, GA. Arts Festival of Atlanta, Gallery 100, Atlanta College of Art at Woodruff Arts Center. *Changing Spaces: Artists' Projects from the Fabric Workshop and Museum, Philadelphia*. 1997. Brochure.

Atlanta, GA. High Museum of Art. *The Lenore and Burton Gold Collection of 20th Century Art*. 2001. Text by Carrie Przybilla.

Atlanta, GA. Michael C. Carlos Museum, Emory University. *Connections, Contradictions: Modern and Contemporary Art from Atlanta Collections*. 1998. Foreword by Anthony Hirschel. Text by Genevieve Arnold.

Baltimore, MD. Maryland Institute. *Tangents: Art in Fiber*. 1987. Texts by Mary Jane Jacob and Jann Rosen Queralt.

Berlin, Germany. Haus am Lützowplatz. *The Shock of September 11 and the Mystery of the Other: A Documentation.* 2002. Foreword by Frank Berberich. Texts by Jean Baudrillard, Hartmut Böhme, Roger Friedland, Bernard Lewis, Mohsen Makhmalbaf, Abdelwahab Meddeb, Toni Morrison, Susan Sontag, Paul Virilio, and Eliot Weinberger. Translated from the French by Chris Turner and Pierre Joris. Translated from the German by Elizabeth Neswald.

Bloomfield Hills, MI. Cranbrook Art Museum. *Skin.* 1999. Text by Irene Hoffman. Brochure.

Boston, MA. Museum of Fine Arts. *Being Human.* 1995. Text by Trevor Fairbrother. Brochure.

Boulder, CO. University of Colorado Art Gallery. *The Lure of the Local: Senses of Place in a Multicultural Society.* 1997. Text by Lucy R. Lippard. Published in association with The New Press, New York, NY.

Bristol, England. Spike Island Artspace. *Humid.* 2001. Text by Juliana Engberg. Brochure.

Brooklyn, NY. Brooklyn Museum of Art. *Digital: Printmaking Now.* 2001. Text by Marilyn S. Kushner.

Brunswick, ME. Bowdoin College Museum of Art. *The Disembodied Spirit.* 2003. Texts by Tom Gunning, Pamela Thurschwell, and Allison Ferris.

Buenos Aires, Argentina. Malba-Colección Costantini, Museo de Arte Latinoamericano de Buenos Aires. *Los Usos de la Imagen: Fotografía, Film y Video en La Colección Jumex.* 2004. Introduction by Eduardo F. Costantini and Eduardo F. Costantini Jr. Text by Carlos Basualdo. Published in association with Espacio Fundación Telefónica, Argentina.

Cambridge, MA. Massachusetts Institute of Technology List Visual Arts Center. *19 Projects: Artists-in-Residence at the MIT List Visual Arts Center.* 1996. Introduction by Katy Kline. Texts by Marie Cieri, Dana Friis-Hansen, Katy Kline, and Helaine Posner. Interviews by Helaine Posner.

Charleston, SC. *Places with a Past: New Site-Specific Art at Charleston's Spoleto Festival.* 1991. Text by Mary Jane Jacob. Published in association with Rizzoli, New York, NY.

Charleston, SC. Tarble Arts Center, Eastern Illinois University. *Objects of Personal Significance: Women Stretching the Definition of Still Life.* 1996. Text by Janet Marquardt-Cherry. Published in association with ExhibitsUSA, Mid-American Art Alliance, Kansas City, MO.

Charlottesville, VA. Bayly Art Museum, University of Virginia. *Hindsight/Foresight: Art for the New Millennium.* 2000. Text by Lyn Bolen Rushton. Brochure.

———. *Siting Jefferson: Contemporary Artists Interpret Thomas Jefferson's Legacy.* 2003. Edited by Jill Hartz. Introduction by Jill Hartz. Texts by John Beardsley, Lyn Bolen Rushton, John T. Casteen III, Peter S. Onuf, and Lucia Stanton. Based on the exhibition *Hindsight/Foresight: Art for the New Millennium.*

Chicago, IL. Art Institute of Chicago. *About Place: Recent Art of the Americas.* 1995. Edited by Madeleine Grynsztejn. Text by Dave Hickey.

———. *The Consistency of Shadows: Exhibition Catalogues as Autonomous Works of Art.* 2003. Texts by Anne Dorothee Bohme, Christian Boltanski, Alan Cravitz, Anthony Elms, Mary Jane Jacob, and Barbara Moore.

Chicago, IL. Museum of Contemporary Art. *Life Death Love Hate Pleasure Pain.* 2002. Foreword by Robert Fitzpatrick. Texts by Elizabeth A. T. Smith, Alison Pearlman, and Julie Rodrigues Widholm.

Cleveland, OH. Cleveland Center for Contemporary Art. *Outside the Frame: Performance and the Object.* 1994. Edited by Gary Sangster.

Cleveland, OH. Cleveland Museum of Art. *Small Works in Fiber: The Mildred Constantine Collection.* 1993. Text by Mary Jane Jacob.

Cologne, Germany. Trinitatiskirche. *Macht und Fersonge: Das Bild der Mutter in der Zeitgenössischen Kunst.* 1999. Edited by Johannes Bilstein, Ursula Trubenbach, and

Matthias Winzen. Texts by Meike Baader, Christa Berg, Johannes Bilstein, Jutta Held, Friedrich Wolfram Heubach, and Dieter Lenzen. Published in association with Oktagon Verlag, Cologne, Germany.

Columbus, OH. Riffe Gallery. *Connections: Ohio Artists Abroad*. 2002. Text by Susan R. Channing. Published in association with the Ohio Arts Council.

Columbus, OH. Wexner Center for the Arts, The Ohio State University. *New Works for New Spaces: Into the Nineties*. 1990. Texts by Claudia Gould, Sarah J. Rogers, and Robert Stearns.

——. *On the Table: A Succession of Collections 3*. 1999. Edited by Mark Robbins.

Des Moines, IA. Des Moines Art Center. *Contemplation: Five Installations*. 1996. Texts by I. Michael Danoff and Deborah Leveton.

——. *Magic Markers: Objects of Transformation*. 2003. Texts by Jeff Fleming, Stanley Cavell, and Malcolm Warner.

Dublin, Ireland. Irish Museum of Modern Art. *The Unblinking Eye: Lens-Based Work from the IMMA Collection*. 2002. Text by Catherine Marshall. Exhibition guide.

Dundee, Scotland. Dundee Contemporary Arts Center. *Prime: Dundee Contemporary Arts 1999*. 1999. Introduction by Andrew Nairne. Texts by Euan McArthur and Charles McKean.

Fort Wayne, IN. Fort Wayne Museum of Art. *2000 Biennial*. 2000. Introduction by Patricia Watkinson. Texts by Robert F. Schroeder and James Yood.

Fort Worth, TX. Modern Art Museum of Fort Worth. *House of Sculpture*. 1999. Brochure.

Gainesville, FL. Samuel P. Harn Museum of Art, University of Florida. *Inner Eye: Contemporary Art from the Marc and Livia Straus Collection*. 1998. Texts by Dede Young and Budd Harris Bishop.

Grand Forks, ND. North Dakota Museum of Art. *increase: Ann Hamilton/Michael Mercil*. 2003. Text by Robert Silberman.

Houston, TX. Contemporary Arts Museum. *Outbound: Passages from the 90s*. 2000. Texts by Dana Friis-Hansen, Lynn M. Herbert, Marti Mayo, and Paola Morsiani.

——. *The Inward Eye: Transcendence in Contemporary Art*. 2001. Texts by Lynne Herbert, Klaus Ottman, and Peter Schjeldahl.

Indianapolis, IN. Indianapolis Museum of Art. *Art for Today*. 1998. Text by Holliday T. Day. Brochure.

Kyoto, Japan. The National Museum of Modern Art. *Images in Transition: Photographic Representation in the Eighties*. 1990.

La Jolla, CA. San Diego Museum of Contemporary Art. *Blurring the Boundaries: Installation Art 1969–1999*. 1997. Edited by Anne Farrell. Texts by Hugh M. Davies and Ronald J. Onorato.

——. *Lateral Thinking: Art of the 1990s*. 2002. Preface by Hugh M. Davies. Text by Toby Kamps.

London, England. Hayward Gallery, South Bank Centre. *Doubletake: Collective Memory and Current Art*. 1992. Texts by Lynne Cooke, Bice Curiger, and Greg Hilty. Published in association with Parkett, New York, NY.

——. *Addressing the Century: 100 Years of Art & Fashion*. 1998. Texts by Judith Clark, Joanne Entwistle, Caroline Evans, Ulrich Lehmann, Robin Muir, Elizabeth Wilson, and Peter Wollen.

Lyon, France. Musée d'Art Contemporain. *3rd Biennale d'Art Contemporain de Lyon: installation, cinéma, vidéo, informatique*. 1995. Introduction by Thierry Prat, Thierry Raspail, and Georges Rey. Texts by Yann Beauvais, Nicolas Bourriaud, Dan Cameron, Gladys Fabre, Jean-Paul Fargier, Friedrich Kittler, Barbara London, Friedrich Malsch, Alice Pratt Brown, David A. Ross, Hans Peter Schwartz, and Christine Van Assche. Published in association with Réunion des Musées Nationaux/Biennale d'Art Contemporain, Paris, France. Includes CD-ROM.

Madrid, Spain. Sala de Exposiciones, Fundación Caja de Pensiones. *El Jardín Salvaje: El Paisaje Como Metáfora en Instalaciones Americanas Recientes*, 1991. Text by Dan Cameron.

Melbourne, Australia. Melbourne International Arts Festival. *Melbourne International Arts Festival: Visual Arts Program 2003*. 2003. Edited by Juliana Engberg. Texts by Geraldine Barlow, Rebecca Coates, Juliana Engberg, Joanne Finkelstein, Hélène Frichot, Chloe Kinsman, and Cynthia Troup. Poetry by Robert Nelson and Leon Van Schaik.

Montréal, Quebec, Canada. Musée d'Art Contemporain de Montréal. *ArtCité: Quand Montréal Devient Musée*. 2001. Texts by Josée Bélisle and Paulette Gagnon.

New York, NY. Akira Ikeda Gallery. *Dreaming III: Contemporary American Art & Old Japanese Ceramics*. 1999.

New York, NY. Apex Art Curatorial Program. *Avoiding Objects*. 1999. Text by Alice Smits. Brochure.

New York, NY. Artists Space. *Social Spaces*. 1988. Text by Valerie Smith.

New York, NY. Cristinerose Gallery. *Thread*. 1997. Text by Tom Moody.

New York, NY. Dorsky Gallery. *Growing Obsession*. 1998. Texts by Donna Harkavy and Margaret Matthews-Berenson. Brochure.

New York, NY. International Contemporary Art Consulting. *Avant-Garde Walk à Venezia*. 2 vols. Vol. 1, 1995. Vol. 2, 1996. Foreword by Marc Pottier. Published in association with Edizioni d'Arte Fratelli Pozzo, Turin, Italy.

New York, NY. The Louis Comfort Tiffany Foundation. *The Louis Comfort Tiffany Foundation 1989 Awards in Painting, Sculpture, Printmaking, and Craft Media*. 1990.

New York, NY. Museum of Modern Art. *Projects 40: Readymade Identities*. 1993. Text by Fereshteh Daftari. Brochure.

———. *Thinking Print: Books to Billboards 1980-95*. 1996. Text by Deborah Wye.

New York, NY. New Museum of Contemporary Art. *Strange Attractors: Signs of Chaos*. 1989. Text by Laura Trippi.

New York, NY. Solomon R. Guggenheim Museum. *Moving Pictures: Contemporary Photography and Video from the Guggenheim Collection*. 2003. Texts by Lisa Dennison, Nancy Spector, Joan Young, and John Hanhardt.

New York, NY. Whitney Museum of American Art. *BitStreams*. 2001. Texts by Lawrence Rinder and Debra Singer.

New York, NY. Whitney Museum of American Art at Equitable Center. *Dirt & Domesticity: Constructions of the Feminine*. 1992. Texts by Jesus Fuenmayor, Kate Haug, and Frazer Ward.

New York, NY. Whitney Museum of American Art at Philip Morris. *Elements: Five Installations*. 1987. Text by Kathleen Monaghan.

North Adams, MA. MASS MoCA. *Yankee Remix: Artists Take On New England*. 2004. Foreword by Joseph Thompson. Text by Laura Stewart Heon.

Paris, France. American Center. *Micromegas*. 1995. Text by Lynne Cooke. Brochure.

Paris, France. Fondation Cartier pour l'Art Contemporain. *êtrenature*. 1998. Texts by Marie Darrieissecq, Jacques Kerchache, Jacques Lacarrière, and Michel Onfray.

Paris, France. Centre Georges Pompidou. *Fémininmasculin*. 1995. Published in association with Gallimard/Electa, Paris, France.

Perth, Australia. Art Gallery of Western Australia and The UWA Perth International Arts Festival. *Seeking Transcendence*. 2005. Edited by Jenepher Duncan and Allan Watson. Text by John Stringer.

Philadelphia, PA. The Fabric Workshop and Museum. *New Material as New Media: 25 Years of The Fabric Workshop and Museum*. 2003. Edited by Kelly Mitchell. Foreword by Anne d'Harnoncourt. Text by Marion Boulton Stroud. Published in association with MIT Press, Cambridge, MA.

Pittsburgh, PA. Carnegie Museum of Art, Carnegie Institute. *Carnegie International 1991*. 1992. Texts by Lynne Cooke and Mark Francis. Published in association with Rizzoli, New York, NY.

———. *Carnegie International 1999*. 1999. 2 vols. Text by Madeleine Grynsztein.

St. Petersburg, Russia. The State Russian Museum. *Along the Frontier*. 1996.

San Francisco, CA. Capp Street Project. *Capp Street Project 1989–1990*. 1991. Text by David Lévi-Strauss.

San Jose, CA. San Jose Museum of Art. *Parallels and Intersections: Art/Women/California 1950–2000*. 2002. Edited by Diana Burgess Fuller and Daniela Salvioni. Published in association with the University of California Press, Berkeley, CA.

———. *The Not-So-Still Life: A Century of California Painting and Sculpture*. 2003. Texts by Susan Landauer, William H. Gerdts, and Patricia Trenton.

Santa Barbara, CA. Santa Barbara Contemporary Arts Forum. *Home Show: 10 Artists' Installations in 10 Santa Barbara Homes*. 1988. Texts by Dore Ashton and Howard S. Becker.

Santa Barbara, CA. Santa Barbara Museum of Art. *Five Artists*. 1988. Text by Kenneth Baker.

Santa Fe, NM. SITE Santa Fe. *Longing and Belonging: From the Faraway Nearby*. 1995. Texts by Bruce Ferguson and Vincent J. Varga.

Saratoga Springs, NY. The Tang Teaching Museum and Art Gallery, Skidmore College. *S.O.S. Scenes of Sounds: The Inaugural Exhibition of the Tang Teaching Museum and Art Gallery*. 2000. Preface by Charles A. Stainback.

———. *Work: Shaker Design and Recent Art*. 2001. Texts by Ian Berry and Tom Lewis.

Sydney, Australia. Art Gallery of New South Wales. *Jurassic Technologies Revenant: Biennale of Sydney*. 1996. Text by Lynne Cooke.

Venice, Italy. 47th Venice Biennale. *Presente, Passato, Futuro, 1965–1997*. Edited by Germano Celant. Published in association with Electa, Milan, Italy.

Vienna, Austria. Hochschule für Angewandte Kunst in Wien, Heiligenkreuzerhof. *Future Perfect*. 1993. Text by Dan Cameron.

Wilmington, DE. Delaware Center for the Contemporary Arts. *Ethereal and Material*. 2000. Introduction by Douglas Maxwell. Text by Dede Young.

Winston-Salem, NC. Southeastern Center for Contemporary Art. *Awards in the Visual Arts 9*. 1990. Text by Lucy R. Lippard.

Yokohama, Japan. The Japan Foundation. *Yokohama 2005: International Triennial of Contemporary Art*. 2005. Edited by Takatoshi Shinoda, Naomi Koyama, and Mikiko Tabata.

Yonkers, NY. The Hudson River Museum. *Hanging by a Thread*. 1997. Text by Ellen J. Keiter.

Books and General Reference

The American Art Book. London: Phaidon Press Ltd., 1999.

Arnason, H. H., ed. *History of Modern Art: Painting, Sculpture, Architecture, Photography*. New Jersey: Prentice Hall, 2003.

Bishop, Claire, ed. *Installation Art: A Critical History*. London: Tate Publishing, 2005.

Blocker, Jane. *What the Body Cost*. Minneapolis: University of Minnesota Press, 2004.

Brignano, Mary. *Curating the District: How the Pittsburgh Cultural Trust Is Transforming the Quality of Urban Life*. Pittsburgh: The Pittsburgh Cultural Trust, 2000.

Bruno, Giuliana. *Atlas of Emotion: Journeys in Art, Architecture and Film*. London: Verso Books, 2002.

Buck, Louisa. *Moving Targets: A User's Guide to British Art Now*. London: Tate Publishing, 1997.

Buskirk, Martha. *A Contingent Object of Contemporary Art*. Cambridge: MIT Press, 2003.

Constantine, Mildred, and Laurel Reuter. *Whole Cloth*. New York: Monacelli Press, 1997.

Debbaut, Jan, and Monique Verhaust, eds. *Van Abbemuseum: A Companion to Modern and Contemporary Art*. Eindhoven: Van Abbemuseum, 2002.

Diamonstein, Barbaralee. *Inside the Art World: Conversations with Barbaralee Diamonstein*. New York: Rizzoli, 1994.

Diepeveen, Leonard, and Timothy Van Laar. *Art with a Difference: Looking at Difficult and Unfamiliar Art*. Mountain View: Mayfield, 2001.

Drobnick, Jim, ed. *Aural Cultures*. Toronto: YYZ Books Publishing Co., 2004.

Farias, Agnaldo, ed. *Bienal 50 Anos, 1951–2001*. São Paulo: Fundação Bienal de São Paulo, 2001.

Fineberg, Jonathan David. *Art Since 1940: Strategies of Being*. New York: Harry N. Abrams, Inc., 1995.

Giannini, Claudia, ed. *Installations: Mattress Factory, 1990–1999*. Pittsburgh: Mattress Factory and the University of Pittsburgh Press, 2001.

Goldberg, RoseLee. *Performance, Live Art Since 1960*. New York: Harry N. Abrams, Inc., 1998.

Golden, Thelma, Lynn M. Herbert, Robert Storr, and Katy Siegel. *Art 21: Art in the Twenty-first Century*. New York: Harry N. Abrams, Inc., 2001.

Gould, Claudia, and Valerie Smith, eds. *5000 Artists Return to Artists Space: 25 Years*. New York: Artists Space, 1998.

Hobbs, Jack, Richard Salome, and Ken Vieth. *The Visual Experience*. 4th ed. Worcester: Davis Publishing, 2005.

Howell, John, ed. *Breakthroughs: Avant-Gardes Artists in Europe and America, 1950–1990*. New York: Rizzoli, 1991.

Jacob, Mary Jane, and Jackie Bass, eds. *Buddha Mind in Contemporary Art*. Berkeley: University of California Press, 2004.

Kämpf-Jansen, Helga. *Ästhetische Forschung*. Cologne: Salon Verlag, 2000.

Kissane, Sean, Catherine Marshall, Eimar Martin, Brenda Moore McCann, Ronan McCrea, Johann Mullan, Marguerite O'Molloy, and Karen Sweeney. *Irish Museum of Modern Art: The Collection*. Dublin: Irish Museum of Modern Art, 2005.

Klausner, Betty. *Touching Time and Space: A Portrait of David Ireland*. Milan: Charta, 2003.

Koumis, Matthew, ed. *Art Textiles of the World, USA*. Winchester: Telos Art Publishing, 2000.

Lacy, Suzanne, ed. *Mapping the Terrain: New Genre Public Art*. Chicago: The Art Institute of Chicago, 1995.

Marcoci, Roxanna, Diana Murphy, and Eve Sinaiko, eds. *New Art*. New York: Harry N. Abrams, Inc., 1997.

Matthew, Ray T., and F. DeWitt Platt. *The Western Humanities*. 4th ed. Mountain View: Mayfield Publishing Co., 2000.

McHale, Brian. *The Obligation Toward the Difficult Whole: Postmodernist Long Poems*. Tuscaloosa: The University of Alabama Press, 2004.

Meskimmon, Marsha. *Women Making Art: History, Subjectivity, Aesthetics*. London: Routledge, 2003.

Neff, Terry Ann R., ed. *Collective Vision: Creating a Contemporary Art Museum*. Chicago: Chicago Museum of Contemporary Art, 1996.

Okabe, Aomi. *Art Women Images—Global Women*. Tokyo: Saikisha, 2003.

de Oliveira, Nicolas. *Installation Art in the New Millenium*. London: Thames & Hudson, 2003.

Phillips, Lisa. *The American Century: Art & Culture 1950–2000*. New York: Whitney Museum of American Art in association with W. W. Norton & Company, Inc., 1999.

Piranio, Michelle, ed. *Sight Lines, Postwar to Contemporary: The Kohlberg, Kravis & Roberts Collection*. New York: Kohlberg Kravis Roberts & Co., 2005.

Plummer, Johanna, ed. *40 Years at the Institute of Contemporary Art*. Philadelphia: Institute of Contemporary Art, University of Pennsylvania, 2005.

Princenthal, Nancy, and Jennifer Dowley. *A Creative Legacy: A History of the National Endowment for the Arts Visual Artists' Fellowship Program 1966–1995*. New York: Harry N. Abrams, Inc., 2001.

Putnam, James. *Art and Artifact: The Museum as Medium*. London: Thames & Hudson, 2001.

Reckitt, Helena, ed. *Art and Feminism*. London: Phaidon Press Ltd., 2001.

Robert Lehman Lectures on Contemporary Art. New York: Dia Center for the Arts, 1996.

Rothfuss, Joan. *Bits & Pieces Put Together to Present a Semblance of a Whole: Walker Art Center Collections*. Minneapolis: Walker Art Center, 2005.

285

Sayre, Henry M. *A World of Art*. New Jersey: Prentice Hall, 1997.

——. *A World of Art*. New Jersey: Prentice Hall, 2000.

——. *A World of Art*. New Jersey: Prentice Hall, 2003.

Shere, Charles. *Notes on Artists and Musicians*. Berkeley: Charles Shere, 1992.

Simon, Joan. *Ann Hamilton*. New York: Harry N. Abrams, Inc., 2002.

——. *Ann Hamilton: An Inventory of Objects*. New York: Gregory R. Miller & Co., 2006.

Smith, Sidonie, ed. *Interfaces: Women/Autobiography/Image/Performance*. Ann Arbor: University of Michigan Press, 2003.

Solnit, Rebecca. *As Eve Said to the Serpent: On Landscape, Gender, and Art*. Athens: The University of Georgia Press, 2001.

Spector, Buzz. *The Bookmaker's Desire: Writings on the Art of the Book*. Pasadena: Umbrella Editions, 1995.

Spector, Nancy, ed. *Guggenheim Museum Collection: A to Z*. 2nd ed. New York: Guggenheim Museum Publications in association with Harry N. Abrams, Inc., 2001.

Stewart, Susan. *On Longing. Narratives of the Miniature, the Gigantic, the Souvenir, the Collection*. Durham: Duke University Press, 1993. Cover by Ann Hamilton.

——. *Crimes of Writing. Problems in the Containment of Representation*. Durham: Duke University Press, 1994. Cover by Ann Hamilton.

——. *Poetry and the Fate of the Senses*. Chicago: University of Chicago Press, 2002. Cover by Ann Hamilton.

——. *Columbarium*. Chicago: University of Chicago Press, 2003. Cover by Ann Hamilton.

——. *The Open Studio. Essays on Art and Aesthetics*. Chicago: University of Chicago Press, 2005. Cover by Ann Hamilton.

Taft, Hope, and Jacqueline Jones Royster. *Profiles of Ohio Women, 1803–2003*. Athens: The Ohio University Press, 2003.

Tanselle, G. Thomas, Peter F. Kardon, and Eunice R. Schwager, eds. *The John Simon Guggenheim Memorial Foundation 1925–2000, A Seventy-Fifth Anniversary Record*. New York: John Simon Guggenheim Memorial Foundation, 2001.

Vodvarka, Frank, and Joy Monice Malnar. *Sensory Design*. Minneapolis: University of Minnesota Press, 2004.

Von Drathen, Doris. *Vortex of Silence*. Milan: Edizioni Charta, 2004.

Whitford, Frank, Frank Zoellner, and Wieland Schmied. *The Prestel Dictionary of Art and Artists in the 20th Century*. Munich: Prestel, 2000.

Wilkins, David, ed., et al. *Art Past Art Present*. New Jersey: Prentice Hall, 2005.

Williams, Donald, and Barbara Vance Wilson. *From Caves to Canvas: An Introduction to Western Art*. 2nd ed. New York: McGraw-Hill, 1998.

Wyman, Marilyn. *Looking and Writing: A Guide for Art History Students*. New Jersey: Prentice Hall, 2003.

Selected Articles and Reviews

"1999 Venice Biennale on Track." *Art in America* 87, no. 2 (February 1999), p. 128.

Abbe, Mary. "Flour Power." *ARTnews*, September 1992, pp. 14, 16.

Abrams, Janet. "The Body and the Object, Ann Hamilton 1984–1996." *ID* 44, no. 1 (January/February 1997), p. 102.

"Accumulated Work." *Selvedge* 4 (January/February 2005), p. 11.

Adolphe, Jean-Marc. "Les Replis de l'Air: Meg Stuart." *Mouvement* 3 (December 1998).

——. "Porosité Contre Morosité: Meg Stuart/Ann Hamilton." *Journal de L'ADC*, January 1999.

"Air." *The Village Voice*, 22–28 January 2003, p. 68.

Aldrich, Hope. "The Little Train That Couldn't." *The Santa Fe Reporter*, 30 August–5 September 1995, p. 5B.

286

Allgårdh, Sophie. "Hör vad träet har att saga." *Svenska Dagbladet,* 15 June 2002, p. 7.

Almoslechner, Patrick. "Tanzbilder." *City Stadtzeitung,* 4–10 June 1999.

Ament, Deloris Tarzan. "Examining a Dream." *The Seattle Times,* 23 January 1992, p. C1.

Amort, Andrea. "Vom Zerstörten Anteil Unserer Gegenwart." *Kurier am Sonntag,* 6 June 1999.

Anderson, Jack. "Mysteries of Life in Images And Music." *The New York Times,* 23 July 2001, p. E5.

"Ann Hamilton." *The Print Collector's Newsletter* 23, no. 1 (March/April 1992), pp. 25–28.

"Ann Hamilton." *Art World,* June 2002, pp. 12–19.

"Ann Hamilton, 1984–1996: The Body and the Object." *Forum,* 1997, p. 29.

"Ann Hamilton à la Maison Rouge." *L'Humanité Hebdo,* 9 April 2005.

"Ann Hamilton at Columbus Museum of Art." *Spring Magazine for Members* 2 (2002).

"Ann Hamilton at Next Venice Biennale." *Flash Art* 31 (October 1998), p. 64.

"Ann Hamilton 'between taxonomy and communion.' " *La Prensa,* 13 April 1990, pp. 9, 12.

"Ann Hamilton: Gestures of the Bodies, Hand, Mouth and Voice, 2001." *Letter International,* Winter 2001, p. 110.

"Ann Hamilton: 'mantle.' " *Miami Art Museum News,* May/June 1998, p. 4.

"Ann Hamilton: Present Past, 1984–1997." *Art Junction,* Winter 1997/1998.

"Ann Hamilton to Represent United States at 1999 Venice Biennale." *Arts Ohio,* June 1999, pp. 1–3.

Anson, Libby. "Deep Pink Solace: An Interview with Ann Hamilton." *Make* 85 (September–November 1999), pp. 16–19.

Anspon, Catherine D. "The Art World Heats up This Spring." *Paper City,* March 2000.

"Appetit auf Exzentrische Dialoge?" *Berner Woche,* 26 August–1 September 1999.

" 'Appetite' ou l'Ode à la Peau." *Le Courrier,* 29 January 1999.

Apple, Jacki. "Ann Hamilton: The Capacity of Absorption." *High Performance #46* 12, no. 2 (Summer 1989), pp. 48–49.

Armitage, Diane. "Bird of Paradise." *The Magazine* 7, no. 7 (2000), pp. 15–17.

"The Art of Exhibition: The Carnegie International Mixed Whimsy and Inquiry." *Pittsburgh Post-Gazette,* 10 April 2000.

"Artworld: People." *Art in America* 86, no. 7 (July 1998), p. 112.

Atraus, Marc J. "Ann Hamilton's 'whitecloth.' " *Provincetown Arts,* Summer 1999, pp. 146–47.

"Arações em Três Pisos do Pavilhão." *O Estado de São Paulo,* 21 September 1991, pp. 6–7.

Austin, Tom. "São Paulo: International Bienal." *ARTnews,* December 1991, p. 143.

——. "Abstractly Fabulous." *Ocean Drive,* May 1998.

"Artworld: Awards." *Art in America* 86, no. 4 (April 1998), p. 136.

Ayers, Robert. "Meg Stuart: Not Really Dance at All." *Dance Theatre Journal London* 15, no. 1 (1999), pp. 8–11.

Bäckstedt, Eva. "Hamilton vill beröra sinnligt." *Kultur,* 30 September 2004, pp. 1, 4–5.

Bair, Jeffrey. "Exhibit Features Crying Wall, Gauze Tunnel." *The Columbus Dispatch,* 1999, p. 5E.

Baker, Kenneth. "Art Comes to Dinner in Santa Barbara." *San Francisco Chronicle,* 21 September 1988.

——. "Artists in Residences." *House & Garden* 161, no. 1 (January 1989), pp. 38, 40.

——. "Pennies from Heaven in Sea of Honey." *San Francisco Chronicle,* 25 March 1989, pp. C3, C8.

——. "Ann Hamilton: The San Diego Museum of Contemporary Art." *Artforum* 29, no. 2 (October 1990), pp. 178–79.

——. "Art Trek: Where No Critic Can See It Whole." *San Francisco Chronicle,* 1991, p. 37.

——. "The 1991 Carnegie International: Inwardness and a Hunger for Interchange." *Artspace,* January–April 1992, pp. 81–85.

——. "A Close Read of Main Library's Art." *San Francisco Chronicle,* 17 April 1996, pp. E1, E3.

———. "Public Artworks: San Francisco Main Library." *ARTnews,* October 1996, p. 144.

———. "Getting History All Tangled Up." *San Francisco Chronicle,* 1 July 2002, pp. D1–D2.

———. "Galleries." *San Francisco Chronicle,* 11 January 2003.

Balken, Debra Bricker. "Ann Hamilton at Louver." *Art in America* 80, no. 3 (March 1992), pp. 121–22.

Barnes, Tom. "The Trees of Life for Downtown." *Pittsburgh Post-Gazette,* 5 December 1995, pp. A1, A11.

Basa, Lynn. "Breaking the Glass Ceilings." *Fiberarts* 20, no. 3 (November/December1993), pp. 37–41.

Batchelder, Ann. "Hanging by a Thread: One Museum's Approach to Presenting Contemporary Fiber Art for the First Time." *Fiberarts* 25, no. 1 (Summer 1998), pp. 36–42.

Baudot, Francois. "Expo Bouche Par La!" *Elle,* 28 February 2005.

Baumgartel, Christian. "Bizarre Figuren." *Journal Frankfurt* 4 (1999), p. 46.

Bayley, Mary Murfin. "Collaboration of Dance and Art Is Playful Exploration of the Senses." *The Seattle Times,* 13 November 1998, pp. F1, F3.

"Behind the Scenes." *Museums Boston* 8, no. 1 (Spring/Summer 2004).

Benhamou-Huet, Judith. "Mystérieux Charme Contemporain." *Les Echoes,* 25 February–3 March 2005.

Benz, Stefan. "Wie Man Sich die Welt Einverleibt: Meg Stuarts Tanzstuck 'Appetite' im Frankfurter Mousonturm." *Darmstädter Echo,* 2 May 1999.

Berardi, Gigi. "On the Rise: Meg Stuart, Ann Hamilton, and Damaged Goods." *Dance Magazine,* February 1999, pp. 94–95.

Bernardina, Marta Dalla. "3e Biennale de Lyon." *Art Monthly,* February 1996, pp. 27–28.

Bernier, Jean-Jacques. "Ann Hamilton: Le Corps et l'Objet 1984–1997/mattering." *Vie des Arts* 42, no. 173 (Winter 1998/1999), pp. 44–46.

Bernstein, Fred A. "Quick Learner." *Elle Décor,* February/March 2001, pp. 14, 121–29.

———. "This Old Museum: The Aldrich Builds a New Home for Artists to Wreck." *The New York Times,* 6 June 2004, p. 26.

Beros, Nada. "It's Better to Keep Moving: An Interview with Robert Storr." *M'ars* 9, no. 3/4 (1997), pp. 49–59.

Birkland, Dave. "Flap over Canary Exhibit." *The Seattle Post-Intelligencer,* 16 February 1992, p. B2.

Bishop, Claire. "Installation Art? A Typology." *Henry Moore Institute Newsletter* 39 (December 2001/January 2002), p. 1.

Bjornland, Karen. "Tang Museum's 'S.O.S.' Exhibit Demonstrates Art of Sound." *The Schenectady Gazette,* 16 November 2000.

———. "Paper, Light Mark 'corpus': New Exhibit at MASS MoCA." *The Schenectady Gazette,* 29 January 2004.

Blanc, Dominique. "La Nature et Son Double." *Connaissance des Arts* 551 (June 1998), pp. 54–59.

Blaser, Agathe. "Die Zügel des Körpers lockern." *Berner Zeitung,* 28 August 1999.

"The Body and the Object: Ann Hamilton 1984–1996." *Artforum* 36, no. 5 (January 1998), p. 36.

"The Body and the Object: Ann Hamilton 1984–1996." *Dialogue Arts in the Midwest,* May/June 1996, p. 35.

"The Body and the Object: Ann Hamilton 1984–1996." *Miami Art Museum News,* March/April 1998, pp. 4–5.

Bohn, Donald Chant. "A Kinder, Gentler Museum?" *New Art Examiner* 19, no. 6/7 (February/March 1992), pp. 26–28.

———. "Ann Hamilton, The Institute of Contemporary Art." *New Art Examiner* 23, no. 3 (November 1995), p. 40.

Boisseau, Rosita. "Meg Stuart, Experte de la Dilatation des Corps." *Le Monde,* 6 March 1999.

Bonenti, Charles. "MASS MoCA Gets into Gear: 'Yankee Remix' Exhibition Rethinks Region's Heritage." *The Berkshire Eagle,* 23 May 2003.

——. "Ann Hamilton's Art Installation Speaks in Spaces." *The Berkshire Eagle,* 12 December 2003.

Bonetti, David. "Art Work for 'People's Palace.' " *San Francisco Examiner,* 15 April 1996, pp. B1, B3.

Bookhardt, D. Eric. "Awards in the Visual Arts: New Orleans Museum of Art, New Orleans, Louisiana." *Art Papers,* September/October 1990, pp. 59–60.

Borges, Luis Bizarro. "O Desejo Oculto de Abandono do Corpo." *Jornal de Notícias,* 9 April 1999, p. 59.

Boulbès, Carole. "Ann Hamilton: La Maison Rouge." *Art Press* 312 (May 2005), pp. 79–80.

Bouruet-Aubetot, Véronique. "Ann Hamilton La Veux du Contrepoint." *Beaux-Arts Magazine,* April 2005, p. 44.

Bowen, Christopher. "Moving On." *The Magazine of the Edinburgh International Festival,* July 1999.

Boxer, Sarah. "Is the Camera's Thrill Gone? Well, It's Trying to Liven Up." *The New York Times,* 17 August 2001, p. E28.

Boyi, Feng. "Art Reform in the Technical Age." *Art China,* 2002.

Brady, Brandon. "Global Warming: Experiences Abroad Shape Vibrant Exhibit at Weston Gallery." *Cincinnati City Beat,* 10–25 December 2002, p. 53.

Braten, Torill. "Meg Stuarts Appetite For Bevegelse og Dans." *Morgenbladet,* 2 October 1998, p. 12.

Bratt, Ann-Klara. "Konstbalansering på slak lina." *Tema: Kvinnokamp Feministisk Kulturtidskrift* 1 (2000), pp. 40–43.

"Brav-Auftakt Beim 'Tanz im August.' " *Lausitzer Rundschau,* 14 August 1999.

Brea, Jose Luis. "The Savage Garden: The Nature of Installation." *Flash Art* 24, no. 158 (May/June 1991), p. 129.

Brennan, Lissa. "Hanging Out in the Unknown." *Spectator,* 19–25 July 2001.

Brennan, Mary. "Dance: Appetite, Edinburgh Festival." *The Herald,* 23 August 1999.

Brenson, Michael. "A Transient Art Form with Staying Power." *The New York Times,* 10 January 1988, pp. 33, 36.

——. "Visual Arts Join Spoleto Festival U.S.A." *The New York Times,* 27 May 1991, pp. A11, A13.

Broderick, Ellen. "Art: Surveying the Carnegie International." *Carnegie Magazine* 61, no. 4 (July/August 1992), p. 7.

Broili, Susan. "Sound, Movement Breathe Life into ADF Performance." *The Melbourne Herald-Sun,* 20 July 2001, pp. C1, C8.

——. "To Get It or Not to Get It, That Is Question of 'mercy.' " *The Melbourne Herald-Sun,* 21 July 2001.

Brookman, Donna. "Collecting Experience: A Conversation with Steve Oliver." *Sculpture* 21, no. 8 (October 2002).

Brown, Gerard. "It's Illuminating: Lumen Reinvents Vision." *Philadelphia Weekly,* 7 June 1996, pp. 41–42.

Brown, Lynne. "Ann Hamilton." *New Art Examiner* 25, no. 7 (April 1998), pp. 50–51.

Brug, Manuel. "Die Erträgliche Leichtigkeit des Seins." *Die Welt* 5 February 1999.

de Brugerolle, Marie. "Ann Hamilton." *Parachute Art Contemporain* 90 (April–June 1998), pp. 33–35.

Brunetti, John. "palimpsest." *dialogue* no. 4 (September/October 1990), p. 24.

"CAA Awards, 1992." *Art in America* 80, no. 3 (March 1992), p. 152.

"Cafe Haig." *Art Monthly,* July/August 1999, p. 28.

Cahill, Timothy. "MASS MoCA Show Makes Postmodern Art out of the Artifacts of Old New England." *Albany Times Union,* 10 August 2003.

Cameron, Dan. "Art and Politics: The Intricate Balance." *Art + Auction,* November 1992, pp. 76–80.

———. "Art and Politics: The Intricate Balance." *Art + Auction,* January 1993.

———. "Sculpting the Town: Sonsbeek 93." *Artforum* 32, no. 3 (November 1993), pp. 89–90, 131.

———. "Two Years Before the Mast." *Artforum* 33, no. 7 (March 1995), pp. 11, 119.

Camhi, Leslie. "Animated by Belief." *The Village Voice,* 23 October 1993, p. 95.

Camnitzer, Luis. "Venice Biennial." *Art Nexus* 34 (November 1999–January 2000), pp. 56–61.

Campbell, Clayton. "Ann Hamilton." *Flash Art* 27 (October 1994), pp. 98–99.

Camper, Fred. "Don't Fence Them In: Ann Hamilton at Perimeter." *Chicago Reader* 29, no. 32 (12 May 2000), pp. 42–43.

"Capp St. Project." *Flash Art* 36 (January/February 2003), p. 44.

Carlier, Vera. "De Choreografie Meg Stuart Mag Het Seizoen Openen Van Het Vernieuwde, Kaaitheater." *Brussel Deze Week,* 9 September 1998.

"Carnegie International." *Tema Celeste,* January/February 2000, p. 104.

Carrier, David. "Pittsburgh: Carnegie International." *Burlington Magazine,* February 2000, pp. 128–29.

Casadio, Mariuccia. "Il Mondo di Ann." *Casa Vogue* 262 (May 1994), pp. 126–129, 164.

Cavener, Jim. "Interwoven Memories: Fiber Arts Exhibit Explores the Very Fabric of Our Youth." *Asheville Citizen-Times,* 27 February 2000, p. 134.

Cena, Olivier. "La Pensée Unique." *Telerama,* 9 March 2005, p. 70.

"Chelsea Passage." *Vogue,* April 1997, pp. 338–41.

Cheng, Scarlet. "California Grrls." *Los Angeles Times,* 29 September 2002.

Cho, Minjee. "Museum Roundup: The Body and the Object, Ann Hamilton 1984–1996." *ARTnews,* March 1998, p. 52.

Clifford, Andrew. "The Bittersweet Taste of Sadness." *New Zealand Herald,* 23 November 2005.

Clothier, Peter. "Santa Monica: Ann Hamilton, Ruth Bloom." *ARTnews,* September 1994, p. 182.

Codrescu, Andrei. "The Might of Bytes." *Architecture* 88, no. 1 (January 1999), p. 154.

Coffey, Mary Katherine. "Histories that Haunt: A Conversation with Ann Hamilton." *Art Journal,* Fall 2001, pp. 11–23.

Cohen, Keri Guten. "Cranbrook Exhibits Ask for Thinking." *Detroit News,* 9 January 2000.

Colby, Joy Hakanson. "If It Makes Your Skin Crawl, Cranbrook Show Is Doing Its Job." *Detroit News,* 7 January 2000, p. D12.

"College Art Association Award for Distinguished Body of Work, Exhibition, Presentation, or Performance." *College Art Association News,* March/April 1992, p. 6.

Collins, Bradford R. "Report from Charleston: History Lessons." *Art in America* 79, no. 11 (November 1991), pp. 64–71.

"The Conversation." *Minneapolis/St. Paul City Pages,* 28 October 1998, p. 29.

Cooke, Lynne. "Charleston, South Carolina: 'Places with a Past.' " *Burlington Magazine,* August 1991, pp. 572–73.

———. "Arnhem and Chicago: Outdoor Exhibitions of Contemporary Art." *Burlington Magazine,* November 1993, pp. 786–87.

———. "Micromegas." *Parkett* 44 (1995), pp. 132–45.

———. "The Ann Hamilton Experience." *Interview* 29, no. 7 (July 1999), pp. 54–56.

———. "Ann Hamilton: La Maison Rouge, Paris." *Artforum* 43, no. 8 (April 2005), p. 183.

Corbett, William. "Digesting the Big Apple." *Arts Media,* 15 November–15 December 2002, cover, pp. 29–31.

Coslovich, Gabriella. "Women Behaving Badly." *The Age,* 27 July 2001.

Cotter, Holland. "Messages Woven, Sewn or Floating in the Air." *The New York Times,* 9 January 1998, pp. E2, 37.

———. "Two Big Milestones and a Biennale." *The New York Times,* 14 March 1999, pp. 12, 39.

Cottingham, Laura. "Ann Hamilton: A Sense of Imposition." *Parkett* 30 (1991), pp. 130–38.

Cowan, Amber. "Art: Five Best Shows Nationwide." *The Times,* 10 March 2001.

Crawford, Anne. "Fun and Sexy: Women Showing a Little Attitude." *The Age,* 15 October 2001, p. 3.

Crevier, Lyne. "Tentacul(art)." *Ici,* 16–23 August 2001, p. 48.

"Critics' Top Picks for 2003-2004." *Art in America* 93, no. 2 (February 2005), pp. 33–34.

"Crossing: Performance." *(ai) Performance for the Planet,* Fall 2002.

Crowder, Joan. "Living Art Poses Question: Who is Watching Whom?" *Santa Barbara News Press,* 9 November 1985.

———. "Rub-a-Dub-Dub Art Critic in the Tub." *Santa Barbara News Press,* 10 June 1988.

Csaszar, Tom. "Installation Art in the 90s: Categories, Sculptures, Installations." *Sculpture* 15, no. 5 (May/June 1996), pp. 34–39.

Cubbitt, Sean. "Dispersed Visions: 'About Place'." *Third Text* 32 (Fall 1995), pp. 65–74.

Curtis, Cathy. "Thoughts on Ann Hamilton: 'the capacity of absorption.' " *Visions* 3, no. 13 (Spring 1989), pp. 15–17.

———. "Art Review: A Point of View on Swiss Artist Markus Raetz." *Los Angeles Times,* 3 May 1990, p. F8.

———. "Arnhem and Chicago: Outdoor Exhibitions of Contemporary Art." *Burlington Magazine,* November 1993, pp. 786–87.

Dagen, Philippe. "Ann Hamilton Réinvente la Préhistoire du Chant et du Dessin." *Le Monde,* 27 February 2005.

Damianovic, Maia. "Ann Hamilton." *Tema Celeste,* May/June 1997, p. 59.

Daniels, Barry. "The Challenge of Documenting the Artistic Process of Performance Art." *Gay People's Chronicle,* 25 February 1994, pp. 12–13.

Danto, Arthur C. "Art: Spoleto Festival U.S.A." *The Nation,* 29 July–5 August 1991, pp. 168–72.

Darling, Michael. "Home Show 2." *Art & Design* 11, no. 11/12 (November/December 1996), pp. 58–61.

Davis, Lisa. "Art: From the Mouths of Artists." *Grand Forks Herald,* 15 August 2003.

"De Part et d'Autre de la Peau: 'Appetite,' Chorégraphie de Meg Stuart." *DDO,* January/February 1999, p. 35.

Deitcher, David. "Art on the Installation Plan: MOMA and the Carnegie." *Artforum* 30, no. 5 (January 1992), pp. 78–84.

Deitz, Paula. "Buttressing an Old City with New Artistic Girders." *The New York Times,* 7 April 2000, pp. 35, 45.

Delgado, Jerome. "Une Ville, Un Canal, Deux Musées." *La Presse,* 26 May 2001.

Demeester, Ann. "Geabsorbeerd Worden Als Vorm Van Fysiek Contact." *De Morgen,* 9 September 1998.

———. "Een Omhelzing Wordt Een Gevecht." *De Morgen,* 11 September 1998.

"Dia Center for the Arts." *Sculpture* 13, no. 2 (March/April 1994), pp. 44–45.

Dobretsberger, Christine. "Sofiensale: 'appetite,' Bilder einer Vorstellung." *Wiener Zeitung,* 7 June 1999.

Dobrzynski, Judith H. "Visionary Installation at Venice Biennale." *The International Herald Tribune,* 29–30 May 1999, p. 6.

———. "Representing America in a Language of Her Own." *The New York Times,* 30 May 1999, sec. 2, pp. 1, 30.

———. "A Vision, A Journey." *The Columbus Dispatch,* 9 June 1999, p. 10E.

Domino, Christophe. "Maison Rouge, Hamilton a Mis le Ton." *Le Journal des Arts*, 18–31 March 2005.

Dorment, Richard. "All the Fun of the Art Fair." *The Daily Telegraph*, 16 June 1999, p. 21.

Dornbusch, Jane. "MASS MoCA Paints New Picture of Art for Children." *Boston Herald*, 1 July 2004.

Dosogne, Ludo. "Leuke Meg Stuart Stopt Publiek Onder de Dekens." *Gazet Van Antwerpen*, 17 September 1998.

Douglas, Anna. "Ann Hamilton." *Art Monthly*, March 1994, p. 29.

———. "A Choreography of Emotions." *Women's Art Magazine* 57 (March/April 1994), pp. 24–25.

Douglas, Sarah. "A Miracle! Apparently There Are No Influences on the Art of Now." *The Art Newspaper*, October 2001, p. 41.

Drake, Jeanette Wenig. "Behind the Scenes at the 2000 Biennial: Seasoned Artists, Sage Advice." *dialogue,* January/February 2001, pp. 21–22.

Drake, Nicholas. "Interview: Mary Jane Jacob." *Art Papers*, July/August 1991, pp. 72–73.

———. "Places Without Past: New Site-Specific Art in Charleston." *Art Papers*, July/August 1991, pp. 63–64.

———. "Interviews with Chris Burden, Christian Boltanski, Ann Hamilton." *Art Papers*, September/October 1991, pp. 25–27.

Drohojowska-Philp, Hunter. "It Ain't Needlepoint." *Los Angeles Times*, 19 June 1994, pp. 4, 79–80.

Dunlap, David. "A Chip Off the Old Park." *The New York Times*, 30 September 2004.

Dunne, Aidan. "The Tops for 2002." *The Irish Times*, 29 December 2001.

———. "The Seeing Mouth, the Speaking Eye." *The Irish Times*, 30 March 2002, p. 5.

Dunning, Jennifer. "Dance: Susan Hadley in 'Caught in the Middle.' " *The New York Times*, 24 March 1986, p. C14.

Eberle, Todd. "Site-Specific." *The New Yorker*, 12 April 1999, pp. 106–7.

Ebony, David. "Pittsburgh Cultural District Takes Shape." *Art in America* 88, no. 3 (March 2000), p. 39.

Echinard-Garin, Sophie. "Dans le Labyrinthe: Ann Hamilton." *Verso* 10 (April 1998), pp. 12–13.

Edit, Andras. "Ezredvegi Szamvetes." *Új Mûvészet*, October 1999, pp. 33–35.

Elias, Dan. "Yankee Nouvelle." *Arts Media*, September 2003.

Embrecht, Annette. "Niet Een, Maar Vijf Witte Jurken." *Volkskrant*, 26 April 1999, p. 9.

Enright, Robert. "The Aesthetics of Wonder: An Interview with Ann Hamilton." *Border Crossings*, May 2000, pp. 18–33.

Ericsson, Lars O. "Historier i marginalen." *Dagens Nyheter,* 31 August 1990, p. B3.

Erieux, Emma. "La Maison Rouge. Antoine de Galbert Foundation: An Art Center with New Incentives." *Arco: Contemporary Art* 32 (Summer 2004), pp. 46–47.

Erno, P. Szabo. "Nyitas, Minden Mennyisegben." *Új Mûvészet,* October 1999, pp. 29–32.

Evans, Peggie. "Live Birds in Art Exhibit Raise Debate." *University Herald*, 4 March 1992, pp. 1, 3.

"Eye: Art Class." *Women's Wear Daily,* 14 June 1999, p. 24.

Fanelli, Franco. "Are We Having Fun Yet?" *The Art Newspaper*, July/August 1997, pp. 17–20.

Farin, Manou. "Ann Hamilton: Qui Parle?" *L'Oïl*, April 2005, p. 26.

Faust, Gretchen. "Ann Hamilton: Louver." *Flash Art* 25 (March/April 1992), pp. 114–15.

Fazenda, Maria Jose. "A Desagregacao Dos Corpos." *Publico*, 9 April 1999, p. 10.

Feaver, William. "Notices: Festering Spectacles." *ARTnews*, March 1998.

———. "48th Venice Biennale." *ARTnews*, Summer 1999, p. 151.

Ferguson, Bruce. "In the Realm of the Senses." *Mirabella*, April 1992, pp. 62–64.

Ferrandi, George. "Interview with Ann Hamilton." *National Forum Phi Kappa Phi Journal* 81, no. 3 (Summer 2001), pp. 18–21.

Ferris, Alison. "Disembodied Spirits: Spirit Photography and Rachel Whiteread's 'Ghost.'" *Art Journal*, Fall 2003, pp. 45–53.

Findsen, Owen. "Animating Spaces." *The Cincinnati Enquirer,* 31 October 1999, pp. F1, F8.

"Flash Art News: Miami's Hot." *Flash Art* 35 (October 2002), p. 40.

"Flash Art News: Sonsbeek '93." *Flash Art* 26 (Summer 1993), p. 129.

Floyd, N. Megan. "New Henry Exhibit 'Engulfs' Viewer." *University Week*, 23 January 1992.

"Food: Event." *New York*, 8 November 2005, p. 55.

Fox, Judith Hoos. "Ann Hamilton's Lignum in Context." *Sculpture* 22, no. 4 (May 2003), pp. 46–51.

Francblin, Catherine. "Ann Hamilton." *Art Press* 232 (February 1998), pp. 80–81.

——. "Biennale de Venise 99: Les Temps Fort. Pavillon des Etats-Unis: Ann Hamilton." *Beaux-Arts Magazine*, June 1999, cover, pp. 82–93.

Franck, Elisabeth. "A Maison of His Own." *Departures*, March/April 2005.

Frank, Peter. "Better Vision through Spectacles." *Los Angeles Weekly,* 13–19 January 1989, p. 50.

Fraser, Marie. "Letter from Montreal: November 1998." *C Magazine* 60 (November 1998–January 1999), p. 47.

"Free University Regional Museums Class Attracts Student to the World of Art." *Williams College Newspaper,* 1999.

Freire, Norma. "A Arte Nos Passos d'Ann Hamilton." *O Estado de São Paulo,* 23 September 1991.

French, Christopher. "The Resonance of the Odd Object." *Shift-6*, 1989, pp. 46–48.

Freudenheim, Susan. "Striking Art Shows Sensual, Subtle." *San Diego Tribune,* 27 April 1990, p. C14.

Friedman, Lise. "Mercy On Us: Meredith Monk's Meditation On Outrage." *Elle*, August 2001, p. 63.

"Future-Present Melds with 'whitecloth.'" *Westport News*, 3 February 1999.

Gablik, Suzi and Ned Rifkin. "Value Beyond the Aesthetic." *Art Papers*, March/April 1992, pp. 26–30.

Gackle, Don. "Here and There." *McLean County Independent*, 7 August 2003, pp. 6–7.

Gann, Klyne. "The Moving Pencil Writes." *The Village Voice*, 18–24 December 2002, p. 67.

Garceau, Anne-Marie. "Ann Hamilton: Expérimenter Avant de Nommer." *Parachute*, October–December 1998, pp. 4–13.

Gardner, Karen. "Yankee Remix Brings New Works to MASS MoCA Galleries." *North Adams Transcript*, 11 April 2003.

Geer, Suvan. "The Cerebral, the Sensory, the Spiritual." *Artweek* 20, no. 4 (January 1989), p. 1.

——. "Adrift in the Primordial Sea: Ann Hamilton at La Jolla Museum of Art." *Artweek* 21, no. 18 (May 1990), p. 10.

——. "Reality and Its Representation: Ann Hamilton at Ruth Bloom Gallery." *Artweek* 25, no. 13 (July 1994), p. 21.

——. "Knowing and Naming: The Search for Tangible Meaning." *Artweek* 28, no. 6 (June 1997), pp. 18–19.

Gellatly, Andrew and Jorg Heiser. "Just Add Water." *Frieze* 48 (September/October 1999), pp. 66–71.

Genocchio, Benjamin. "Beyond Boredom." *The Weekend Australian*, 27–28 October 2001, p. R11.

Gibson, Jeff. "Virtually a Biennial: Conferences as a Prelude to the 10th Biennial of Sydney." *Flash Art* 28 (October 1995), p. 45.

Gilbert, Jenny. "Freudian Slips Can Make for Giant Leaps." *The Independent,* 29 August 1999, p. 7.

Gilmore, Jonathan. "Ann Hamilton at Sean Kelly." *Art in America* 90, no. 4 (April 2002), pp. 142–45.

Gilson, Nancy. "Body and Soul: Ann Hamilton Creates Artful Ambiguity." *The Columbus Dispatch,* 19 May 1996, p. G1.

———. "Hamilton Chosen to Create Installation for Venice Exhibition." *The Columbus Dispatch,* 29 May 1998.

———. "A Score of Stars: Artists and Entertainers Who Called Columbus Home." *The Columbus Dispatch,* 17 October 1999, pp. 1B, 4B–5B.

Giuliano, Mike. "Home Is Where the Art Is." *Baltimore City Paper,* 29 September 1999, pp. 29–30.

Gladstone, Valerie. "Three Easy Pieces." *ARTnews,* September 1991, p. 95.

Gladysz, Thomas. "Unusual Material Featured in Museum's Exhibits." *Berkeley Tri-City Post,* 26 August 1988.

"Gli Artisti della Biennale di Venezia." *Tema Celeste,* May/June 1999, p. 74.

Glowen, Ron. "Big Numbers, Ann Hamilton: 'accountings' at the Henry Art Gallery, University of Washington." *Artweek* 23, no. 9 (March 1992), pp. 18–19.

Glueck, Grace. "The Cars Aren't Exploding, but the Terrorist Metaphor Is." *The New York Times,* 18 February 2005, p. E39.

Godfrey, Tony. "Halifax, Liverpool and Dublin: Plensa, Hamilton, Gormley." *The Burlington Magazine* 136 (April 1994), pp. 253–54.

Goin, Chelsea Miller. "Sheri Simons: Infected Strains." *Fiberarts* 21, no. 1 (Summer 1994), p. 26.

Goodeve, Thryza Nichols. "Lipschtick Traces." *Artforum* 35, no. 2 (October 1996), pp. 9–10.

Gookin, Kirby. "Louver Gallery, New York: Ann Hamilton." *Artforum* 30, no. 6 (February 1992), p. 114.

Gouveia, Georgette. "Weaving an Exhibit on Fabric's Function." *Gannett Newspapers,* 21 October 1997, pp. C1, C3.

"Governor's Awards for the Arts." *The Columbus Dispatch,* 11 March 2005, p. D4.

Graeber, Laurel. "Making Art Young." *The New York Times,* 12 October 2003, p. 8.

Grahn-Hinnfors, Gunilla. "Under och uppochner." *Göteborgs-Posten Lördag,* 1 June 2002, pp. 50–51.

Grant, Annette. "Let 7 Million Sheets of Paper Fall: 'corpus' Fills a Cavernous Room with Crunches, Moans and Whispers." *The New York Times,* 11 April 2004, p. 31.

Grant, S. "Mega Death in Venice." *Blueprint* 163 (July/August 1999), p. 72.

Green, Frank. "Making Connections." *Northern Ohio Live,* September 2002, pp. 12–13.

Green, J. Ronald. "Maximizing Indeterminacy: On Collage in Writing, Film, Video, Installation and Other Artistic Realms (as well as the Shroud of Turin)." *afterimage: The Journal of Media Arts and Cultural Criticism* 27, no. 6 (June 2000), pp. 8–11.

Greenberg, Sarah. "The Marco Polo Biennale." *The Art Newspaper,* July/August 1999, pp. 30–33.

———. "Seeing Through the American Dream." *The Art Newspaper,* July/August 1999, p. 34.

Greene, David A. "Ann Hamilton." *Art Issues* 34 (September/October 1994), p. 42.

Griffin, Tim. "Ann Hamilton, 'filament.'" *Time Out New York,* 22–29 May 1996.

———. "Thread." *Time Out New York,* 25 September–2 October 1997, p. 43.

Guénard Éloïse. "Phora: Exposition Personnelle: Ann Hamilton." *Art 21,* March/April 2005, pp. 60–61.

Gumpert, Lynn. "Cumulus from America." *Parkett* 29 (1991), pp. 163–66.

Gutnick, Todd. "Decades-Old Vision of Riverfront Park a Reality." *Pittsburgh Tribune-Review,* 1 December 1998, pp. B1–B2.

Haase, Amine. "Versöhnung der Gegensatze: Harald Szeemann Rereint in Venedig das Scheinbar Unvereinbare." *Kunstforum International* 147 (September–November 1999), pp. 151–59.

Hackett, Regina. "Volunteers Leave Their Many Marks on Ann Hamilton's New Installation." *Seattle Post-Intelligencer*, 20 January 1992, pp. C1–C2.

——. "Hamilton Puts Art Underfoot, Overhead, All Around." *Seattle Post-Intelligencer*, 23 January 1992, p. C7.

——. " 'appetite' Serves Up Satisfying Twist of Dance and Art." *Seattle Post-Intelligencer*, 14 November 1998.

——. "Videos, Talking Heads, and a Multilingual Floor." *Seattle Post-Intelligencer*, 20 May 2004, p. F10.

Hall, Jacqueline. "Trilogy's Offbeat Final Phase is Shaped to Center's Oddity." *The Columbus Dispatch*, 21 October 1990.

——. "Eclectic Exhibit Challenges Viewers, Assumptions." *The Columbus Dispatch*, 30 June 1996.

Hamilton, Ann. "Ann Hamilton: A Text for 'privation and excesses.' " *Artspace* 14, no. 1 (November/December 1989), p. 59.

Hamilton, Ann and Wes Jackson. "The Tended Earth." *Grant Makers in the Arts*, Autumn 1996, pp. 1–5.

Hamlin, Jesse. "SF MoMA Chairman Offers a One of a Kind Gallery on His Geyserville Ranch." *San Francisco Chronicle*, 5 January 2005, pp. E1, E3.

Hanley, Elizabeth. "The Believers." *More*, October 2002, p. 6.

Harris, William. "Digging Venice." *Artforum* 36, no. 1 (September 1998), p. 60.

Hass, Nancy. "Living With Work That Needs Its Own Room," *The New York Times*, 9 August 1998, sec. 2, pp. 1, 33.

Haus, Mary. "Dia Center for the Arts, New York." *ARTnews*, January 1994, p. 157.

Heartney, Eleanor. "Elements: Five Installations." *ARTnews*, April 1988, p. 156.

——. "Strong Debuts." *Contemporanea* 2, no. 5 (July/August 1988), pp. 110–12.

Heller, Lori. "Flood Helps Design of Project." *Tribune-Review*, 20 March 1996.

Henn, Ulrike. ". . . Das Leben Wundervoll und Schwierig Machen." *ART: das Kunstmagazin* 12 (December 1989), pp. 92–100.

Hennequin, Annie. " 'Appetite': Dérangeant et Superbe a la Fois." *La Dépêche*, 11 March 1999.

Hilty, Kat. "Hayward Gallery London: Ann Hamilton Installations." *Harvard Architecture Review* 8 (1992), pp. ii, vi, 192, 200.

Hines, Thomas S. "Richard Meier: Bridging the Public and Private Realms in a Dallas House." *Architectural Digest* 54, no. 4 (April 1997), pp. 118–25, 214.

Hirsch, Faye. "Ann Hamilton." *Arts Magazine* 66, no. 7 (March 1992), p. 67.

——. "Art at the Limit: Ann Hamilton's Recent Installations." *Sculpture* 12, no. 4 (July/August 1993), pp. 32–39.

Hixson, Kathryn. "Chicago in Review." *Arts Magazine* 65, no. 3 (November 1990), p. 123.

——. "The 48th Venice Biennale." *New Art Examiner* 27, no. 1 (September 1999), pp. 22–23.

Ho, Cathy Lang. "Barrack-Room Bohemia." *Metropolis*, January/February 1994, pp. 52–55, 60.

Hoffman, Hank. "Connecting the Dots at Yale." *New Haven Advocate*, 21 March 2002.

Hogrefe, Jeffrey. "The U.S. Export to the Biennale; A SoHo Art Scene in Miami." *New York Observer*, 12 April 1999, p. 27.

"Holiday Gift: More Time to Spend with Art." *The Bennington Banner*, 8 December 2003.

Holmqvist, Åke. "Lågmäld och eftersinnad iscensättning i magasinet." *Norra Skåne*, 11 June 2002, pp. 10–11.

Holsbeek, Dan. "Van Abbemuseum Verrekent Tijdelijke Ruimten." *De Standaard*, 1996.

Holst-Ekström, Måns. "Magasinerade stämningar." *Sydsvenskan*, 11 June 2002, p. B3.

"Honorable Mentions: Ann Hamilton (The Body and the Object, 1984–1996 CD-ROM." *ID* 44, no. 4 (June 1997), pp. 73–77.

Hoorn, Jeanette. "48th Venice Biennale 1999." *Art & Australia* 37, no. 2 (1999), pp. 204–5.

Houdek, Richard. "Art and Entertainment Samplings." *Berkshire Home Style,* February 2004.

Hovey, Kendra. "Thinking Big." *Columbus Monthly* 25, no. 9 (September 1999), pp. 89–92.

Howell, John. "Alchemy of Edges." *Elle,* April 1990, p. 228.

Howell, Steven. "ArtCité Works Fan Out Across Montréal." *Press Republican,* 16–23 August 2001, pp. C1, C5.

Hubl, Michael. "USA." *Kunstforum International,* September/November 1999, pp. 90–91.

Hughes, Robert. "Mechanics Illustrated." *Time Magazine,* September 1993, p. 72.

Hughes, Robert, and Peter Plagens. "Beer Cans And Bellini?" *Newsweek,* 14 April 1997, p. 79.

Hugo, Joan. "Domestic Allegories." *Artweek* 19, no. 32 (October 1988), pp. 5–6.

———. "Ann Hamilton: Cocoons of Metaphors." *Artspace* 14, no. 1 (November/December 1989), pp. 54–59.

Hullinghorst, Joni. "The Currier Goes to New York." *The Keene Sentinel,* 8 November 2002.

Hunt, Ken. "Hamilton's 'accountings' Transforms the Henry." *The Daily of the University of Washington* 1, no. 3 (January 1992), pp. 1A–5A.

Hurwitz, Laurie. "A Public Space for Private Collections." *ARTnews,* April 2005.

Hutera, Donald. "Dance: Damaged Goods." *The Times,* 23 August 1999.

Iacobucci, Cara. "SPNEA and MASS MoCA: Mix It Up." *Nema News,* Fall 2003.

Iken, Fatima Dias. "Corpos Com 'appetite' Devorador." *O Comercio do Porto,* 9 April 1999, p. 21.

"In the Frame." *The Art Newspaper,* November 2004, p. 2.

"Indigo Blue (Installation, 1991)." *Art & Design* 11, no. 1/2 (January/February 1996). pp. 40–41.

"Inside the Massachusetts Museum of Contemporary Art, Which Brightened the Economy of North Adams, Massachusetts." *Fortune Small Business,* December 2004/January 2005, p. 9.

Ivry, Benjamin. "La Serenissima's 48th Biennale." *Art + Auction,* June 1999, p. 83.

Jaeger, William. "Visual Foods for Thought: Williams College Shows Share Dual Realms." *Times Union,* 2 April 2000, p. 12.

Jinker-Lloyd, Amy. "The 51st Carnegie International." *Art Papers,* January/February 1992, p. 64.

———. "Report from Pittsburgh: Musing on Museology." *Art in America* 80, no. 6 (June 1992), pp. 44–51.

Jodidio, Philip. "Vivant a Venise." *Connaissance des Arts* 563 (July/August 1999), pp. 44–47.

Johnson, Ken. "Ann Hamilton at Sean Kelly." *Art in America* 84, no. 9 (September 1996), p. 106.

———. "Ann Hamilton 'at hand.' " *The New York Times,* 23 November 2001, p. E34.

Johnson, Patricia C. "Outbound Captures Moments of a Decade." *Houston Chronicle,* 18 March 2000, pp. 7D–8D.

Jowitt, Deborah. "Marrying the Arts." *The Village Voice,* 18 December 2002.

Juliett, Neil. "Russians Rule at Week Two of Festival." *The Sunday Age,* 21 October 2001, p. 9.

Kargl, Silvia. "Tanzen Bis Zum Herumhupfen." *Salzburger Nachrichten,* 9 June 1999.

Karmel, Pepe. "Ann Hamilton: seam." *The New York Times,* 23 December 1994, p. C26.

Kastner, Irmela. "Ein Gruss an Arlene: Meg Stuart im Interview." *Tanzdrama,* 17 January 1999.

Kastner, Jeffrey. "Mary Jane Jacob: An Interview with Jeffrey Kastner." *Art & Design* 11, no. 1/2 (January/February 1996), cover, pp. 36–47.

Katz, Rachel. "New York Plans St. Petersburg Tribute." *The St. Petersburg Times,* 12 July 1996.

Katz-Freiman, Tami. "Ann Hamilton at the MOMA." *Studio: Israeli Art Magazine* 60 (February 1995), pp. 69–71.

———. "Ann Hamilton." *Art Papers,* September/October 1998, p. 40.

Keeley, Pam. "On What Counts: Living in Awe." *Reflex* 6, no. 2 (March/April 1992), pp. 8–9.

Kendricks, Neil. "Ann Hamilton: Crossing Borders, Both Real and Imagined." *San Diego Arts Calendar*, May 1990, p. 14.

Kerr, Merrily. "Sidney Felsen and the Artist Observed." *Art on Paper*, March/April 2004, pp. 26–28.

Kersels, Martin, et al. "A Thousand Words." *Artforum* 37, no. 1 (September 1999), pp. 142–56.

Ketcham, Diana. "700,000 Pennies for Her Thoughts." *The Oakland Tribune*, 28 March 1989, p. C3.

Keyes, Bob. "Haunting Images Lead to Spirited Exhibition. *Portland Press Herald*, 25 September 2003, p. 8D.

Kimmelman, Michael. "Searching for Some Order in a Show Based on Chaos." *The New York Times*, 15 September 1989, p. C20.

———. "At Carnegie 1991, Sincerity Edges Out Irony." *The New York Times*, 27 October 1991, pp. 31–34.

———. "Ann Hamilton." *The New York Times*, 10 May 1996, p. C23.

———. "Installation Art Moves In, Moves On." *The New York Times*, 9 August 1998, sec. 2, p. 1.

———. "The Art of the Moment (And Only for the Moment)." *The New York Times*, 1 August 1999, sec. 2, pp. 1, 34.

———. "Art Club: Twenty Years of Superstars and Shooting Stars." *The New York Times Magazine*, 24 October 1999, pp. 82–83.

———. "Creativity, Digitally Re-mastered." *The New York Times*, 23 March 2001, pp. B29, B38.

King, Elaine A. "Carnegie International Mattress Factory, Pittsburgh." *Sculpture* 2, no. 3 (May/June 1992), p. 95.

———. "Pittsburgh: 53rd Carnegie International/Carnegie Museum of Art." *Sculpture* 19, no. 4 (May 2000), pp. 75–77.

Kirshner, Judith Russi. "About Place: Art of the Americas." *Artforum* 34, no. 2 (October 1995), p. 106.

Kissick, John. "Feelin' Mighty Real (I Think): The 1999/2000 Carnegie International." *New Art Examiner* 28, no. 6 (March 2000), pp. 35–39.

Klaasmeyer, Kelly. "Video Visions a Provoking Canvas." *The St. Petersburg Times*, 28 June 1996.

———. "Caution: Swoon Zone." *Houston Press*, 20–26 April 2000, pp. 71–72.

Kneiss, Ursula. "Getanzte Gier nach Leben." *Der Standard*, 7 June 1999.

Kneller, Bettina. "Gequälte Kreaturen: Die Choreographie 'Appetite' im Frankfurter Mousonturm." *Main Echo*, 13 February 1999.

Knight, Christopher. "In Santa Barbara, Home Is Where the Art Is." *Los Angeles Herald Examiner*, 11 September 1988.

Koebel, Caroline. "Factory Outlet." *In Pittsburgh Newsweekly*, 17 September 1997, p. 35.

Kokke, Paul. "La Bonne Espérance Helpt Van Abbe Zinged Met Boomstammen." *ED*, 2 January 1996.

Koplos, Janet. "Report from the Netherlands: Parachuting into Arnhem." *Art In America* 81, no. 10 (October 1993), pp. 52–57.

———. "Reverie aan de Rivier." *Metropolis M* 4, no. 14 (August 1993), p. 30.

Koppman, Debra. "Parallels and Intersections: Art/Women/California, 1950–2000." *Artweek* 33, no. 5 (June 2002), pp. 6, 24.

Krainak, Paul. "Cabinet of Curiosities." *Afterimage* 24, no. 4 (January/February 1997), p. 20

Krider, Dylan Otto. "Outbound." *Houston Press*, 16–22 March 2000, p. 43.

Krinn, Linda. "Tangents: Art in Fiber." *Fiberarts* 14, no. 3 (May/June 1987), pp. 55–56.

Kunitz, Daniel. "The Art of the Familiar." *Harper's Magazine*, August 2002, pp. 72–78.

Kuspit, Donald. "Going, Going, Gone." *Art Criticism* 15, no. 1 (September 1999), pp. 71–97.

Kyriacou, Sotiris. "Previews: Ann Hamilton at the Irish Museum of Modern Art, Dublin." *Contemporary*, March 2002. p. 13.

"La Maison Rouge." *Flash Art* 37 (May/June 2004).

Lagnado, Lisette. "EUA Trazem Ann Hamilton para a Bienal de São Paulo." *Ilustrada,* 23 February 1991, p. 3.

Lamarche, Bernard. "Fragments de Rituels: Ann Hamilton Représentera les Etats-Unis a la Prochaine Biennale de Venise." *Le Devoir*, 10 October 1998, p. D9.

Landi, Ann. "Generation Next." *ARTnews*, Summer 1997, p. 30.

——. "Who Are the Great Women Artists?" *ARTnews*, March 2003, pp. 94–97.

"Larry Aldrich Foundation Award 2000." *Tema Celeste*, November/December 2000, p. 117.

Larson, Kay. "Coming Round Again." *New York*, 23 October 1989, pp. 149–150.

——. "Of Mice and Men." *New York*, 13 January 1992, pp. 65–66.

——. "Miro, Miro on the Wall." *New York*, 1 November 1993, p. 98.

——. "Women's Work (Or Is It Art?) Is Never Done." *The New York Times,* 7 January 1996, p. 35.

——. "Wild at Art: Ann Hamilton." *Mirabella*, September 1999, p. 105.

"The Last Great Love Affair." *The Denver Art Museum* 70 (14 February 1998).

Leddy, Kim. "Accessible Genius." *The Columbus Alive*, 5–11 June 1996, p. 10.

Leffingwell, Edward. "The Bienal Adrift." *Art in America* 80, no. 3 (March 1992), pp. 82–87, 135.

——. "Carnegie Ramble." *Art in America* 88, no. 3 (March 2000), pp. 86—92, 142.

Levin, Kim. "Art-Walk." *The Village Voice*, 5 January 1988, p. 84.

Lewine, Edward. "Art That Has to Sleep in the Garage." *The New York Times*, 26 June 2005, pp. E1, E26.

Ligon, Margy. "Library Verse." *Public Art Review* 10, no. 1 (Fall/Winter 1998), pp. 4–9.

Lillingtonn, David. "David Lillington Talks to Greg Hilty, One of the Curators of Doubletake." *Frieze* 4 (April/May 1992), pp. 12–13.

Lind, Angela. "Pionjärer vågar ta plats." *Kultur Konst*, 9 October 2004, pp. 1, 8–9.

Lipsyte, Sam. "The Relentless Approximation of Feeling." *Film Comment*, May/June 2002, pp. 20–21.

Lista, Marcella. "48th Biennale de Venise." *Parachute* 96, October 1999.

Lister, David. "Venetians Turn Blind Eye as Brit-Art Chums Invade for Biennale Bash." *The Independent*, June 1999.

Litt, Steven. "New Works with Too Few New Ideas." *The News and Observer,* 17 August 1990, pp. 5, 22.

——. "Exhibition of Today's Art a Triumph: Works at Carnegie Local and Global at Same Time." *The Plain Dealer*, 14 November 1999.

Lloyd, Ann Wilson. "Preserving Yankee History with International Ingenuity." *The New York Times*, 3 August 2003.

Lovelace, Carey. "Weighing in on Feminism." *ARTnews*, May 1997, pp. 40–45.

Lowry, Patricia. "Art on the Cutting Edge." *Pittsburgh Press,* 18 October 1991, p. C1.

——. "Park Utilizes Native Amenities." *Pittsburgh Post-Gazette*, 30 November 1998, pp. B1, B11.

Lunberry, Clark. "Theatre as Installation: Ann Hamilton and the Accretions of Gesture." *Mosaic* 37, no. 1 (March 2004), pp. 119–33.

Lunin, Lois. "Focus on Fiber; Reflections on the Venice Biennale." *Surface Design,* Fall 2000, pp. 36–39.

Lutticken, Sven. "Tegen Het Dorre Verstand." *Het Parooll*, 3 February 1996.

Luzina, Sandra. "Meg Stuart Tanzt Mit Appetit." *Der Tagespiegel*, 12 August 1999.

——. "Brot Fliegt Durch die Luft." *Der Tagespiegel*, 14 August 1999.

Lyttleton, Celia. "Biennale Fever." *Telegraph Magazine*, 1999, pp. 9–11.

MacAdam, Barbara A. "A Space for the 90s with the Spirit of '76." *ARTnews*, November 1997, pp. 82, 84.

———. "Warm Words." *ARTnews*, February 2001, p. 45.

Madoff, Steven Henry. "After the Roaring 80's in Art, A Decade of Quieter Voices." *The New York Times*, 2 November 1997, sec. 2, pp. 1, 45.

———. "Codes and Whispers." *Time*, 12 July 1999, p. 75.

———. "All's Fair." *Artforum* 37, no. 9 (September 1999), pp. 145–146.

Maiden, Emma. "Humid." *Venue*, February 2001.

Majcen, James. "Visual Artist to Showcase at Wexner." *The Ohio State Lantern,* 25 July 1996.

Maksymowicz, Virginia. "The Atelier Revisited." *Sculpture* 20, no. 6 (July/August 2001), pp. 38–43.

Malacart, Laura. "Sighting the Sites: Animal, Vegetable, or Mineral." *Make* 85 (September–November 1999), pp. 20–21.

Marincola, Paula. "Prisons, Temples, and Other Alternative Spaces." *ARTnews*, October 1995, pp. 61–62.

Marsching, Jane D. "Ridgefield, Connecticut." *Art Papers,* November/December 1999, p. 52.

Martin, Pierre. "La 48e Edition de la Biennale de Venise: Sous le Signe de la Liberté et de la Jeunesse." *Vie des Arts* 44, no. 176 (Autumn 1999), p. 70.

Martinez, Rosa. "Venetian Views: 2." *C Magazine* 68 (September–November 1999), pp. 26–27.

Martinho, Maria Ester. "Artista dos EUA coloca Besouros e 20 Mil Velas em Instalação na Bienal." *Ilustrada,* 28 August 1991, sec. 5, p. 1.

Maschal, Richard. "Dark Visions: Winston-Salem Exhibit Showcases Disturbing Images of Our World." *The Charlotte Observer,* 16 September 1990, pp. 1F–2F.

Maurer, David A. "Fore-Site: It's a New Way to Look at Art." *The Daily Progress*, 10 August 2000, pp. D1–D2.

Mauro, Lucia. "Appetite for Dance Grows at MCA." *PerformInk*, 23 October 1998, p. 19.

Mavrikakis, Nicolas. "Place Publique." *Voir*, 16–22 August 2001.

Maxwell, Douglas F. "Interview with Ann Hamilton and Sean Kelly." *Review*, June 1999, pp. 18–26.

———. "The 48th Biennale di Venezia." *Review*, September 1999, pp. 44–45.

Mayr, Bill. "Global Workplace, Columbus Address." *The Columbus Dispatch*, 12 January 2005.

McCormack, Derek. "Boo! Halloween Isn't All Costumes and Candy." *Saturday Night*, 28 October 2000, p. 54.

McGarrahan, Ellen. "In the Cards." *San Francisco Weekly*, 7–13 February 1996, p. 5.

McGee, Celia. "A Certified 'Genius' Tangles with Horsehair." *The New York Times*, 3 October 1993, sec. 2, p. 41.

McGee, Melanie. "A Stitch in Time." *Manhattan Express*, 17 March 2000, p. 26.

McGee, Robert. "Getting to the Heart of the 'matterings.' " *Border Crossings*, May 1999, pp. 68–69.

McQuaid, Cate. "Communing with the Ghosts of Technologies Past and Present." *Boston Sunday Globe*, 2 November 2003.

Meadows, Gail. "MAM Leaders Consider Sites for New Museum." *The Miami Herald,* 5 April 1998, p. 121.

"Meg Stuart/Damaged Goods with Ann Hamilton, Sewn Under the Lip of the Skin." *Performing Arts, 1998–1999*, 18 February 1999, p. 3.

"Meg Stuart Naar Edinburgh." *De Standaard*, 2 February 1999.

"Meg Stuart Rapproche La Danse et Les Arts Plastiques." *La Dépêche,* 9 March 1999.

Melkisethian, Angela. "Public Art Projects in the Seattle Region." *Sculpture* 23, no. 10 (December 2004), pp. 26–27.

Melrod, George. "Reviews: New York." *Sculpture* 13, no. 2 (March/April 1994), pp. 44–45.

"Menotti Blasts Spoleto Art." *Art in America* 79, no. 7 (July 1991), p. 25.

Mensing, Margo. "Dissolving Language: What the Unreadable Tells Us About Words." *Fiberarts* 23, no. 4 (January/February 1997), pp. 45–50.

Mertes, Lorie, Joan Simon and Tami Katz-Freiman. "Scents and Sensibility." *ARTnews*, December 1998, pp. 132–33.

Meulenbroek, Desiree. "Academische Boonstammen Schietente Kort." *ED*, 2 October 1996.

Micucci, Marjorie. "Ann Hamilton, 'phora': La Maison Rouge, Paris." *Questions de Femmes*, April 2005.

Midgette, Anne. "Few Words in a Poetry of Sound." *The New York Times*, 5 December 2002.

Mifflin, Margot. "Performance Art: What Is It and Where Is It Going?" *ARTnews*, April 1992, pp. 84–89.

Mileaf, Janine. "The House That Carrie Built: The Stettheimer Doll's House of the 1920's." *Art & Design* 11, no. 11/12 (November/December 1996), pp. 76–81.

Miller, Donald. "51st International True to Curators' Conception." *Pittsburgh Post-Gazette*, 19 October 1991.

———. "Proposed River Park a Vision in Green." *Pittsburgh Post-Gazette*, 9 December 1995, p. D5.

———. "Hamilton Displays Her Body of Work." *Pittsburgh Post-Gazette*, 7 September 1996, p. D8.

———. "Hamilton's Work is Full of Invention." *Pittsburgh Post-Gazette*, 19 October 1996, p. D7.

———. "Pittsburgh Riverfront Project." *Public Art Review* 8, no. 2 (Spring/Summer 1997), pp. 28–29.

———. "Part Way to a Park." *Pittsburgh Post-Gazette*, 5 December 1998, p. D12.

———. "Installation Art: A Trend That's Run Out of Steam." *Pittsburgh Post-Gazette*, 2 February 1999, p. G2.

Millet, Catherine. "La Biennale, 48th Exposition Internationale d'Art: Venice." *Art Press* 249 (September 1999), pp. 65–69.

Mirapaul, Matthew. "Making an Opera From Cyberspace, Tower of Babel." *The New York Times*, 16 December 2001, p. E2.

Mitchell, John E. "MoCA's Ream Room: Loose Papers Carry Weight." *North Adams Transcript*, 8 January 2004.

———. "Museum's Paper Exhibit a Tinderbox of Safety Issues." *North Adams Transcript*, 6 February 2004.

Mitchell, Julian. "All 'myein' and Betty Martin." *Modern Painters*, Autumn 1999, pp. 56–59.

"MoCA's Largest Gallery to Re-Open." *North Adams Transcript*, 11 December 2003.

Molzahn, Laura. "Meg Stuart/Damaged Goods." *Chicago Reader*, 23 October 1998, p. 37.

Montgomery, Robert. "Ann Hamilton." *ArtLies*, Winter 1998, p. 38.

Moore, Lynn. "Peacocks, a Pole, and Peace Get Volunteers High on Art." *The Gazette*, 22 November 1998, pp. A1–A2.

Moraes, Angelica. "Ibirapuera: A Invasão Japonesa." *Divirtas*, 20 September 1991, p. A9.

Morgan, Anne. "Beyond Post-Modernism: The Spiritual in Contemporary Art." *Art Papers*, January/February 2002, pp. 31–36.

Morgan, Anne Barclay. "Review of 'the body and the object: Ann Hamilton 1984–1996.' " *Sculpture* 18, no. 3 (April 1999), pp. 70–72.

———. "Food and the Senses in the Art of Ann Hamilton and Ursula Von Rydingsvard." *Copia* 3, no. 1 (2000), pp. 5–8.

Morgan, Margaret. "From Dada to Mama: Feminism, the Ready-Made and Contemporary Practice." *Binocular*, 1994, pp. 11–29.

Morgan, Stuart. "Thanks for the Memories." *Frieze* 4 (May 1992), pp. 7–11.

Morris, Gay. "Ann Hamilton at Capp Street Project." *Art in America* 77, no. 10 (October 1989), pp. 221, 223.

"Moving Pictures: Guggenheim Museum." *The Art Newspaper*, July/August 2002, p. 2.

300

Muchnic, Suzanne. "Venetian Finds." *Los Angeles Times,* 18 July 1999, pp. 6, 62.
Muhlemann, Marianne. "Eigenwillig Verstörende Grunge Ästhetik." *Der Bund,* 28 August 1999.
Muller, Katrin Bettina. "Meine Figuren Sind Keine Verlierer." *Die Tageszeitung,* 12 August 1999.
Murdock, Robert M. "Growing Obsession." *Review,* February 1998, pp. 19–20.
Murphy, Deborah. "A Ghostly Exhibition Illuminates." *The Times Record,* 30 October 2003.
Muschamp, Herbert. "Room for Imagination in a Temple of Reason." *The New York Times,* 12 May 1996, sec. 2, p. 54.
"Museum Preview." *Art in America 2003 Guide,* 2003/2004, p. 37.
"Museum Weaves Exhibition and Events." *Currents,* Fall 1997, p. 1.
"The National Exhibitions." *The Art Newspaper,* June 1999, p. 32.
"National News in Brief." *ARTnews,* Summer 1998, p. 53.
Nelson, Robert. "From the Sublime to the Terrifying." *The Age,* 20 October 2001, p. 20.
———. "A Sexy League for us to Ponder." *The Age,* 5 November 2001, p. 6.
"New Life for Art . . . and Ants." *Tate: The Art Magazine,* Winter 1997, p. 12.
"The New Season: Art." *The New York Times,* 7 September 2003, p. 100.
"News and Around-MASS MoCA." *Tema Celeste,* May/June 2003, p. 111.
"News and Coups." *The Aldrich Museum of Contemporary Art Museum News,* Summer 1998, pp. 14–15.
"News of the Print World: People & Places." *The Print Collector's Newsletter* 23, no. 5 (November/December 1992), p. 172.
"Next Biennale Confirmed for 1999." *The Art Newspaper,* December 1998, p. 9.
Ngai, Sianne. "Stuplimity: Shock and Boredom in 20th Century Aesthetics." *Postmodern Culture* 10, no. 2 (January 2000).
Nilsson, Håkan. "Upp och nedvända världen." *Dagens Nyheter,* 1 June 2002, p. B3.
Nobles, Barr. "700,000 Pennies—It's Art." *San Francisco Chronicle,* 25 March 1989, p. C3.
Ogawa, Alfredo and Miriam Scavone. "Veleidades, Vaidades e Variedades." *Veja São Paulo,* 25 September 1991, pp. 12–18.
Ohlin, Alix. "Ann Hamilton at MASS MoCA." *Art on Paper,* March/April 2004.
Ollman, Leah. "Artist Ann Hamilton Takes on New Borders in La Jolla Installation." *Los Angeles Times,* 29 March 1990, pp. F1, F4–F5.
Oppenheimer, Daniel. "The Way We Never Were: New England Revisited at MASS MoCA's Yankee Remix." *Valley Advocate,* 7–13 August 2003.
O'Sullivan, Michael. "Our Picks: Exhibition." *The Washington Post,* 24 October 2003, p. 3.
"Our National Image." *The Miami Herald,* 7 June 1999, p. 2E.
Pachikara, Cynthia. "Intimate Parallels Between Installation and Wearable Art." *Metalsmith* 15, no. 3 (Summer 1995), pp. 32–37.
Packer, William. "Never Mind the Art, Switch on the Video." *Financial Times,* June 1999, p. 17.
Pagel, David. "Ann Hamilton." *Arts Magazine* 63, no. 7 (March 1989), p. 76.
———. "Vexed Sex." *Art Issues* 9 (February 1990), pp. 11–16.
———. "Still Life: The Tableaux of Ann Hamilton." *Arts Magazine* 64, no. 9 (May 1990), pp. 56–61.
———. "Ann Hamilton." *Lapiz International Art Magazine,* June 1990, p. 67.
"Paris: La Maison Rouge, Ann Hamilton: 'phora.'" *Contemporary,* June 2005, pp. 52–53.
Pearson, Clifford A. "Michael Van Valkenburgh Takes People for a Walk Over the Water's Edge in His Design for Pittsburgh's Allegheny Riverfront Park." *Architectural Record* 188, no. 3 (March 2000), pp. 102–5.
Pedrosa, Joao. "Carnegie International 1999/2000." *Casa Vogue* 23, no. 10 (2000), pp. 230–31.
Peiken, Matt. "'mercy' Gently Blends Music, Video into Hypnotic Show." *Pioneer Press,* 21 February 2002, p. 9E.

Percival, John. "The Naked and the Ridiculous." *The Independent*, 24 August 1999.

Phillips, Patricia C. "Social Spaces." *Artforum* 26, no. 9 (May 1988), p. 148.

———. "Ann Hamilton: Dia Center for the Arts." *Artforum* 32, no. 6 (February 1994), p. 90.

Pincus, Robert L. "Hamilton's Artwork Has Teeth to It: Everyday Items Used in Huge Installations." *The San Diego Union-Tribune*, 6 April 1990, pp. E1, E14.

———. "Hamilton's Obsessive, All-Encompassing Art Envelops the Viewer." *The San Diego Union-Tribune*, 16 February 1992, p. E5.

———. "Pride Shows in Seattle's New Museum." *The San Diego Union-Tribune*, 16 February 1992.

———. "World-Class Exhibition: Carnegie International Takes an Ambitious Look at the Art of the Moment." *The San Diego Union-Tribune*, 21 November 1999, pp. E1, E10–E11.

Plagens, Peter. "Talent Pool." *Newsweek*, 28 June 1999, pp. 42–45.

———. "A Visionary Hits Venice." *Newsweek*, 12 July 1999, p. 65.

———. "Folk's Art." *Artforum* 40, no. 1 (September 2001), p. 45.

Ploebst, Helmut. "Confetti in the Sound Desert." *Ballet International,* November 1998, pp. 49–50.

———. "The Flesh Is Stronger Than the Word." *Ballet International*, February 1999, pp. 20–23.

———. "Verdammte im Paradies." *Der Festwochen Standard,* 20 May–20 June 1999.

———. "Verbeulte Götter." *Die Wochenzeitung,* 26 August 1999, p. 21.

Politi, Giancarlo. "The Venice Biennale." *Flash Art* 32 (October 1999), pp. 76–80.

Pollack, Barbara. "A Sean Kelly Production." *Art + Auction*, July/August 1999, p. 32.

———. "Divine Inspiration." *ARTnews,* October 1999, p. 144.

———. "Modern Times; the Trouble with Tastefulness at MoMA." *Art + Auction*, February 2005, pp. 84–87.

Porges, Maria. "Learning by the Skin." *Shift-6*, 1989, pp. 50–51.

———. "Ann Hamilton." *Shift-6*, 1991, pp. 38–41.

Porges, Tim. "Ann Hamilton." *New Art Examiner* 25, no. 5 (January 1998), pp. 60–61.

Potter, Chris. "Far Away, So Close: The Carnegie International Explores Boundaries in a Complicated World." *Pittsburgh City Paper,* 3–10 November 1999, pp. 18–23.

"Prints and Photographs Published: Ann Hamilton." *The Print Collector's Newsletter* 23, no. 1 (March/April 1992), p. 25.

"Progressive Architecture Awards: Awards for Architectural Research." *Architecture*, January 1997, p. 59.

Provenzano, Frank. "Peeling Away Layers of Skin Utterly Surreal." *Farmington Observer*, 9 January 2000, pp. C1–C2.

"Public Art Hits Puerto Rico." *Artnet Online*, 14 September 2004.

Raspail, Thierry. "Musée d'Art Contemporain de Lyon: Productions, Generic Works, Moments, Complicity and Mobility." *Arco: Contemporary Art* 36 (Summer 2005), pp. 64–67.

Rau, David D. "Skin: Cranbrook Art Museum." *New Art Examiner* 28, no. 8 (April 2000), p. 55.

Reardon, Valerie. "Humid." *Art Monthly*, April 2001, pp. 36–37, 245.

Regnier, Phillipe. "Ann Hamilton en Péronne." *Le Journal des Arts*, 21 November 1997, p. 172.

Reid, Calvin. "Spoleto USA." *Arts Magazine* 66, no. 2 (October 1991), pp. 104–6.

Restany, Pierre. "The Biennale of Global Culture." *Domus* 819 (October 1999), pp. 99–110.

"Reviews International: Istanbul Biennial." *ARTnews,* December 2003, p. 128.

Rice, Robin. "Hungry Eyes." *Philadelphia City Paper*, 19–26 May 1995, p. 25.

Richison, Nancy. "The Wexner Goes High-Tech." *Columbus Monthly* 23, no. 4 (April 1997), p. 11.

Rimanelli, David. "Ann Hamilton: Dia Center for the Arts, New York." *Frieze* 15 (March/April 1994), pp. 59–60.

Ritchie, Matthew. "Love, Sweat, and Tears: Ann Hamilton, Jason Rhoades, Brian Tolle, Andrea Zittel." *Flash Art* 31 (November/December 1998), pp. 78–81.

Robertson, Allen. "Nouvelle Cuisine Hunger Pangs." *The Scotsman,* 23 August 1999.

Robinson, Walter. "Weekend Update." *Artnet Online,* 24 June 2002.

Rockwell, John. "Stretching Traditional Art and Inviting Other Arts In." *The New York Times,* 24 September 2004, p. E3.

"Rocky Read. The New Museum of Contemporary Art has Issued the Latest in Its Benefit Limited Editions Sculpture Project." *The Print Collector's Newsletter* 23, no. 5 (November/December 1992), p. 172.

Roland, Marya. "Southeast: Asheville." *Art Papers,* July/August 2000, p. 30.

Roos, James. "Singer Goes Beyond the Music." *The Miami Herald,* 1 March 2002, p. 36G.

———. " 'mercy' is Strange, Yet Oddly Inviting." *The Miami Herald,* 9 March 2002, p. 5E.

Roos, Robbert. "Geur Van Vers Gekapt Hout Zorgt Voor Sensatie." *Trouw,* 17 February 1996.

Rothman, Sabine. "Why Is Blue America's Favorite Color?" *House & Garden* 171, no. 4 (April 2002), pp. 174–81.

Row, D. K. "Mixing It Up with the Ann Hamilton Experience." *The Oregonian,* 11 April 2005.

Rowlands, Penelope. "Micromegas." *ARTnews,* September 1995, pp. 151–52.

Rudenauer, Meinhard. "Die Performance-Schiene der Wiener Festwochen: Tanzlektion im Kunstlabor." *Täglich Alles,* 2 June 1999, p. 4.

Rush, Michael. "Whitecloth: Ann Hamilton at The Aldrich Museum." *Art New England,* April/May 1999, p. 22.

———. "whitecloth." *Review,* March 1999.

———. "Starting with Fabric, Branching into Everything," *The New York Times,* 2 February 2003, p. 35.

Rushing, W. Jackson. "Ann Hamilton at MASS MoCA." *Art on Paper,* March/April 2004, p. 72.

Rushworth, Katherine. "The Human Body Speaks." *The Syracuse Post-Standard,* 4 January 2004.

de Rycke, Lisa. "Avec 'Appetite,' Meg Stuart Explore les Plis de l'Epiderme." *Le Temps,* 29 January 1999.

Saccoccia, Susan. "Maker of Huge Art Builds a 'Mystery.' " *Christian Science Monitor,* 6 August 1999, p. 20.

Saldo, Carrie. "Liz Lerman Dance Exchange 'Connects the Dots.' " *North Adams Transcript,* 17 June 2004.

"São Paulo Forecast." *Art in America* 79, no. 9 (September 1991), p. 160.

Saunders, Wade. "Making Art, Making Artists: The Assistant Question." *Art in America* 81, no. 1 (January 1993), pp. 70–95.

Saurisse, Pierre. "Artiste du Mois: Ann Hamilton." *Beaux-Arts Magazine,* January 1998, p. 23.

Saxe, Alicia. "The Subject Becomes the Object." *The Sun Post,* 16 April 1998.

Schapiro, Mark. "The Bay Area: The Persistence of Light." *ARTnews,* December 1989, pp. 132–137.

Scherr, Apollinaire. "Keeping Two Talents in Balance." *The New York Times,* 15 July 2001, sec. 2, pp. 4, 18.

Schjeldahl, Peter. "Festivalism: Oceans of Fun at the Venice Biennale." *The New Yorker,* 5 July 1999, pp. 85–86.

Schlagenwerth, Michaela. "Tanz: Luft in der Hose." *Berliner Zeitung,* 13 August 1999.

Schmerler, Sarah. "Temporarily Possessed." *Time Out New York,* 6–13 December 1995, p. 33.

———. "Ann Hamilton: Biennale Fever." *ARTnews,* May 1999, pp. 5–6.

Schmidt, Jochen. "Federballe aus Teig." *Frankfurter Allgemeine Zeitung,* 5 February 1999.

Schuman, Aaron. "A Breath of Fresh Air." *Modern Painters,* December 2004/January 2005, pp. 57–59.

Schwabsky, Barry. "Report: 48th Venice Biennale." *art/text* 67 (November 1999/January 2000), pp. 40–41.

Schwalb, Harry. "The Mattress Factory: 'Flexibility, Innovation and Risk.' " *ARTnews*, September 1997, pp. 43–44.

——. "Carnegie International: Carnegie Museum of Art." *ARTnews*, January 2000, p. 170.

Schwartzman, Allan. "Ann Hamilton: Room for Interpretation." *Interview,* December 1992, p. 42.

Scott, Michael. "Ghost Images: Ann Hamilton's VAG Exhibit Undermines the Power of the Written Word." *Vancouver Sun*, 23–30 December 1999.

Seijdel, Jorinde. "Ann Hamilton en de Vraag om Terughoudendheid." *Kunstkroniek,* 25 March 1996, p. 11.

Serbelloni, Alberico Cetti. "Al Diavolo I Calcoli dell'Economista!" *Tema Celeste*, September 1999, p. 7.

Shapiro, Linda. "Body Shots." *City Pages*, 20 February 2002, p. 36.

Shearing, Graham. "Factory Works in Limelight." *Pittsburgh Tribune-Review*, 23 September 1997, p. C6.

Sheets, Hilarie M. "Review: Ann Hamilton at Sean Kelly." *ARTnews*, February 2002.

Shere, Charles. "The Mess Hall." *Headlands Journal,* 1991, pp. 28–36.

Shermeta, Margo. "Ann Hamilton: Installations of Opulence and Order." *Fiberarts* 18, no. 2 (September/October 1991), pp. 30–35.

Siegel, Katy. "Rad Weather." *Artforum* 37, no. 9 (September 1999), p. 149.

Siegmund, Gerald. " 'Ich Habe Eine Komödie Gemacht': Befragt, Meg Stuart." *Frankfurter Allgemeine Zeitung*, 3 February 1999.

Simon, Joan. "Temporal Crossroads: An Interview with Ann Hamilton." *Kunst & Museum-journaal* 6, no. 6 (1995), cover, pp. 32–36, 51–60.

——. "Ann Hamilton: Carrefours Temporels." *Art Press* 208 (December 1995), cover, pp. 21–30.

——. "Report from San Francisco: Art for Tomorrow's Archive." *Art in America* 84, no. 11 (November 1996), pp. 40–47.

——. "Ann Hamilton: Inscribing Place." *Art in America* 87, no. 6 (June 1999), cover, pp. 76–85, 130.

——. "whitecloth." *Art in America* 87, no. 6 (June 1999).

Simonian, Karen. "The Wexner: One Stop, Three Summer Exhibits." *The Other Paper,* 4–10 July 1996.

Smallwood, Lyn. "Why the Caged Bird Sings." *Seattle Weekly*, 29 January 1992, pp. 39–40.

——. "Ann Hamilton: Natural Histories." *ARTnews*, April 1992, pp. 82–83.

Smith, Richard. "Ann Hamilton." *New Art Examiner* 16, no. 8 (April 1989), pp. 55–56.

Smith, Roberta. "Social Spaces." *The New York Times*, 12 February 1988, p. C17.

——. "Ann Hamilton: Malediction." *The New York Times*, 20 December 1991, p. C25.

——. "A Conceptual Face-Off at 2 Whitney Branches." *The New York Times,* 26 June 1992, p. C22.

——. "Ann Hamilton: 'tropos.' " *The New York Times*, 22 October 1993, p. C24.

——. "When Context Outshines Content." *The New York Times*, 24 September 1999, p. E31.

Smith, Sid. "Meg Stuart Dance at the MCA." *The Chicago Tribune*, 30 October 1998.

Söderholm, Carolina. "Good Even as a Book." *Kristianstadsbladet,* 30 May 2005.

Solnit, Rebecca. "Ann Hamilton: 'privation and excesses'." *Artweek* 20, no. 14 (April 1989), p. 5.

——. "On Being Grounded: Ann Hamilton Talks About the Values Informing Her Work." *Artweek* 21, no. 13 (April 1990), p. 20.

——. "The View from Mount Venus/On the Aesthetic of the Exquisite." *Art Issues* 48 (Summer 1997), pp. 23–27.

——. "From the Studio to the Sweatshop, and Back Again." *Art Issues* 58 (Summer 1999), pp. 27–29.

Solomons Jr., Gus. "Meredith Monk: A Voice in Motion." *Dance Magazine*, July 2001, pp. 47–49, 70–71.

Sorkin, Jenni. "The Carnegie International: Carnegie Museum of Art, Pittsburgh." *Art Monthly*, December 1999/January 2000, pp. 28–30.

de Souza, Okky. "Festa de Penetras." *Veja São Paulo,* 2 October 1991, pp. 102–3.

Sozanski, Edward J. "Sight-and-Sound Installation Takes over ICA." *The Philadelphia Inquirer,* 23 May 1995, pp. E1, E3.

Spaeth, Kathryn. "Mercy: An Interview with Ann Hamilton." *dialogue,* November/December 2001, pp. 49–51.

Sparks, Amy. "Ann Hamilton." *dialogue,* May/June 1992, pp. 13–15.

Spector, Buzz. "A Profusion of Substance." *Artforum* 28, no. 2 (October 1989), pp. 120–28.

——. "Residual Reading: the Altered Books of Ann Hamilton." *The Print Collector's Newsletter* 26, no. 2 (May/June 1995), pp. 55–56.

Staniszewski, Mary Anne. "The Body and the Object: Ann Hamilton 1984–1996." *Artforum* 36, no. 5 (January 1998), p. 36.

Stanley, Alessandra. "What's Doing in Venice." *The New York Times,* 23 May 1999, p. 13.

Staude, Sylvia. " …Dass Wir Immer Alles Wollen: Ein Gespräch Mit der Choreographin Meg Stuart." *Frankfurter Rundschau,* 3 February 1999.

——. "Alarm im Herzen: Meg Stuarts und Ann Hamiltons 'appetite' im Mousonturm." *Frankfurter Rundschau,* 2 May 1999.

Stearns, Robert. "Genius: Imagine What Could Happen." *dialogue,* January/February 2002, pp. 32–36.

Steele, Mike. "Meg Stuart's 'appetite' a Lighter Treat." *Star Tribune,* 4 November 1998.

——. " 'Appetite' Is Compelling, Quirky, but Its Meaning Remains Elusive." *Star Tribune,* 6 November 1998, p. B6.

Storr, Robert. "Prince of Tides." *Artforum* 37, no. 9 (May 1999), pp. 160–65, 194.

——. "No Stage, No Actors, but It's Theater (and Art)." *The New York Times*, 28 November 1999, sec. 2, pp. 1, 48.

Straus, Marc J. "Ann Hamilton's 'whitecloth'." *Provincetown Arts,* Summer 1999, pp. 146–47.

"Stuart's 'appetite' for Transformation." *Austria Today,* 2 June 1999.

Suh, Sang Suk. "Ann Hamilton." *Wolganmisool*, August 2004, pp. 111–15.

Supree, Burt. "Misalliances." *The Village Voice*, 15 April 1986, p. 88.

Swed, Mark. "In 'mercy,' Looking for Truths in Human Nature." *Los Angeles Times*, 16 February 2002.

Teltsch, Kathleen. "A 1993 MacArthur Award Adds New Joy to a Singer's Hallelujahs." *The New York Times,* 15 June 1993, p. B10.

Temin, Christine. "Hamilton Installation Explores the Link Between Body and Word." *The Boston Globe,* 29 October 1992, pp. 53–57.

——. "Two from List to Organize Pavilion for Venice Biennale." *The Boston Globe,* 29 May 1998, p. C13.

——. "Cutting-Edge Art Draws Blood at MFA." *The Boston Globe,* 22 September 1999, p. E6.

——. "New Museum Debuts with Sound, Muniz." *The Boston Globe*, 12 November 2000.

——. "Red, White, and Pink Cellophane." *The Boston Sunday Globe,* 18 May 2003, cover.

——. "Past Becomes Present in Sophisticated 'Yankee Remix.' " *The Boston Sunday Globe,* 3 August 2003.

——. "Life's Rhythms Quietly Revealed in a Snowstorm of Floating Paper." *The Boston Globe,* 21 July 2004.

——. "Ohioan's Installation in Boston Dazzling." *The Columbus Dispatch*, 1 August 2004, p. D4.

Temko, Allan. "Great Thing Comes in So-So Package." *San Francisco Chronicle*, 18 April 1996, pp. 32, 42.

Thea, Carolee. "Venice Biennale 1999." *Sculpture* 18, no. 8 (October 1999), pp. 85–87.

———. "Ann Hamilton: Aldrich Museum." *Sculpture* 19, no. 3 (April 2000), pp. 65–67.

"The Third Lyon Biennale of Contemporary Art." *Art Press* 208 (December 1995), p. 21.

Thomas, Mary. "Sculpting a Show." *Pittsburgh Post-Gazette*, 28 August 1999, p. C12.

———. "State-of-the-International Address." *Pittsburgh Post-Gazette*, 28 November 1999, pp. G3–G5.

Thompson, Chris. "Mixing Mediums: 'The Disembodied Spirit' at Bowdoin College." *The Portland Phoenix*, 17 October 2003.

Tillmans, Wolfgang. "Tom Ford and Ann Hamilton with Wolfgang Tillmans." *Index*, September/October 1999, pp. 66–74, 77–78.

Tirapelli, Percival. "Vanguarda e Pós-Modernidade na Bienal: a XXI Bienal Internacional de São Paulo e o Esquema Geral da Nova Objectividade de Hélio Oiticica." *ARTEunesp* 9 (1993), pp. 241–49.

T'Jonck, Pieter. "Meg Stuart Vindt Lichtere Toonaard." *De Standaard,* 12 September 1998.

Topos, Greg. "Something New to Lick At." *The Santa Fe New Mexican*, 6 September 1995, p. A1.

Tracy, Allison. "Liz Lerman: Dance Democracy." *The Berkshire Eagle*, 18 June 2004.

Tranberg, Dan. "Collector Is Determined to Push Boundaries." *The Plain Dealer*, 9 May 2004.

Trebay, Guy. "Front Row." *The New York Times*, 19 February 2002, p. B10.

Troncy, Eric. "Germano Celant: Le Voyage du Commissaire." *Art Press* 225 (June 1997), pp. 48–55.

Turino, Kenneth. "Artists Mix It Up." *Historic New England*, Summer 2003.

Turner, Elisa. "Artist Weaves Tapestry of History with Ageless Elements." *The Miami Herald*, 5 April 1998, p. 11.

———. "Powerful Works Challenge Senses, Explore Life Styles." *The Miami Herald*, 5 April 1998, p. 31.

Ullrich, Polly. "Beyond Touch: The Body as Perceptual Tool." *Fiberarts* 26, no. 1 (Summer 1999), pp. 43–48.

Van Arcken, Julie. "Activists Protest Use of Canaries in Exhibit," *The Daily Newspaper of the University of Washington* 100, no. 6 (1992).

Van der Burght, Angela. "Diaphaneity." *This Side Up* 7 (Autumn 1999).

Van der Linden, Mirjam. "Meg Stuart Blijft Boeien Met Haar Serie 'Insert Skin.' " *NRC,* 24 April 1999, p. 9.

Van Leeuwen, Astrid. "Jong Talent 'Springdance' Stelt Teleur." *Algemeen Dagblad,* 26 April 1999.

Van Proyen, Mark. "The New Pusillanimity; California Art and the Post-Regional Climates." *Art Criticism* 8, no. 1 (September 1993), pp. 81–96.

Van Rhyn, Jacqueline. "Curator's Highlights." *Newsprint*, Spring 2005, pp. 4–5.

Van Ryzin, Jeanne Claire. "Engaging Passage from '90s to Now." *Austin American-Statesman,* 25 March 2000.

Van Valkenburgh, Michael. "Faculty Project: Teardrop Park." *Harvard Design Magazine*, Fall 2000, pp. 92–93.

Venturi, Riccardo. "Il Senso de Ann Hamilton per Parigi." *Exibart.onpaper*, April 2005.

Verduyckt, Paul. " 'Appetite' van Meg Stuart." *Knack*, 23 September 1998.

Vernay, Marie-Christine. "Meg Stuart a Bon 'Appétit.' " *Libération*, 5 March 1999, p. 39.

Verzotti, Giorgio. "La Biennale delle Culture Emergenti." *Tema Celeste*, September 1999, pp. 46–54.

Vetrocq, Marcia E. "AVA 9." *Arts Magazine* 65, no. 1 (September 1990), p. 80.

———. "The Venice Biennale: Reformed, Renewed, Redeemed." *Art in America* 87, no. 9 (September 1999), pp. 83–93.

Vielhauer, Annette. "Hinter Jeder Bewegung Steckt Ein Unstillbarer Hunger." *Frankfurter Neue Presse*, 2 May 1999.

Vincent, Steven. "Carpenter Loses Suit." *Art + Auction*, October 1997, pp. 35–36.

Vogel, Carol. "The U.S. Choice for Venice." *The New York Times*, 29 May 1998, p. E36.

——. "Inside Art: To the Rescue." *The New York Times*, 7 May 1999, p. E30.

——. "At the Venice Biennale, Art is Turning Into an Interactive Sport." *The New York Times*, 14 June 1999, p. E1.

Vollmer, Horst. "Zusammenleben Allein, Verloren Unter Zuviel Stoff." *Berliner Zeitung*, 9 February 1999.

Von Drathen, Doris. "Ann Hamilton: Gespeicherte Zeit, Gespeichertes Tun." *Kunstforum International,* August 1999, pp. 289–97.

——. "Ann Hamilton." *Kunstler, Kritisches Lexikon der Gegenwartskunst*, 2000.

Wachtmeister, Marika. "Magi och poesi: I ett skimrande Venedig." *Femina* 9 (September 1999), pp. 174–78.

Wakefield, Neville. "Presence of Mind." *Vogue*, March 1994, pp. 374–79, 432–34.

Wallach, Amei. "Evoking Unwilled Memories at Dia." *New York Newsday*, 15 October 1993, p. 89.

——. "Display Types." *Home Style*, December 2001/January 2002, pp. 56–63.

Walter, Lucie. "Unstillbares Verlangen." *Neues Deutschland,* 18 August 1999.

Wasserman, Burton. "ICA Installation Transforms Gallery With 'Rare Magic.'" *Art Matters*, July/August 1995, p. 21.

Weber, Kathrin. "Das Aushalten von Menschen und Situationen." *Giessener Allgemeine,* 2 June 1999.

Weber, Lilo. "Wunde Körper in Neuen Hallen." *Neue Zürcher Zeitung*, 28–29 August 1999, p. 65.

Weiss, Hedy. "Meg Stuart/Damaged Goods in 'appetite.'" *Chicago Sun-Times*, 29 October 1998, p. 34.

Weissman, Michaele. "The 25 Most Influential Working Mothers." *Working Mother*, February 1998, pp. 26–34.

Weitz, Jay. "Immersive Collaboration." *Columbus Alive* 18, no. 41 (11 October 2001).

Weschler, Lawrence. "Table Talk." *The Three-Penny Review* 16, no. 1 (Spring 1995), p. 3.

White, Cheryl. "Fibers in the Modern Sensibility." *Artweek* 18, no. 30 (September 1987), p. 1.

Wilkens, Stephanie. "Wexner Arts Fest Invites Students to Dabble at the 'Artomat.'" *The Ohio State Lantern*, 22 May 1996, p. 7.

Withers, Rachel. "Allied Forces." *Artforum* 37, no. 9 (May 1999), p. 81.

Wittstock, Susan. "New Artistic Perspectives." *OnCampus*, 11 October 2001, pp. 7–8.

Wolf, Barnet D. "Artistic Advantage." *The Columbus Dispatch,* 7 February 1997, pp. 1D–2D.

Woodard, Joseph. "Nature Revealed and Interpreted." *Artweek* 19, no. 21 (May 1988), p. 5.

Woods, Byron. "Lovely Images, Uncertain Message." *The News & Observer*, 21 July 2001, p. 14.

"Works on Paper: Evo Gallery, Santa Fe, NM." *ARTnews*, November 2002. p.175.

Yablonsky, Linda. "Air: James Cohan Gallery, through February 15." *Time Out New York,* 6–13 February 2003, p. 52.

"Yankee Remix Shines a New Light on Old Objects." *The Advocate*, 20 August 2003.

Yates, Christopher A. "Contemporary View." *The Columbus Dispatch*, 2 May 2004, p. D4.

Yood, James. "The 51st Carnegie International: Taking Stock." *New Art Examiner* 19, no. 5 (January 1992), pp. 16–19, 44.

Young, Clara. "The Patron Age of Fashion: Sponsoring with Style." *Dutch Magazine,* March/April 2000, p. 116.

Young, Jenny. "The Erratic Professors." *The Other Paper*, 22–28 November 2001, p. 14.

Young, Margaret. "Ann-thology." *In Pittsburgh Newsweekly*, 5–11 September 1996, cover, pp. 12–16.

Youssi, Yasmine. "Ann Hamilton Donne de la Voix." *Journal du Dimanche*, 27 February–5 March 2005.

Zevi, Adachiara. "Gober, Stockholder, Hamilton: Pre-Logical Associations." *L'Architettura* 42 (1996), pp. 56–58.

——. "The Biennial of Globalization." *L'Architettura* 45 (1999), pp. 468–70.

Zimmer, Elizabeth. "Susan Hadley/Bradley Sowash, P.S. 122." *Dance Magazine,* September 1986, p. 84.

Zimmer, William. "Works that Are Made from Textiles." *The New York Times,* 18 January 1998, p. C18.

——. "A Pair of Unsettling Shows to Prod the Viewer." *The New York Times,* 2 May 1999, p. C18.

Zuck, Barbara. "Collaborative 'Appetite' Satisfies Playful Cravings." *The Columbus Dispatch,* 18 October 1998, pp. 18, 1F.

——. " 'Appetite' Offers Full Course of Nontraditional Dance Movement." *The Columbus Dispatch,* 22 October 1998, p. 7E.

——. "Talented Teams: Ann Hamilton's Projects with Husband, Others Aren't Installations—They're Experiences." *The Columbus Dispatch,* 7 October 2001, pp. F1–F2.

——. "Unconventional 'mercy' Delivers Its Message." *The Columbus Dispatch*, 13 October 2001, p. D3.

Zuckriegl, Margit. "3rd Biennale d'Art Contemporain de Lyon." *Eikon* 16/17 (1995–1996), pp. 112–13.

Dissertations and Theses

Basha, Regina. "Diary of a Human Hand." Master of Arts Thesis. Bard College, 1996.

Bousman, Kelly Claire. "A Poetry of Place: An Intertextual Study of Three Installations by Ann Hamilton." Master of Arts Thesis. University of South Florida, 1995.

Cramer, Deanna M. "Bringing Back the Body." Master of Fine Arts Thesis. University of Iowa, 1996.

Stevenson, Karen. "Memory: Necessity for Error." Master of Fine Arts Thesis. University of Notre Dame, 1999.

Vigna, Lean Marie. "Ann Hamilton and Issues of the Body." Doctoral Dissertation. University of Illinois at Urbana-Champaign, 1999.

Acknowledgments

In the process of reviewing and assembling material from more than twenty years, we have revisited many of the conversations that shaped and influenced the work documented in this inventory.

In conversation, you hear yourself say things you didn't know you knew, thinking things you didn't know you thought, making connections that weren't there before. As a form of making, the landscape of conversation with friends and colleagues has as much to do with the history of a work as a description of materials and processes. Talk prepares the ground for imagining work, supports the process of finding form. This book, now another object in hand, was similarly formed by recognitions discovered in and through conversation, and we are grateful for the generous thought and time given by the many who took part in preparing it.

The materials in Ann Hamilton's Ohio studio were initially organized by Maggie Moore and Kristine Helm, who set order to the archives, unearthed video and audio recordings in multiple formats, and righted a documentation system ordered more by association than by category. More recently, Jessica Larva helped bridge the divide between analog and digital records and histories. Each time the technological edge threatened to overwhelm, their patience and good nature reset the course and kept the studio a happy place to work. In Paris, Stephanie Schumann, working with Joan as research associate and curatorial assistant, set an energetic pace and offered informed and lively debate. Lucy Gallun at Gregory R. Miller & Co. and Tei Carpenter at Sean Kelly Gallery shepherded the manuscript and images through production. Tei Carpenter prepared the book's exhibition history and bibliography and researched collection credits. Lucy Gallun prepared the index of titles. Together they brought their exacting attention to deadlines and detail.

We are both grateful to Sean Kelly for his passionate involvement in presenting artists' work—and with this artist, his ongoing conversation and vigorous believe in her practice for fifteen years. His enthusiasm for this publication and the responsiveness of his gallery's staff to our innumerable requests for detailed information have been critical in this book's formation.

Hans Cogne, with subtle understanding of the work and sensitivity to the challenges of representing it, has designed the weight, feel, and image of this book. We hope this is just one addition to a series of works we will have future opportunities to make together across many time zones separating our work spaces.

We feel privileged and grateful, in particular, for the lead and example of our visionary publisher, Gregory Miller, who always engaged an open and exploratory method and sought with patience the highest quality materials for the book's production. Because of him, the making of this book became a richly conversational, critically expansive project.

For each of us, the first and last conversation takes place at the tables where we gather regularly. The ongoing love and support of our families and the engaged discussion among colleagues and friends provides the solid ground and ballast from which all "what ifs?" might spring. Ann Hamilton with Michael Mercil, Emmett Mercil, Ann Chamberlain and Jessie Shefrin. Joan Simon with Alan Kennedy, Ani Simon-Kennedy, Kira Simon-Kennedy, Elizabeth Baker, and Susan Rothenberg.

Finally, for the two of us this decade-long conversation is, with this book, a summation of what has been and an opening to the possibilities of what is next.

Ann Hamilton and Joan Simon, 2006

About the author

Joan Simon, curator-at-large for the Whitney Museum of American Art, New York, is a writer, curator, editor, and arts administrator based in Paris who has worked independently for museums, foundations, and publishers in the United States and in Europe. A former managing editor of *Art in America* (1974–83), Simon has published extensively on contemporary art. Among her books and catalogues are *Susan Rothenberg* (1991), *Ann Hamilton* (2002), and *William Wegman : Funney / Strange* (2006). She has contributed to publications on Gordon Matta-Clark, Rosemarie Trockel, Jenny Holzer, Cynthia Schira, Fred Sandback, Sheila Hicks, and Joan Jonas, among others, and served as general editor of the exhibition catalogue and catalogue raisonné *Bruce Nauman* (1994).

Photo credits

Blaise Adilion, pp. 77, 94, 113, 161 bottom; Christopher Baker p. 157 left; Dave Barker p. 201; Jeff Bates p. 6; Philip Beaurline p. 203; Ben Blackwell pp. 81, 82–83; Will Brown p. 120; Jenni Carter p. 150; Hans Cogne pp. 23 left, 245, 254–255; Dawid p. 248; D. James Dee pp. 68–69, 80, 88, 89, 90–91, 99 right, 102–103, 118, 166; Liz Deschenes pp. 169, 170, 172–173, 176, 178; Kevin Fitzsimons, p. 29 top—left/right; Hugo Glendinning p. 119; David Grimes pp. 58–59; Glen Halvorson pp. 100, 101; Ann Hamilton pp. 3 bottom, 15, 25, 29 middle—left/right, 31 bottom—all, 63, 125, 155, 171, 177, 243 bottom, 249; Steven P. Harris pp. 124, 134, 162, 164, 198; Hester + Hardaway pp. 156, 167; Timothy Hursley p. 17 top—left; Aaron Igler pp. 116, 121; Thibault Jeanson pp. 13, 17 top—right, 18–19, 26–27, 30 top and middle—left/right, 31 top, 32–33, 112, 114, 152–153, 157 right, 163, 165, 168, 193, 199, 224, 240–241, 251; Kevin Kennefick p. 226 top; Richard Loesch pp. 52–53, 54, 72–73, 76, 84–85, 98, 104, 123; Charles Mayer p. 7; Wayne McCall pp. 14, 66, 70, 78–79; Wit McKay pp. 38, 194 pinholes 1–2, 200, 206, 214; Gary McKinnis pp. 132–133, 135; Trevor Mills p. 128; Bob McMurtry pp. 10, 55, 56–57; Richard Nicol pp. 95, 96–97; Cheryl O'Brien pp. 108–109; Michael Olynick p. 92; Douglas M. Parker pp. 208–209, 260–261; Ondrej Polák pp. 130–131; Rik Sferra p. 234; Jessie Shefrin p. 17 bottom—right; Shawn Skully p. 192; Lara Swimmer p. 17 bottom—left; Eiichi Tanakka p. 20; Robert Wedemeyer pp. 75 bottom, 117; Steve Willard pp. 174–175, 184–185

Index of Titles

Published in 2006 by Gregory R. Miller & Co., New York

Gregory R. Miller & Co., LLC
62 Cooper Square
New York, New York 10003

Available through D.A.P./Distributed Art Publishers
155 Sixth Avenue, 2nd Floor
New York, New York 10013
Tel: (212) 627-1999
Fax: (212) 627-9484

Library of Congress Cataloging-in-Publication Data

Simon, Joan, 1949–
Ann Hamilton : an inventory of objects / Joan Simon.
 p. cm.
Includes bibliographical references and index.
ISBN-13: 978-0-9743648-5-8 (alk. paper)
ISBN-10: 0-9743648-5-1 (alk. paper)
1. Hamilton, Ann, 1956—Catalogs. I. Hamilton, Ann, 1956– II. Title.
N6537.H337A4 2006
709'.2—dc22
2006009915

Book design, including cover: Hans Cogne
Printing: Fälth & Hässler, Värnamo
Book binding: Carl Svanberg, Lessebo

Printed and bound in Sweden

Ann Hamilton
An Inventory
of Objects